I0234958

IMAGES
of America

THE DIOCESE OF WILMINGTON

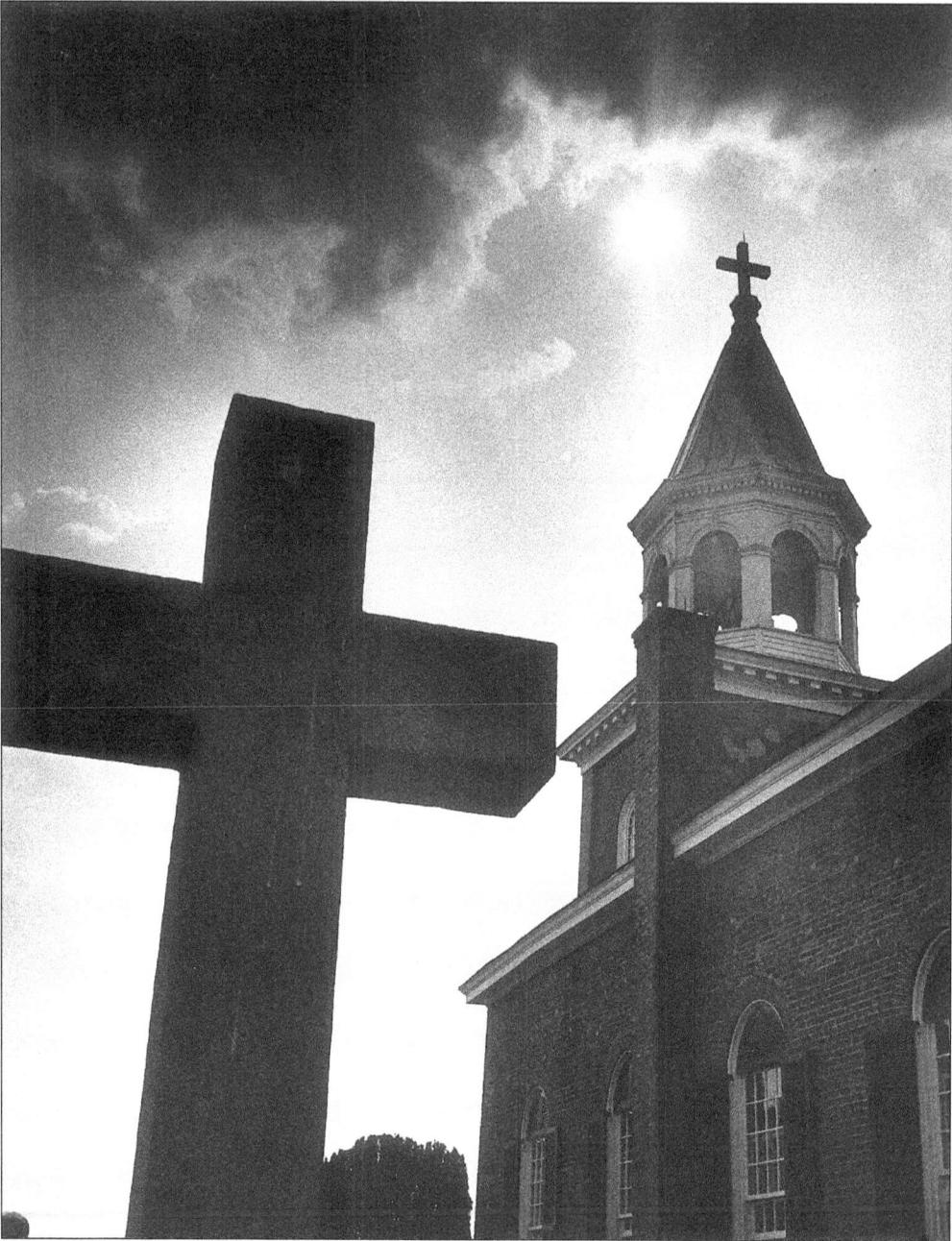

IMAGES
of America

THE DIOCESE OF WILMINGTON

Jim Parks

ARCADIA
PUBLISHING

Copyright © 2001 by Jim Parks
ISBN 978-0-7385-1365-2

Published by Arcadia Publishing
Charleston, South Carolina

Printed in the United States of America

Library of Congress Catalog Card Number:

For all general information contact Arcadia Publishing at:
Telephone 843-853-2070
Fax 843-853-0044
E-Mail sales@arcadiapublishing.com
For customer service and orders:
Toll-Free 1-888-313-2665

Visit us on the Internet at www.arcadiapublishing.com

DEDICATION

To the thousands of men and women—clergy, religious, and laity—whose faith, dedication, and good works have defined our diocese, this slim volume, which only hints at the extent of their efforts, is dedicated.

CONTENTS

Acknowledgments 6

Prologue 7

1. Solid Foundation 9

2. Growing Years 27

3. Coming of Age 63

4. A Time for Change 79

5. The People of God 99

6. Into the Future 121

ACKNOWLEDGMENTS

Intended primarily as a sort of family photo album, this book is not meant to be a history of the diocese. It is hoped, however, that it will evoke memories among those who were along on parts of the journey and inspire all by the example of those who have gone before.

It could not have happened without the help and cooperation of several archivists, resident historians, and tenders of the scrapbooks at each of the parishes, schools, and other venues represented. Special thanks are extended to Mr. Donn Devine, diocesan archivist; Mr. Jim Grant, editor of *The Dialog*; Monsignor Joseph F. Rebman, vicar general for pastoral services; and Mr. F. Eugene Donnelly, recently retired diocesan director of communications. Much of the biographical information was obtained from *Catholic Priests of the Diocese of Wilmington* by Father Thomas J. Peterman. Mr. Richard Lee, of Christ Our King Parish, made sure dates and other details in the manuscript were accurate.

PROLOGUE

Unless we know where we have been, we cannot possibly understand where we are going.

Catholic faith was first brought to the peninsula that lies between the Chesapeake and Delaware Bays by Jesuit priests who rode circuit from the Maryland colony, offering Mass and bringing the Word of God and the sacraments to private homes. Mass is known to have been celebrated on Kent Island, Maryland, as early as 1639. St. Francis Xavier Mission in Cecil County, Maryland, was founded in 1704. Also known as Bohemia Manor or Old Bohemia, the shrine still welcomes visitors, and worshippers gather there on selected Sundays during the spring and summer.

The earliest documentation of Catholics in Delaware, according to Henry Clay Reed's *Delaware: A History of the First State*, was in 1751 when it was reported from Dover that "there are five or six families of Papists, who are attended once a month from Maryland with a priest." Various missions were established before and subsequent to that in both Maryland and Delaware.

In 1772, Jesuit Father Matthew Sittensperger, from Bohemia Manor, purchased a farm along Coffee Run near what is now Hockessin, Delaware. There he built a log chapel that he named to commemorate the Assumption of the Blessed Mother.

The Diocese of Baltimore, which included all of the new United States, was established in 1789 under Bishop John Carroll, the first English-American bishop. That was the same year in which constitutional government began with the inauguration of George Washington as the first President. Delaware was included as part of Philadelphia when that diocese was split off from Baltimore in 1808.

Three years earlier, Father Patrick Kenny came to St. Mary of the Assumption at Coffee Run, by then a parish, as the fourth pastor, ministering to a small congregation scattered over a large area from West Chester, Pennsylvania, to Havre de Gras, Maryland. Most of that population, however, was concentrated in Wilmington, Delaware. So it was there that Father Kenny built a permanent church, St. Peter's, now the cathedral, which was completed in 1816. He divided his time between there and St. Mary's and its mission circuit until the coming of Father George Carrell, first resident pastor of St. Peter's, in 1829. Father Patrick Reilly succeeded him in 1835.

Also designated by Father Kenny to be a permanent church was the mission in New Castle, Delaware. He laid the cornerstone in 1807, but the church, also dedicated to St. Peter, was not completed until 1835.

Meanwhile, on the banks of the Brandywine in Christiana Hundred, a French émigré, Éleuthère Iréné du Pont, in 1802 built the first of several mills to produce gunpowder. As the result of the company's recruiting immigrant laborers, there soon was a large Irish-Catholic population at Henry Clay, Delaware. Although of Huguenot Protestant heritage themselves, several members of the Du Pont family were solicitous for the religious well-being of their workers and therefore provided material support for the establishment in 1841 of St. Joseph-on-the-Brandywine Parish. Father Kenny collaborated with Charles I. du Pont, who donated land and arranged for company stonemasons to construct the church building of the same stolid "Brandywine granite" that was used for the mills in the powder yard.

Irish laborers came also to Cecil County, Maryland, which along with the other Eastern Shore counties west of the Mason-Dixon Line remained under the jurisdiction of Baltimore, to build the Susquehanna and Chesapeake & Delaware Canals. Mrs. Margaret Butler Lyons bought property on the outskirts of Elkton, which she transferred to the archdiocese, as the site for a permanent church. Father George King, from Bohemia Manor, oversaw the project and in 1849 a house of worship commemorating Mary's Immaculate Conception was opened.

St. Paul's, a mission of Jesuits from Philadelphia, was established at Delaware City, Delaware, in 1852, as was one in Galena, Maryland, dedicated to St. Dennis, in 1856.

While St. Peter's served the west side of Wilmington, Father Riley soon saw the need on the other side of the growing town for a second parish. That, too, was dedicated to Mary and the then recently proclaimed dogma of the Immaculate Conception. A church, school, convent, and rectory were built in 1858 and consecrated by then Bishop, now Saint, John Neumann of Philadelphia.

As the Civil War drew to a close, Catholics in the Newark, Delaware, area acquired the building and grounds of First Presbyterian Church and converted the church to Catholic worship, initially under the patronage of St. Patrick and later St. John the Baptist.

Thus it was from a relative handful of people in 1800 that the Catholic population had significantly expanded a half-century later to an estimated 3,000. By then it was realized that the tide of immigration from Europe was just beginning. Irish and Germans made up most of the initial wave. They were to be followed between 1885 and 1910 by even greater numbers of Italians and Poles.

Among the new dioceses for which the bishops at the Second Plenary Council of Baltimore saw pressing need and petitioned the Holy See to establish was one encompassing the Delmarva Peninsula and seated in Wilmington. Pope Pius IX acceded to their wishes on March 3, 1868.

Bishop Thomas A. Becker from Richmond, Virginia, was appointed to take jurisdiction over the three counties of Delaware, nine in Maryland, and two in Virginia, which constitute the peninsula. The Virginia counties were ceded to the Diocese of Richmond in 1974 after the bridge-tunnel connector was built and they no longer were isolated from the rest of the state. Bishop Becker began his service in the new diocese with eight priests serving 18 churches. There were three parochial schools and an orphanage.

From that humble start the Diocese of Wilmington has emerged today, with a Catholic population of more than 190,000, or about 17 percent of the total population, worshipping in 56 parishes and 20 missions. The current *Catholic Directory* lists 236 diocesan and religious priests, 260 religious sisters, 25 religious brothers, and 48 permanent deacons in the diocese. There are 37 parochial, diocesan, and private Catholic schools serving 15,000 students with another 10,000 children enrolled in religion education classes in the parishes.

What follows is an all-too-limited photographic glimpse of this small part of the earthly Kingdom of God and His people.

One

SOLID FOUNDATION

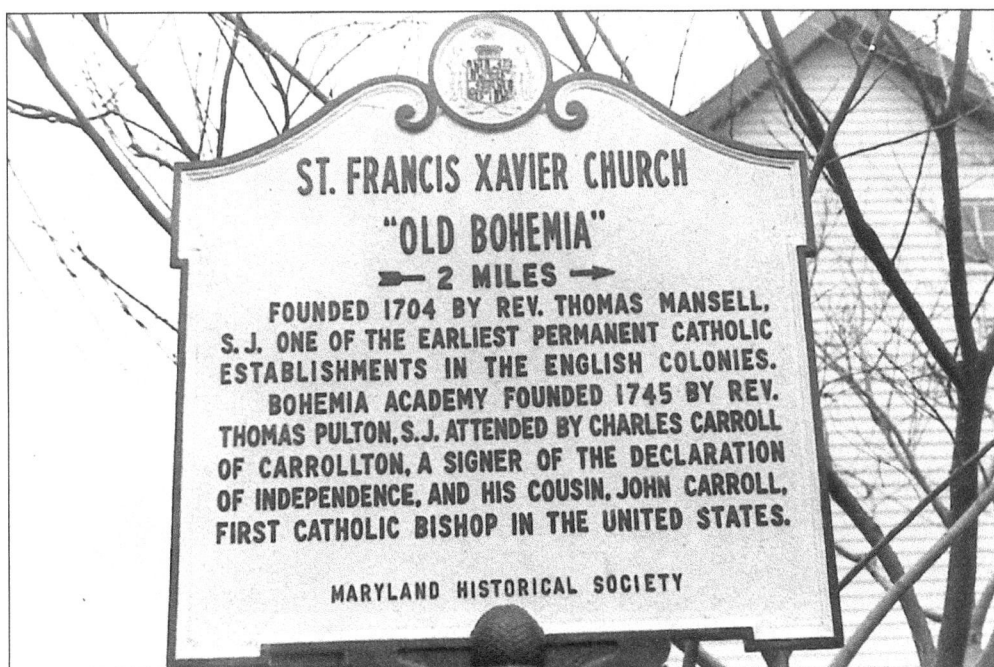

The site near Warwick, Maryland, identified by this historical marker, is where it all began—long before the Diocese of Wilmington, or for that matter, the United States came into existence. As the marker notes, however, one of the students at the school that was conducted here went on to play a prominent role in bringing about the new nation. (Photo from *The Dialog*.)

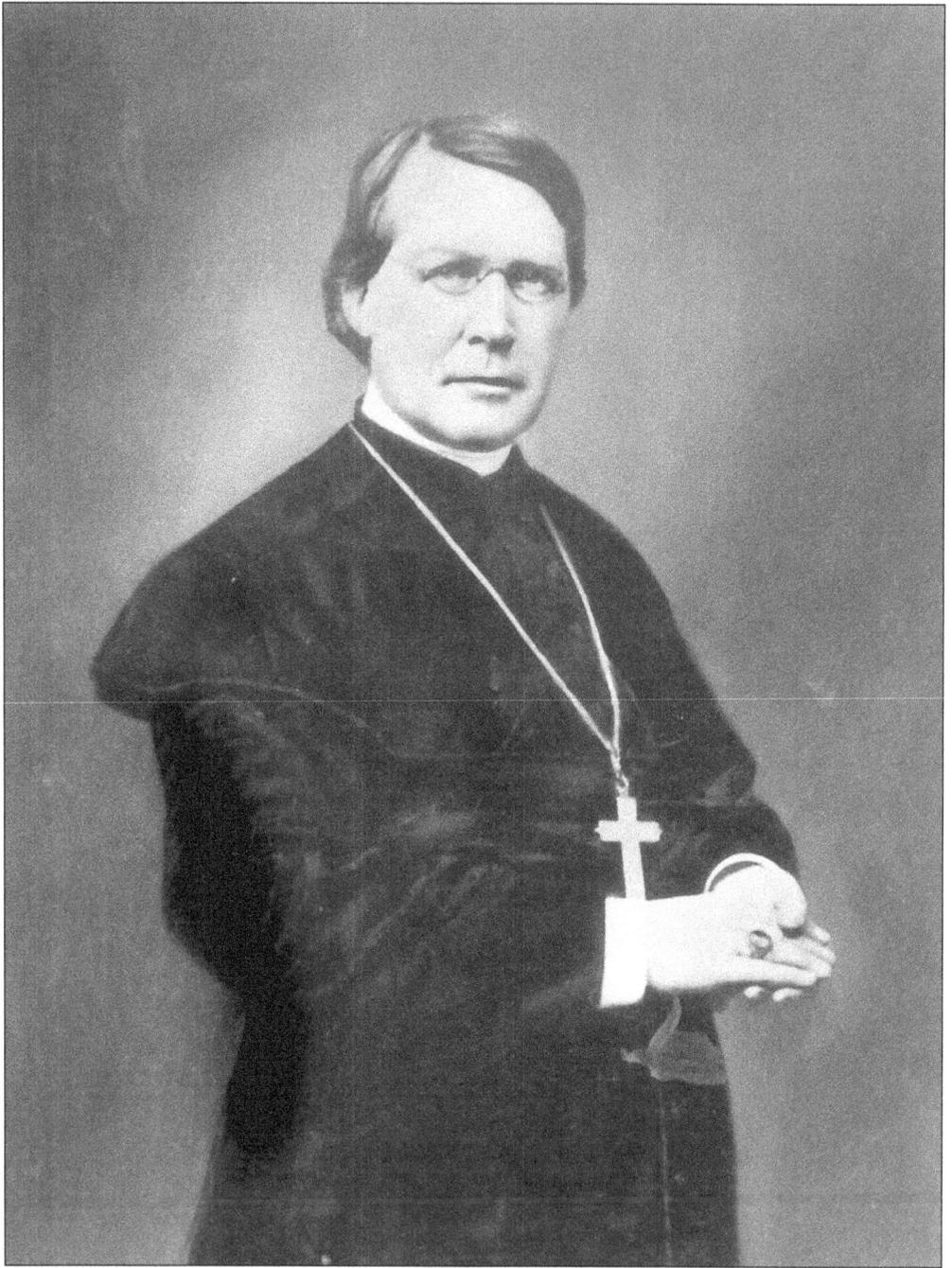

Bishop Thomas Andrew Becker was born in Pittsburgh, Pennsylvania, on December 20, 1832. He converted to Catholicism in 1853 and was ordained in Rome, Italy, on June 18, 1859. On August 16, 1868, he was consecrated as first bishop of Wilmington. He was appointed to be the sixth bishop of Savannah, Georgia, in May 1886. Bishop Becker died on July 29, 1899.

A procession leaves the St. Francis Xavier Shrine at Bohemia Manor after one of the public events during the summer of 1986. The historic site, which includes a visitors' center, is maintained to commemorate the diocese's colonial roots.

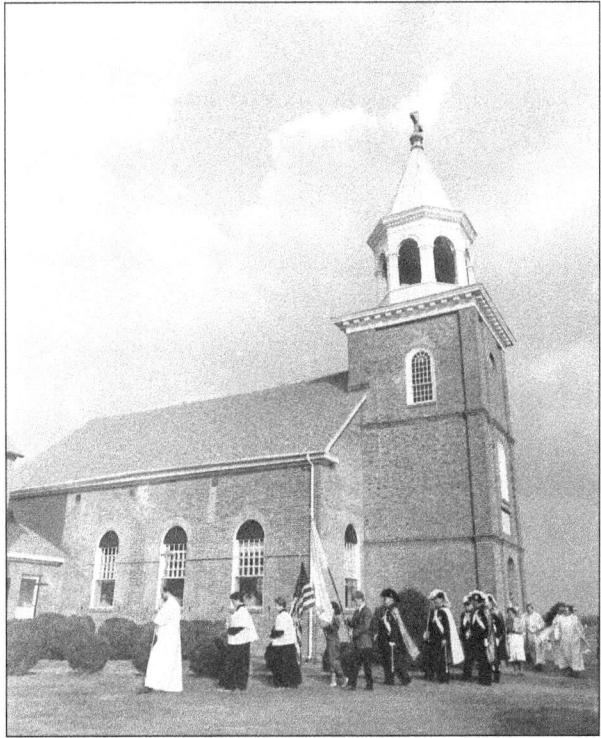

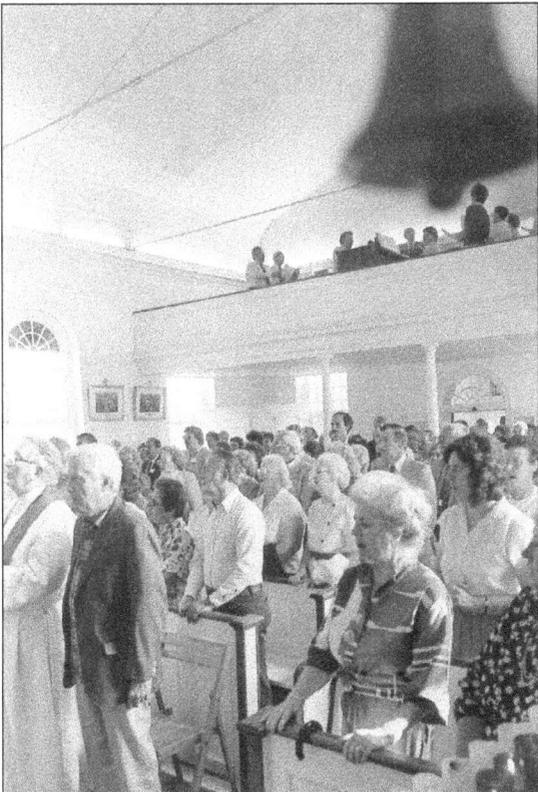

Worshippers are pictured here at Mass in the church on the same occasion. Mass is offered at the shrine during the spring and autumn. (Both Kathleen M. Graham photos from *The Dialog*.)

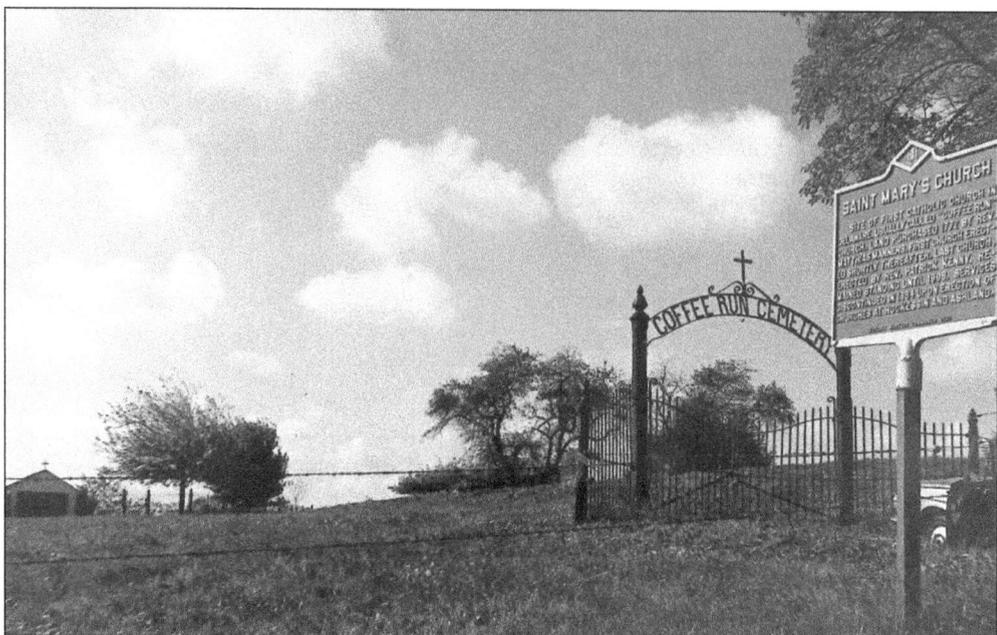

The cemetery connected to the original St. Mary's Church on the banks of Coffee Run, near Hockessin, is preserved and maintained as a historic site. The church was constructed in 1790 and rebuilt in 1850. It no longer exists. (Photo from *The Dialog*.)

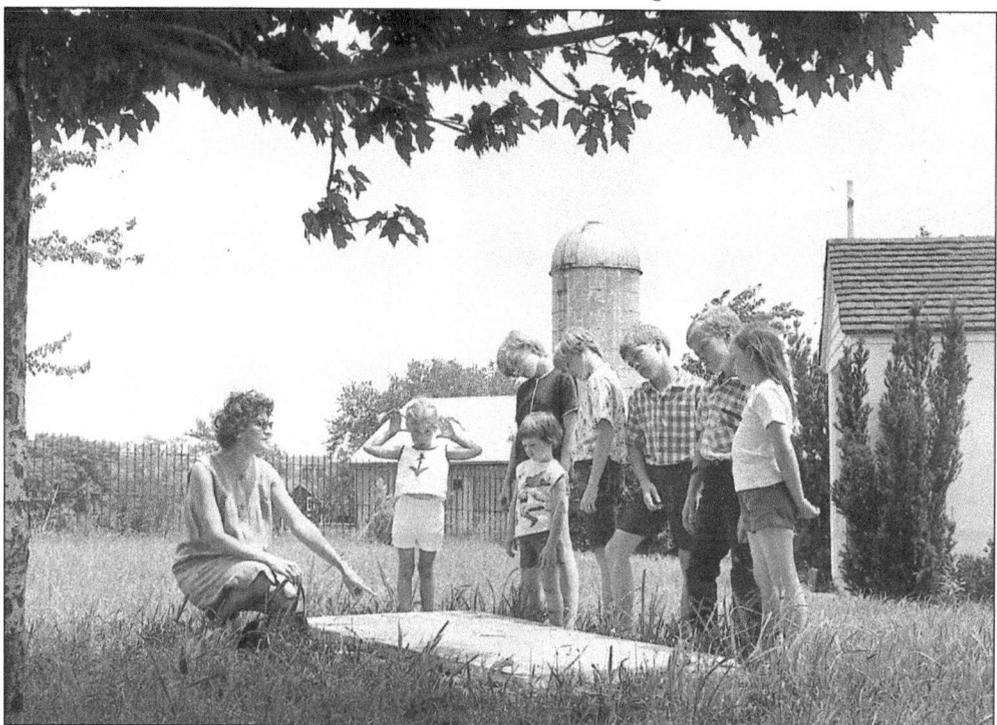

Mrs. Edward Gormley explains the significance of the Coffee Run cemetery site off Lancaster Pike to Ann Marie Gormley, Dawn and Kelly Ann Ford, and Michelle, Susan, Brian, and Gregory Swift. (Photo by Lloyd Teitsworth, Action Photo.)

Father William Hickley Gross, a German Redemptorist missionary, was the first pastor of Ss. Peter and Paul Parish, Easton. The parish was founded in 1868, coinciding with creation of the diocese.

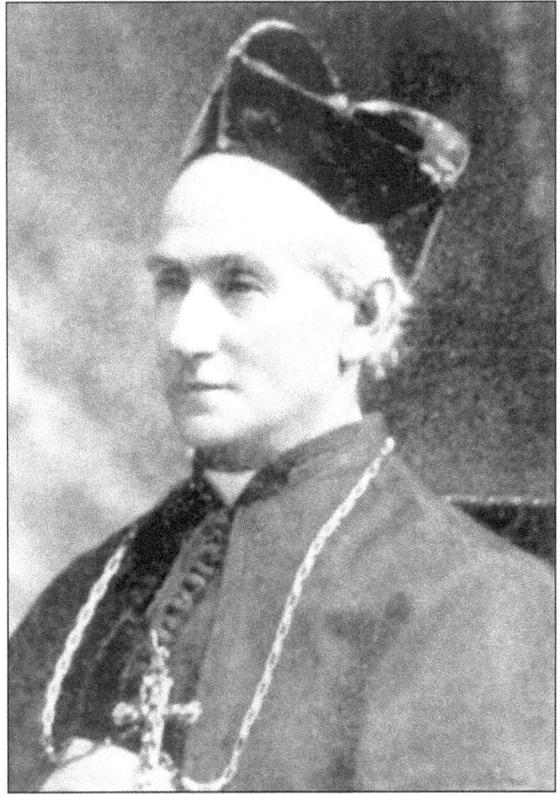

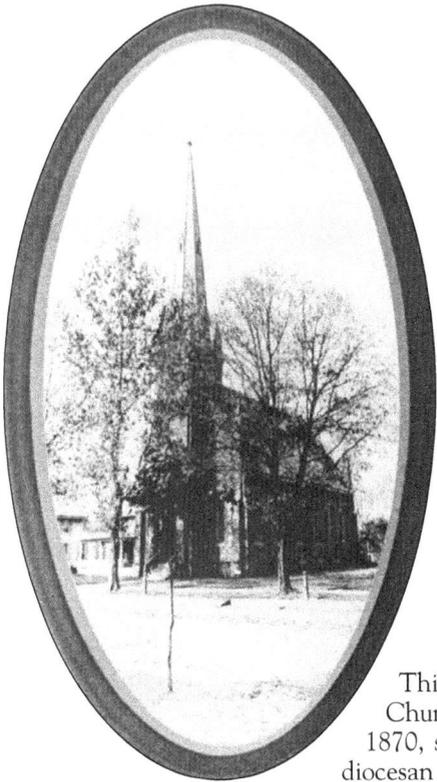

This photograph, showing the original Holy Cross Church on South State Street in Dover, was taken around 1870, soon after the parish was founded. (Courtesy of the diocesan archives.)

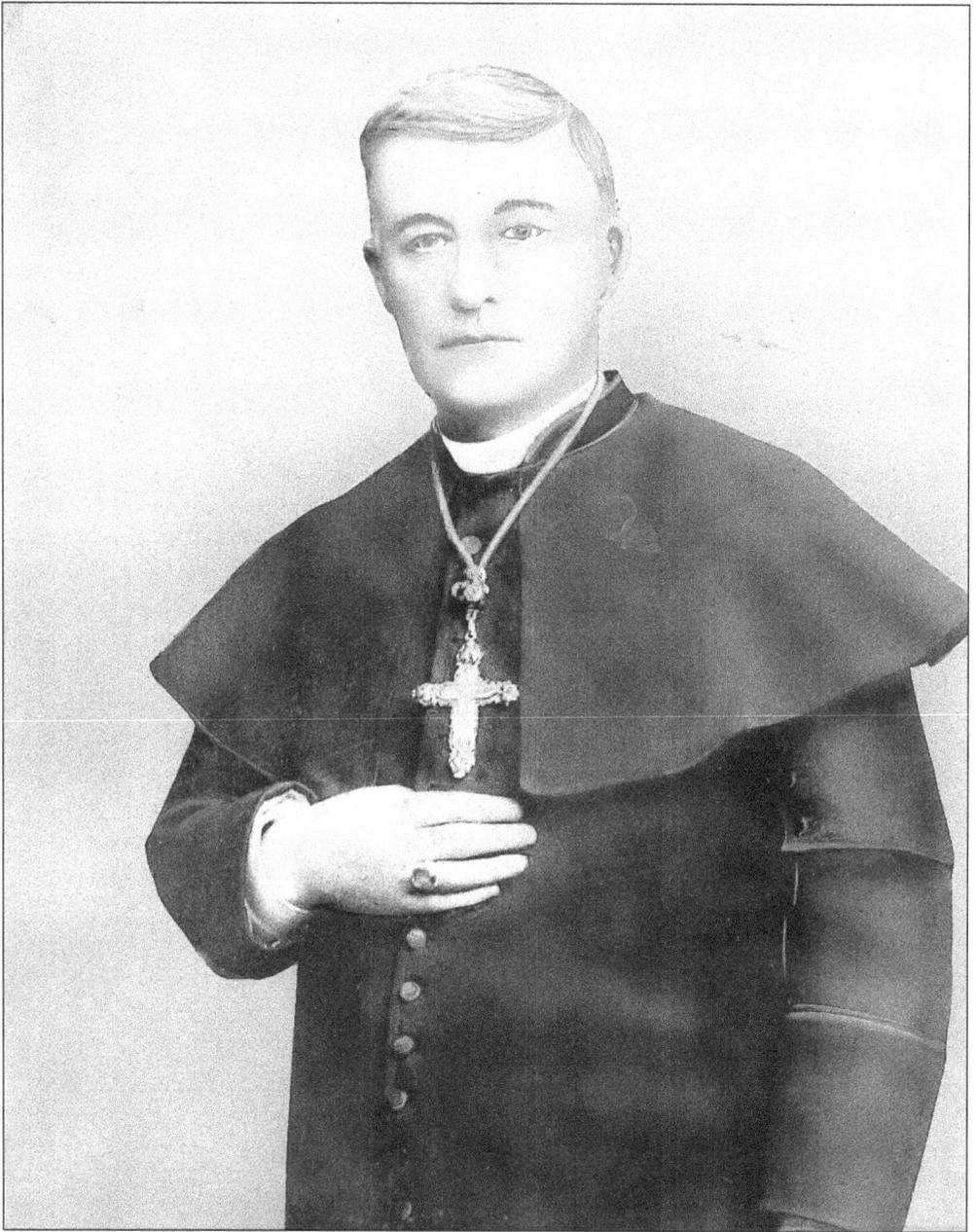

Bishop Alfred Allen Curtis was born in Rehobeth, Maryland, on July 4, 1831. He was ordained an Episcopal priest in 1859, and was received into the Catholic Church in Oxford, England, by John Henry Cardinal Newman on April 18, 1872. On December 19, 1874, he was ordained a Catholic priest in Baltimore, Maryland, and on November 14, 1886, he was consecrated as second bishop of Wilmington. He resigned and was named titular bishop of Echinus in 1896. He died on July 11, 1908.

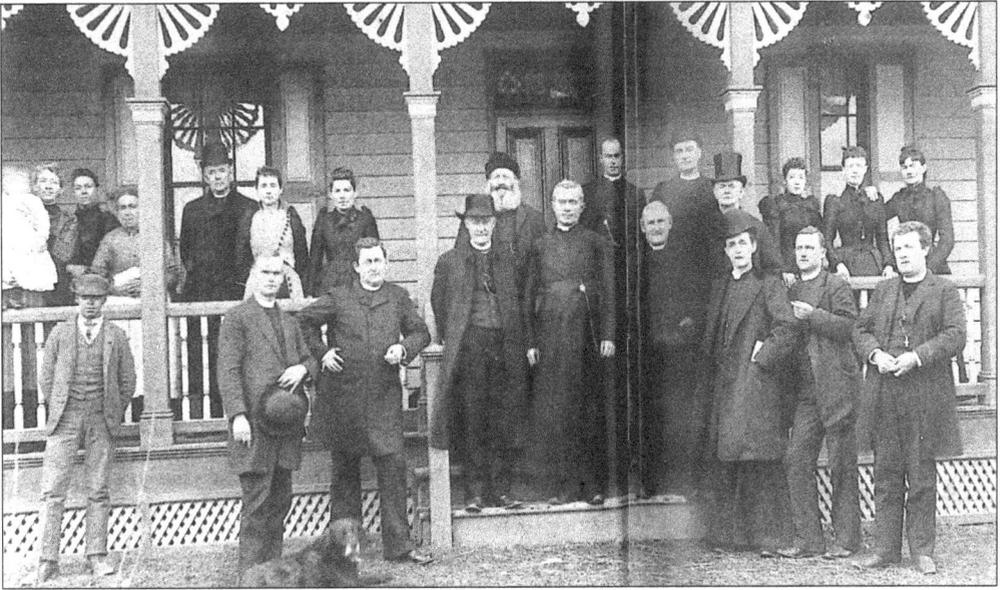

Priests of the diocese gather with Bishop Curtis (front row, fifth from left) on the front porch of the Immaculate Conception rectory in Elkton in 1892. They are (front row) Fathers John D. Carey, Francis J. Connelly, Daniel F. Haugh, George J. Kelly, Bishop Curtis, J.J. McGill, Dennis J. Crowley, William J. Scott, and George S. Bradford; (back row) William Dallard, John M. Giraud, Edward G. Mickle, and Edward L. Brady. Parishioners in the photograph are not identified. (Photo from the Immaculate Conception sesquicentennial history.)

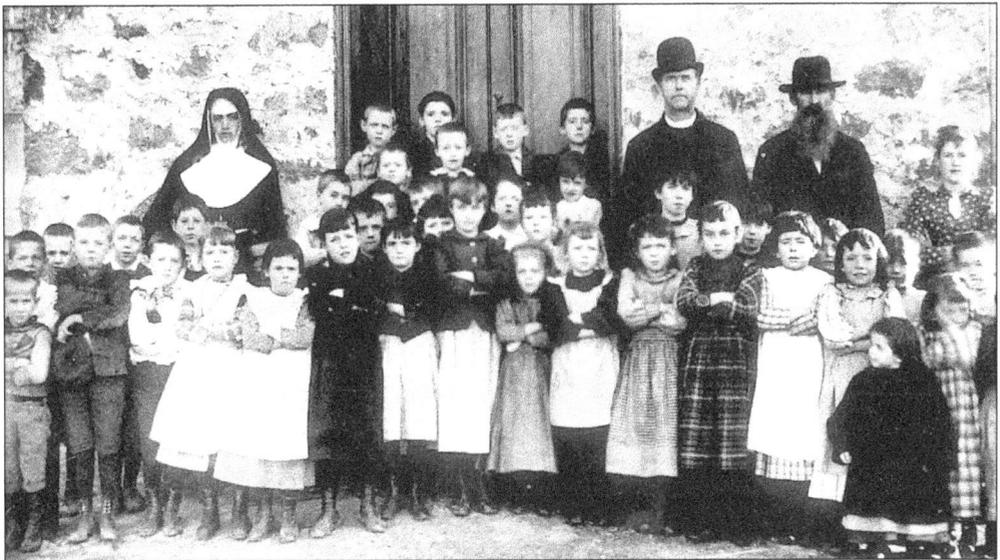

St. Joseph-on-the-Brandywine Sunday school students are pictured in 1887. The tall priest wearing a derby and standing third from the right in the back row is Father Edward Henchy, who served briefly as St. Joseph's pastor but was better known for many years of work in the Eastern Shore counties. Ordained as a Jesuit, he elected to become a diocesan priest so he could continue his ministry when the part of Maryland east of the Chesapeake Bay was ceded to the new Diocese of Wilmington. (Hagley Museum and Library photo from the parish's sesquicentennial history.)

The original Visitation, and later Ursuline, convent and academy at Delaware Avenue and Harrison Streets in Wilmington looked like this around the turn of the 20th century. Several years after the Ursulines moved to their present location on nearby Pennsylvania Avenue, this building was torn down to make way for the Mayfair Apartments. (Photo from the Ursuline Academy's 1993 centennial booklet.)

This Visitation community and academy faculty turned over the school, which they had conducted since 1870, to the Ursulines in 1893, soon after this photograph was taken. The Visitandines, who had come to this country in the mid-1800s, had long cherished the idea of returning to the way of life in an apostolate of prayer and spiritual outreach that their order had known in France. (Courtesy of the Visitation archives.)

St. James Church, at Lovering Avenue and Du Pont Street in west Wilmington, shown here in 1869, served a growing congregation of predominantly Irish immigrant workers at the Bancroft and Riddle textile mills and other establishments along the Brandywine. The church gave way to the Baltimore & Ohio Railroad viaduct in 1887, and the parish was renamed in honor of St. Ann when the church was relocated to its present site on Union Street. (Courtesy of the diocesan archives.)

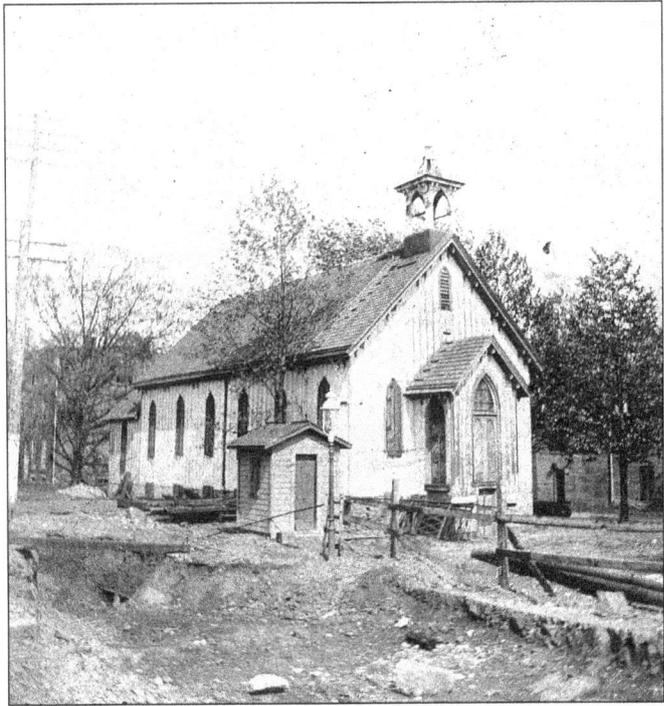

St. Peters Cathedral, 6th & West St.
Wilmington, Del.

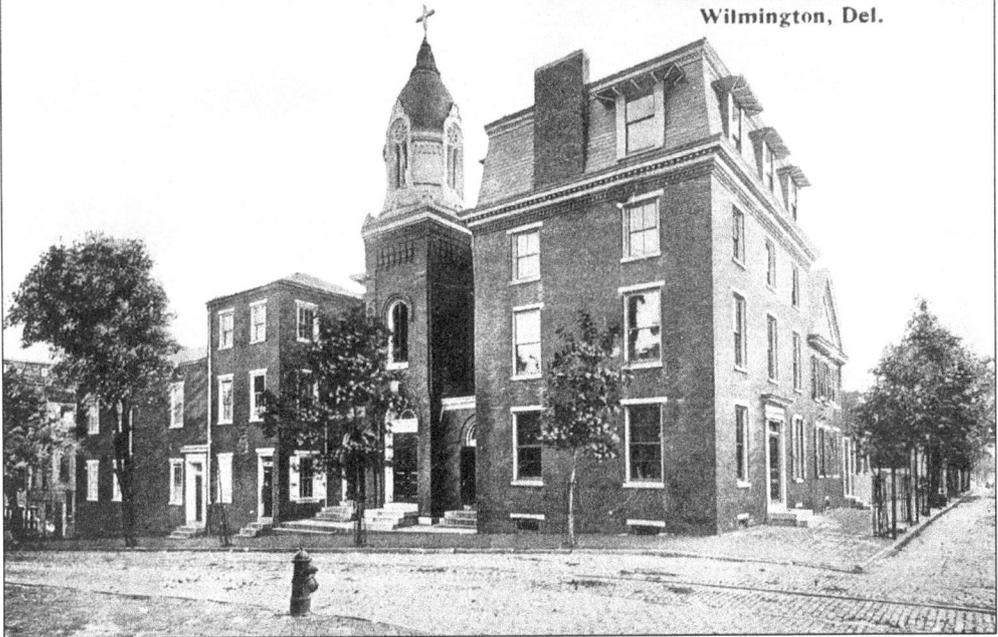

Cathedral of St. Peter at Sixth and West Streets in Wilmington, pictured here c. 1920, is the oldest church building in the diocese still in active service. It had undergone several renovations and additions since it was built in 1816 and there would be several more in later years. It has served as cathedral for all eight bishops of Wilmington as well as a parish for residents of west center city and elsewhere. (Courtesy of the diocesan archives.)

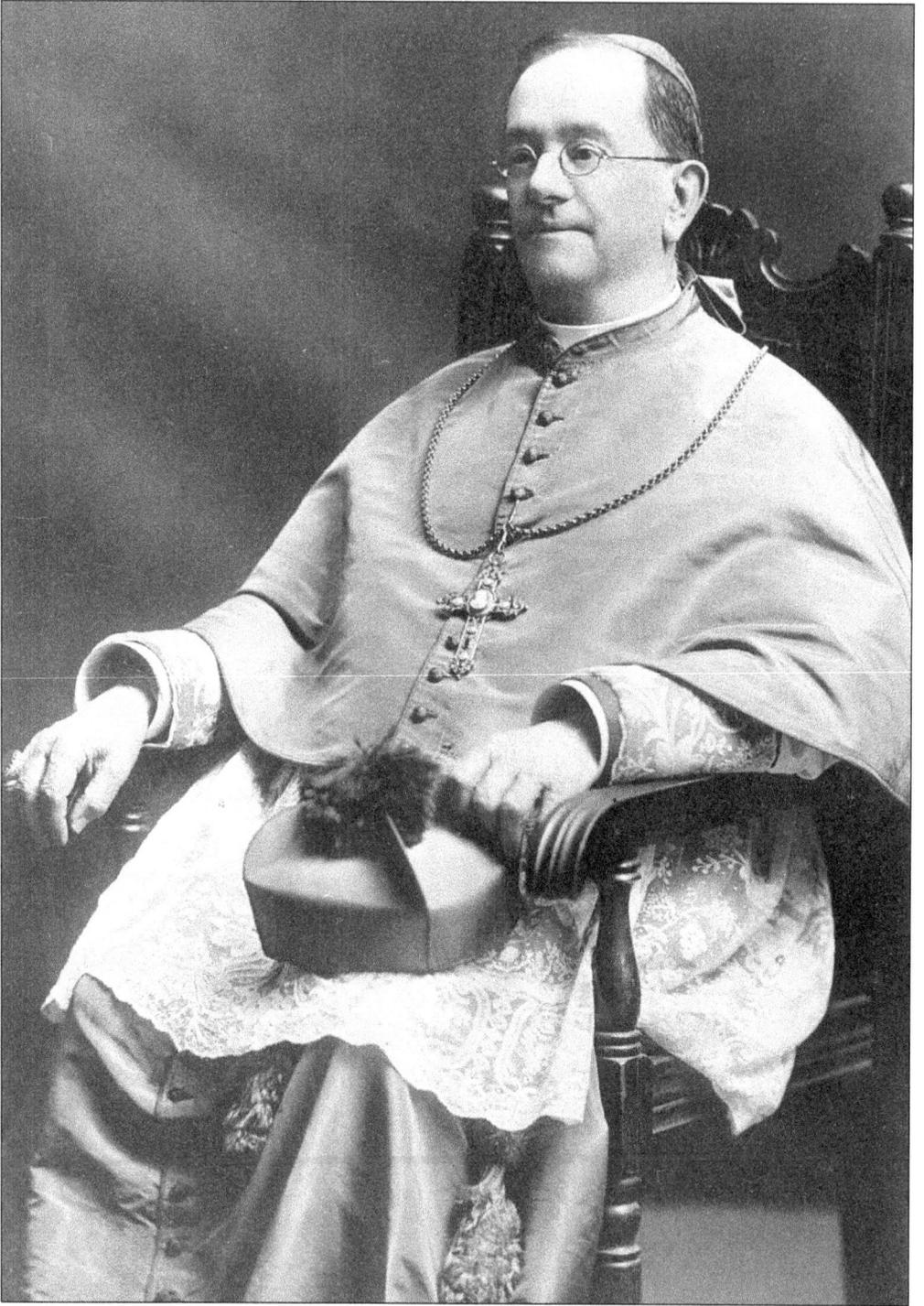

Bishop John J. Monaghan was born in Sumter, South Carolina, on May 23, 1856. He was ordained in Baltimore, Maryland, on December 19, 1880. Consecrated as third bishop of Wilmington on May 9, 1897, he resigned and was named titular bishop of Lydda on August 1, 1925. He died on January 7, 1935.

A son of the Eastern Shore, Father William G. Temple grew up in Centerville, was ordained in 1895, and served as pastor at Ss. Peter and Paul Parish in Easton. He was appointed founding pastor of St. Elizabeth Parish in south Wilmington in 1908 and served there for 31 years. He died in 1939 at age 71 and is memorialized by Temple Terrace, a street in the neighborhood. (Courtesy of the diocesan archives.)

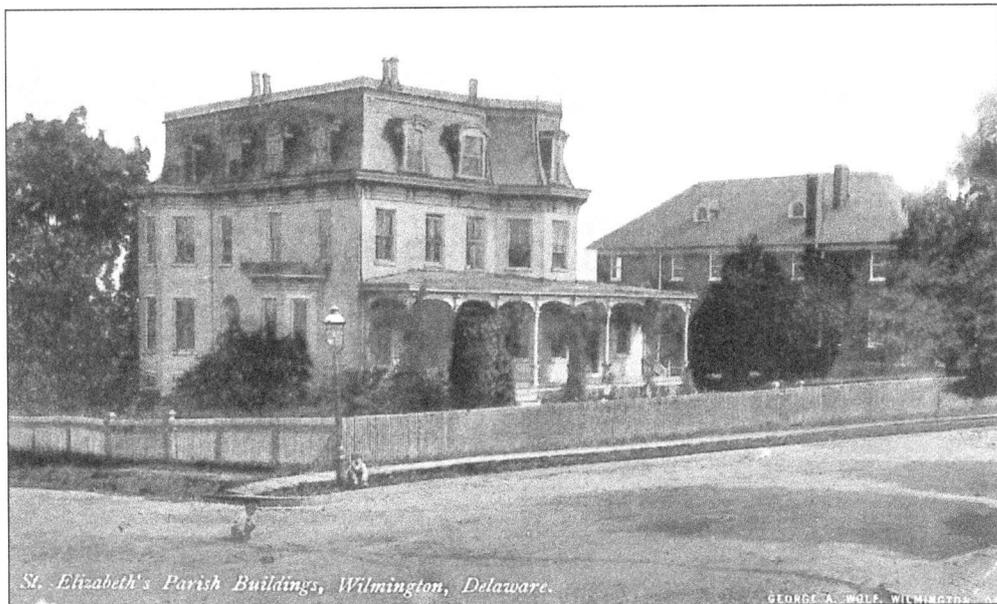

The original St. Elizabeth's convent (foreground) stands at the corner of South Broom and Oak Streets. Behind it is the building that housed the original church. Two of the four buildings that previously comprised the Wilmington Military Academy, they served until 1922 when Father Temple purchased the Banning family estate across Broom Street, where the present church and school now stand. This is a postcard view published by George A. Wolf. (Courtesy of St. Elizabeth Parish.)

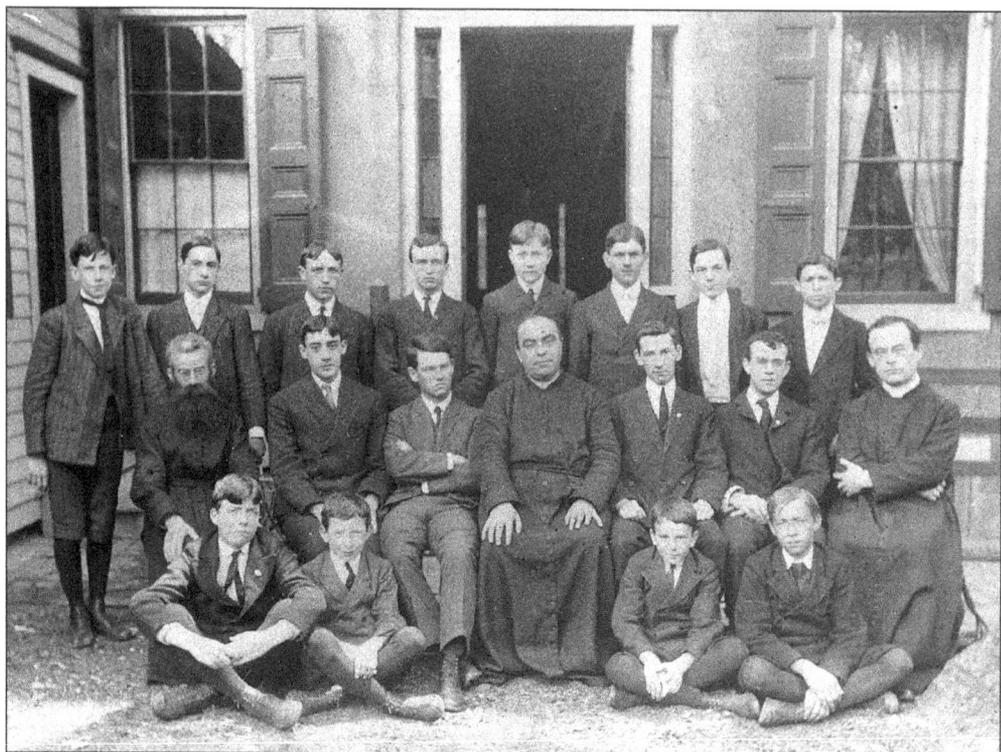

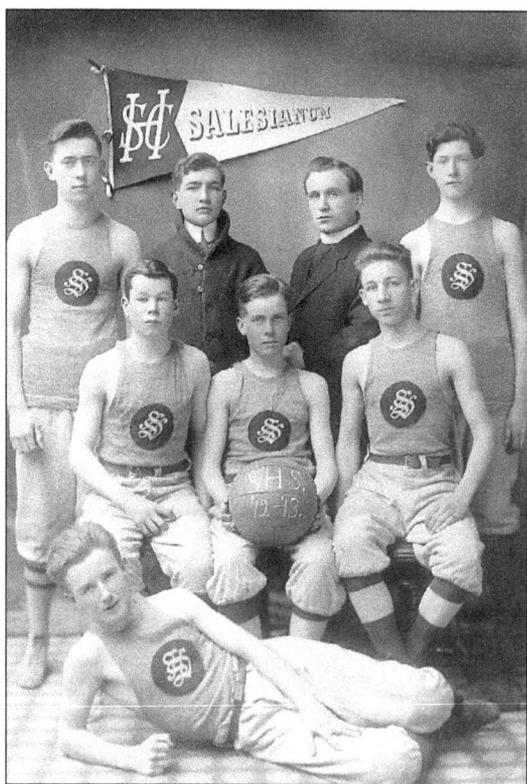

Salesianum School faculty and student body are pictured above in 1904, a year after the school was founded. It was popularly known then as the French Academy. The priests in the second row are the founders, Fathers James Isenring (left), Charles Fromentin (fourth from left), and Louis Jacquier (right). The future Father Thomas Lawless is seated on the ground, second from the left.

A long tradition of Salesianum sports began when this team took to the basketball court for the 1912–1913 season. The rules have changed and the uniforms are certainly different, but their spirit continues as the school holds a leading position in Delaware schoolboy athletics. Mr. Edward Rimlinger (back row, left center) was coach and Father Paul Fournier (back row, right center) was the moderator. Team members are Daniel Casey, John Byrne, Charles Conway, Francis O'Neill, Francis Dunn, and Daniel Kelly. (Both photos courtesy of the Oblates of St. Francis de Sales.)

From left to right, Benedictine Sisters Stella Walls, Eugenia McIntyre, Veronica Baudermann, Hilda Boehm, and Margaret Mary Meyer make music on the front steps at St. Gertrude Monastery in the late 1800s. In 1887, the order transferred its motherhouse from Newark, New Jersey, to a 750-acre plantation near Ridgley. Soon afterwards the sisters opened an academy for girls there and later accepted teaching assignments and other ministries in the diocese. (Courtesy of St. Gertrude Monastery.)

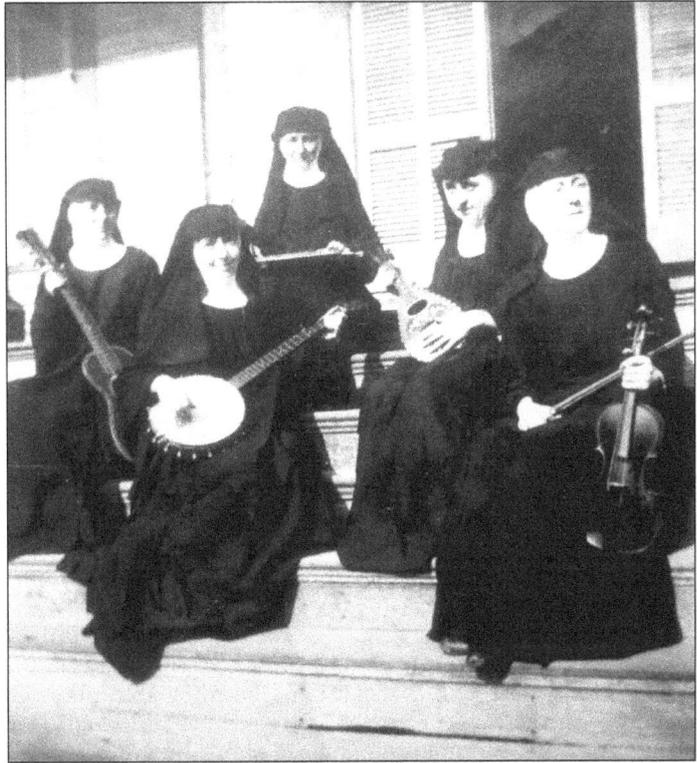

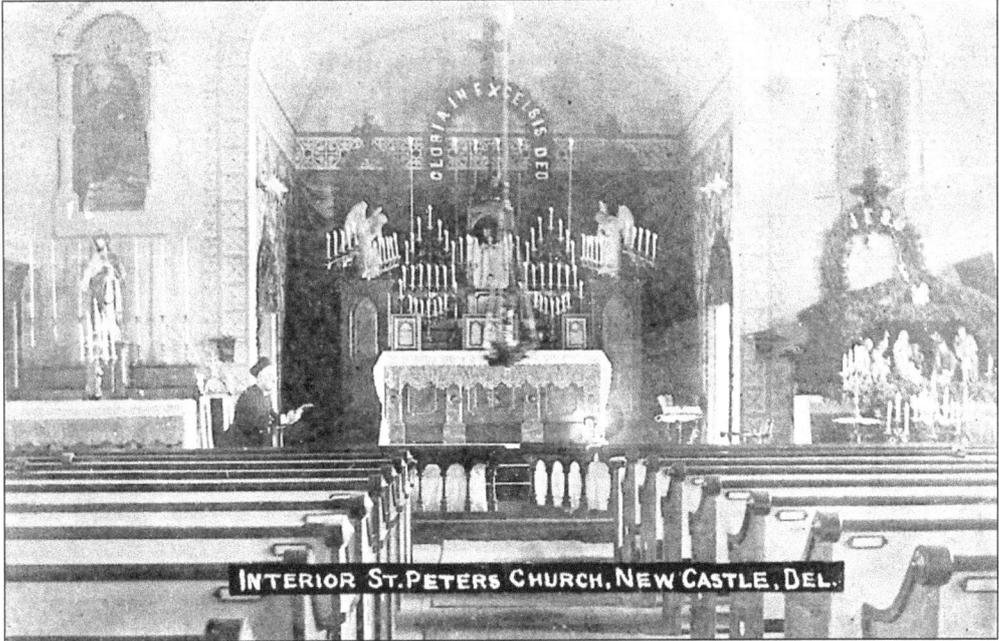

The interior of St. Peter the Apostle Church in New Castle is decorated for Christmas on a postcard published in the early 1900s. First established as a mission in 1804, St. Peter's, at Fifth and Harmony Streets, had parish status in 1847–1848 and since 1858. (Courtesy of the diocesan archives.)

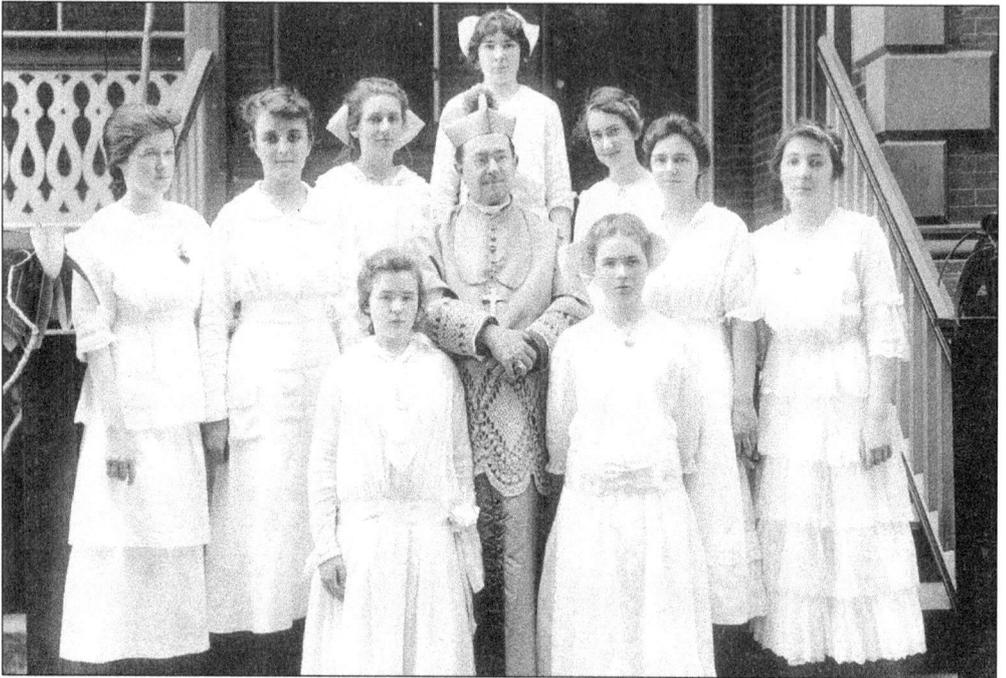

Bishop Monaghan poses with Ursuline boarding students in 1917. The bishop was highly supportive of the academy, having persuaded the Mother General of the order in Rome to permit establishment of an autonomous community of sisters to conduct it. Mother Olympias Gleeson was the first superior. Under her leadership, the school was extended to include a College of New Rochelle (New York) extension department and a conservatory of music. (Photo from the Ursuline Academy's 1993 centennial booklet.)

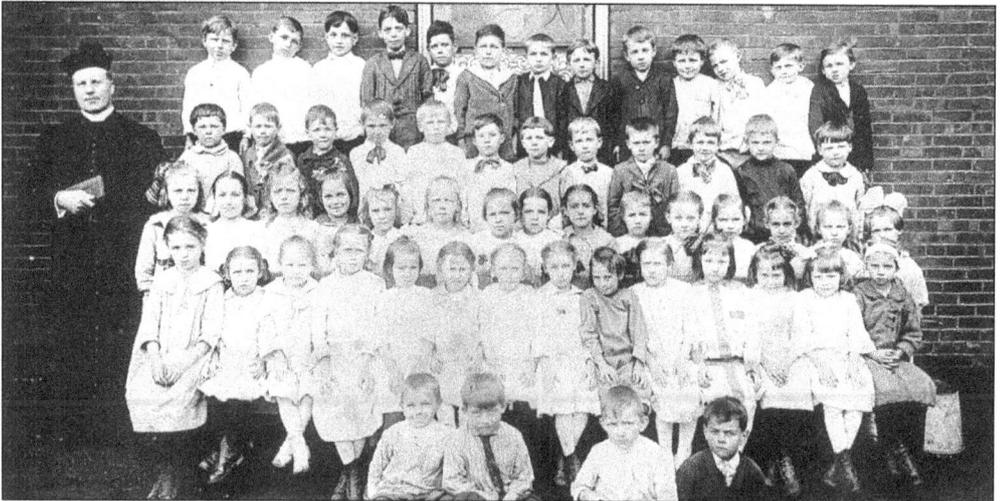

The children of St. Stanislaus Kostka Parish are shown here in 1918. The priest, Father Antoni C. Oleksinski, was born in Poland. He came to this country at age 16, alone and without family or friends, to study for the priesthood. In 1915, he was appointed pastor of St. Stanislaus, where he served for nearly 16 years. In 1924, he was overcome by smoke while rescuing the Blessed Sacrament during a fire at the church. He recovered and was responsible for restoring the church before his death in 1930. (Courtesy of St. Stanislaus Kostka Parish.)

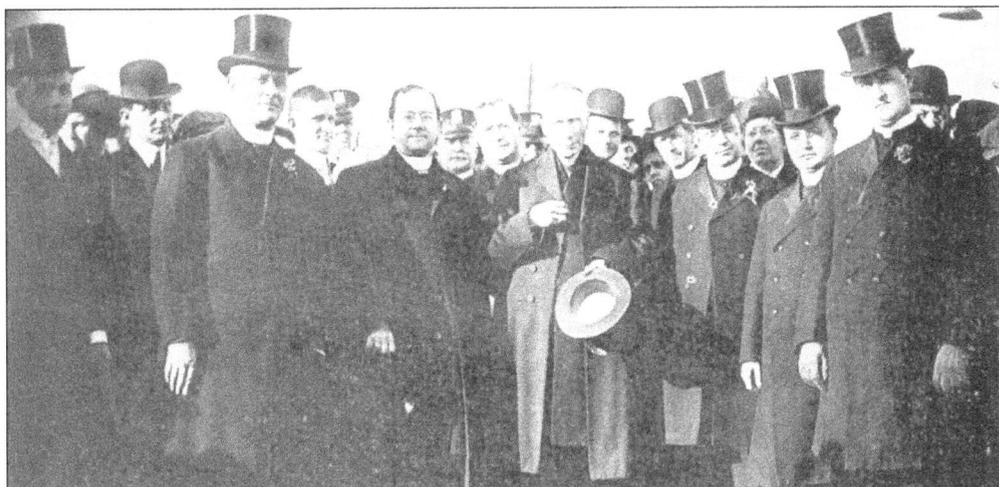

James Cardinal Gibbons, archbishop of Baltimore, (right center, holding his hat) with dignitaries attends the dedication in 1914 of the rebuilt St. Paul's Church on Wilmington's near west side. Standing to the prelate's right are Bishop Monaghan and the pastor, Father Thomas F. Waldron. Built at a cost of $75,000, the stone structure replaced a brick one dating from soon after the founding of the parish in 1869, a year after the diocese was established. (Photo from the booklet issued for the dedication of a new school building in 1957.)

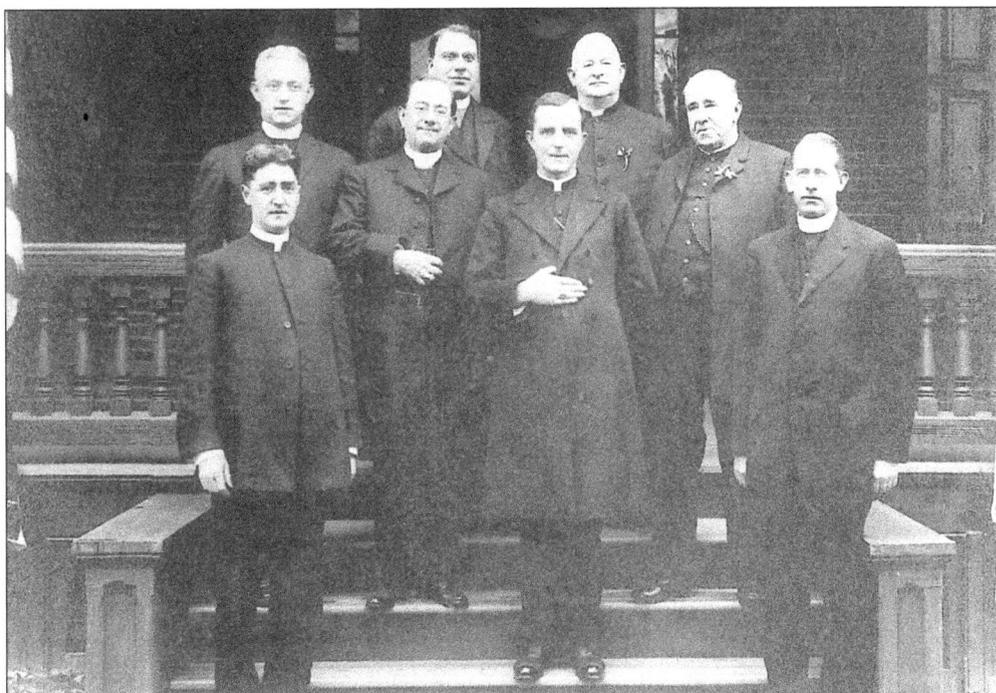

Bishop Monaghan (center front) poses with some of his priests in front of his residence at 1301 Delaware Avenue, Wilmington, in 1916. To his left is Archbishop Giovanni Bonzano, apostolic delegate to the United States, who was in town for the rededication of the Cathedral of St. Peter. Priests in the photograph are Fathers James M. Grant, John J. Dougherty, Martin M. Ryan, John J. Connelly, and John A. Lyons. Also present is Monsignor Ceretti, the delegate's secretary. (Courtesy of Cathedral of St. Peter Parish.)

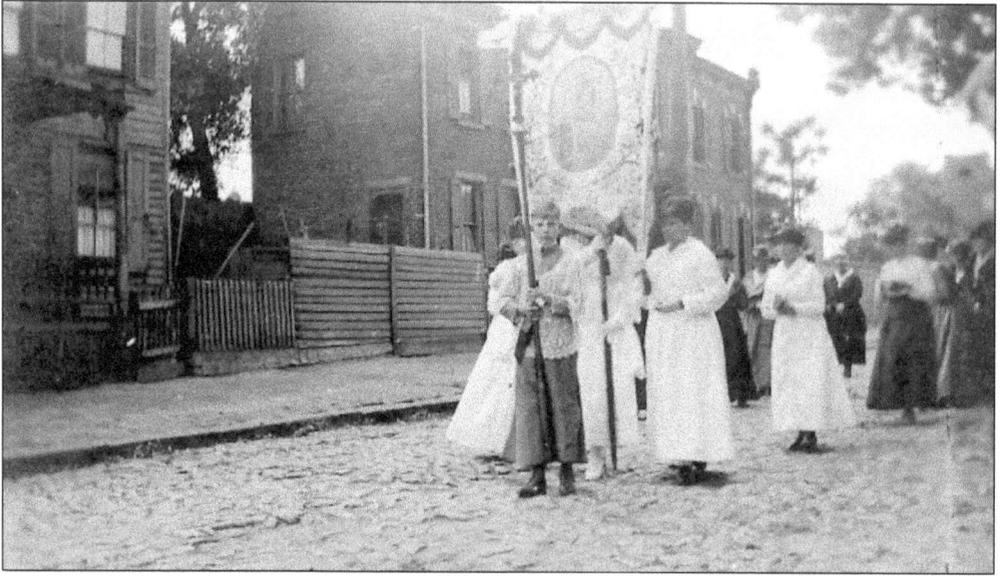

A procession of St. Peter the Apostle parishioners wends its way along a cobblestone street in historic New Castle. The occasion is not identified on the original snapshot, which apparently was taken c. 1920. (Courtesy of the diocesan archives.)

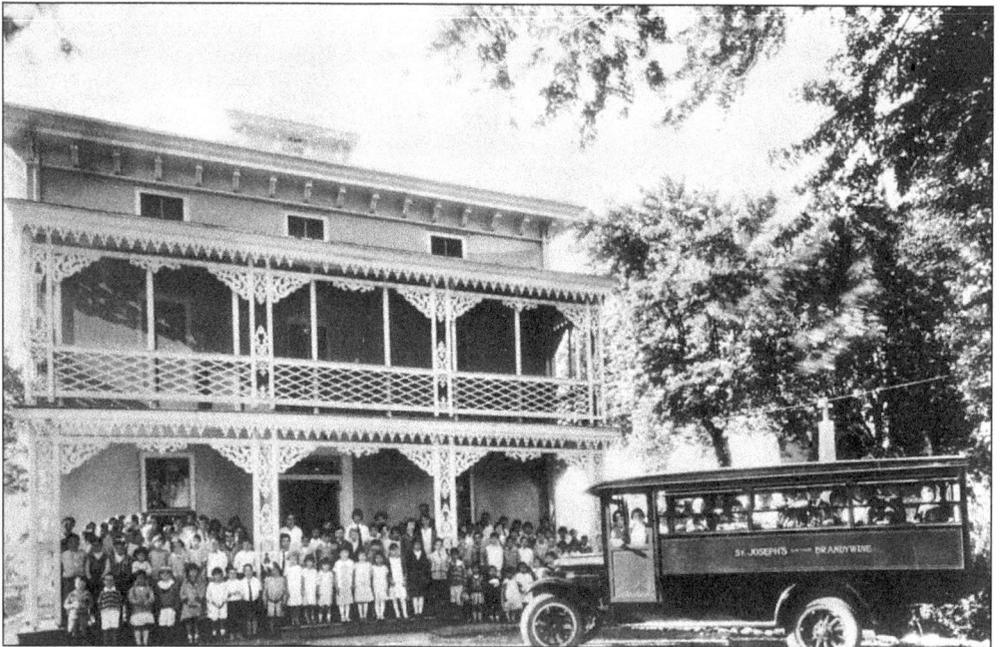

St. Joseph-on-the-Brandywine Parish acquired its own school bus in the 1920s. By then the parish was serving a large area north and west of Wilmington that included worker communities associated with the several mills powered by the fast-flowing Brandywine. Parochial school students evidently were turned out in front of the rectory to greet and record for posterity the arrival of the new bus. (Photo from the parish's sesquicentennial book by Joyce Kettaneh Longworth and Marjorie Gregory McNinch.)

24

Ursuline Academy Class of 1914 wear then-stylish basic black uniforms. Alice Kelleher (third from the left) entered the Ursuline order and was known to future generations of academy students as Mother Margaret Mary. From left to right are Helen Casey, Margaret Kane, Miss Kelleher, Marion Casey, Mary Lally, Marion Dougherty, Louise Hughes, and Helen Hughes. (Photo from the Ursuline Academy's 1993 centennial booklet.)

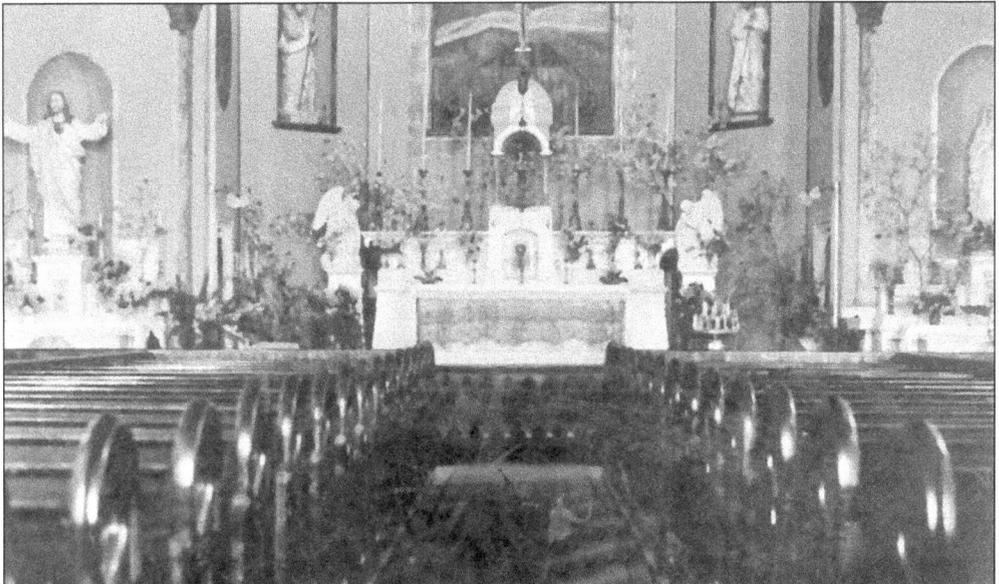

The interior of St. John the Baptist Church in Newark shows how typical sanctuaries in Catholic churches, here and elsewhere, looked in the 1920s, 1930s, and 1940s. The ornate main altar, with its tabernacle in the center, is the focus. It is flanked by side altars, dedicated to the Blessed Mother and St. Joseph, and separated from the body of the church by an altar rail, at which worshippers knelt to receive Holy Communion. (Courtesy of St. John-Holy Angels Parish.)

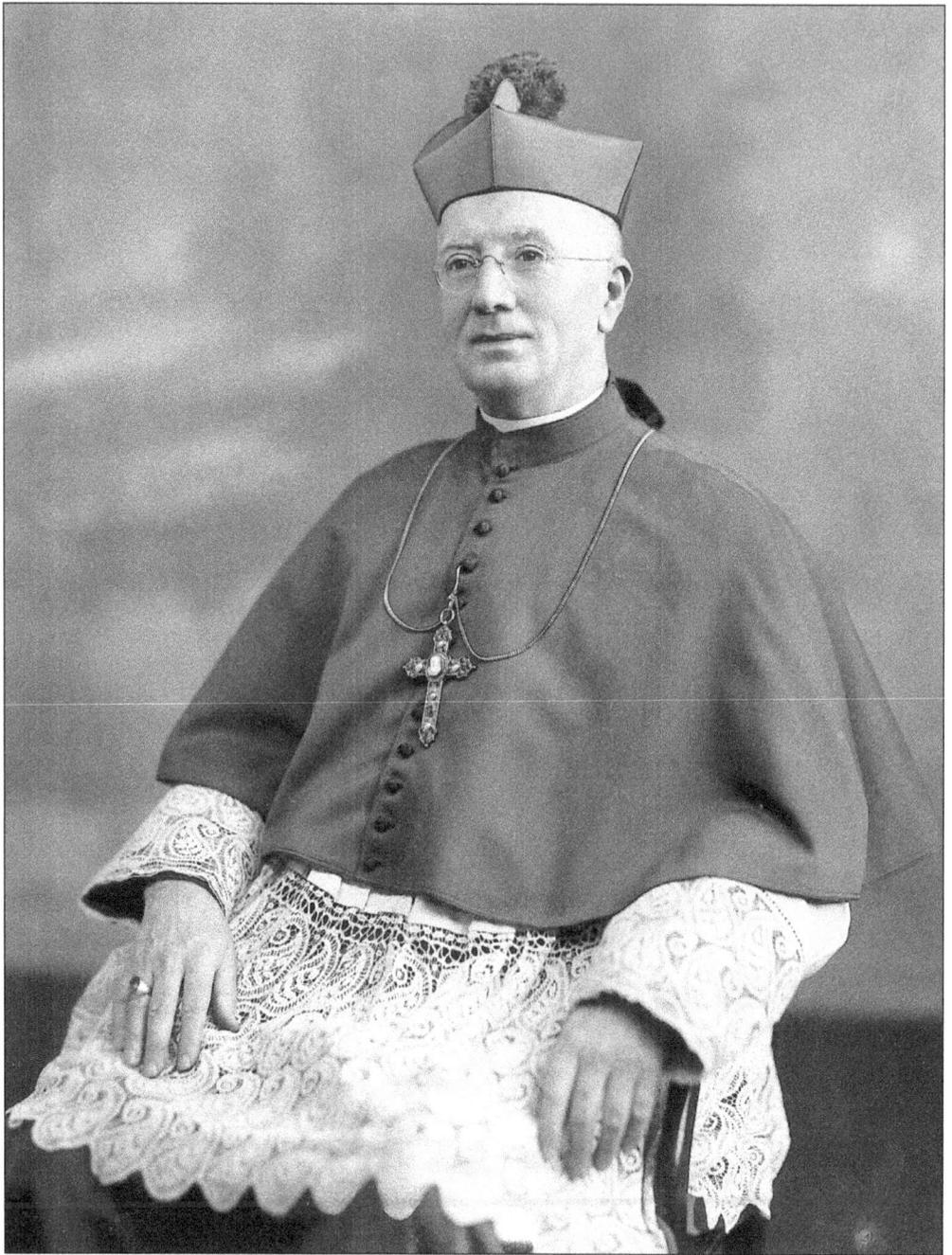

Bishop Edmond John FitzMaurice was born in Tarbert, County Kerry, Ireland, on June 24, 1881. He was ordained in Rome, Italy, in May 1904 and was consecrated as fourth bishop of Wilmington on November 30, 1925. On March 2, 1960, he resigned and was named titular archbishop of Tomi. He died on July 25, 1962.

Two

GROWING YEARS

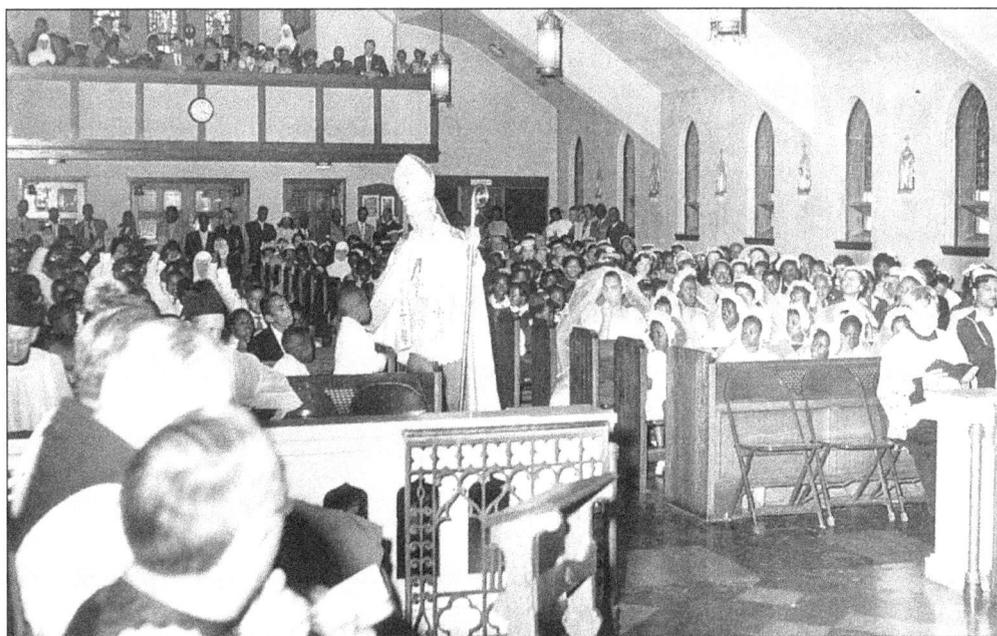

A friendly but firm Bishop FitzMaurice makes sure the children know the answers to catechism questions before conferring Confirmation on the class. The quiz used to be an integral part of the sacramental preparation and this scene—in St. Joseph Church in downtown Wilmington in the mid-1950s—was repeated many times during Bishop FitzMaurice's long episcopate. (Fred Weicht photo courtesy of the Josephite Fathers archives.)

Participants in the dedication of Archmere Academy on October 12, 1932, are shown outside the Raskob mansion. This structure initially housed both the school and the Norbertine priests—officially Canons Regular of Praemontre, abbreviated O. Praem.—who comprised its faculty. Bishop FitzMaurice stands at the center of the photograph. Father M.J. McKeough, first

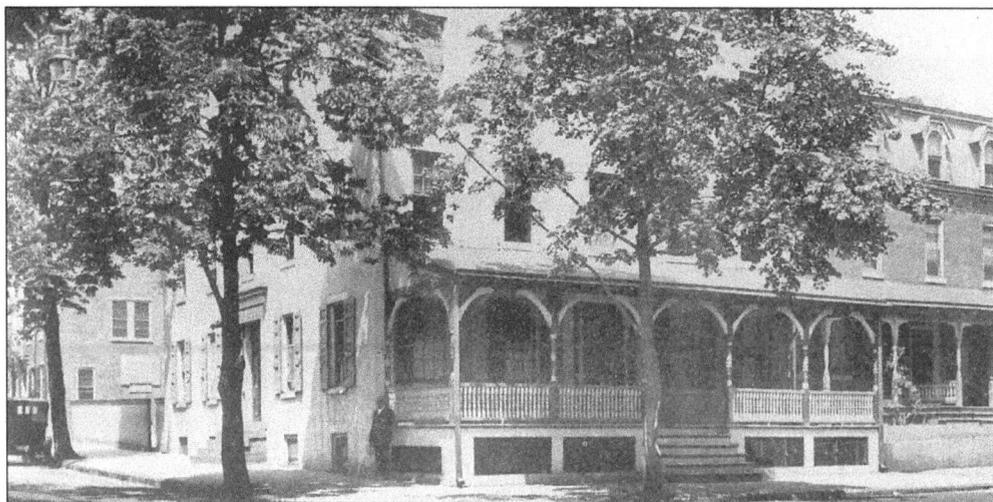

The original Salesianum School building was located at Eighth and West Streets in downtown Wilmington. A covered porch ran along the east side of the building and there was a backyard, behind the low wall where the automobile is parked, which eventually became the site of a below-ground gymnasium. (Courtesy of the Oblates of St. Francis de Sales.)

28

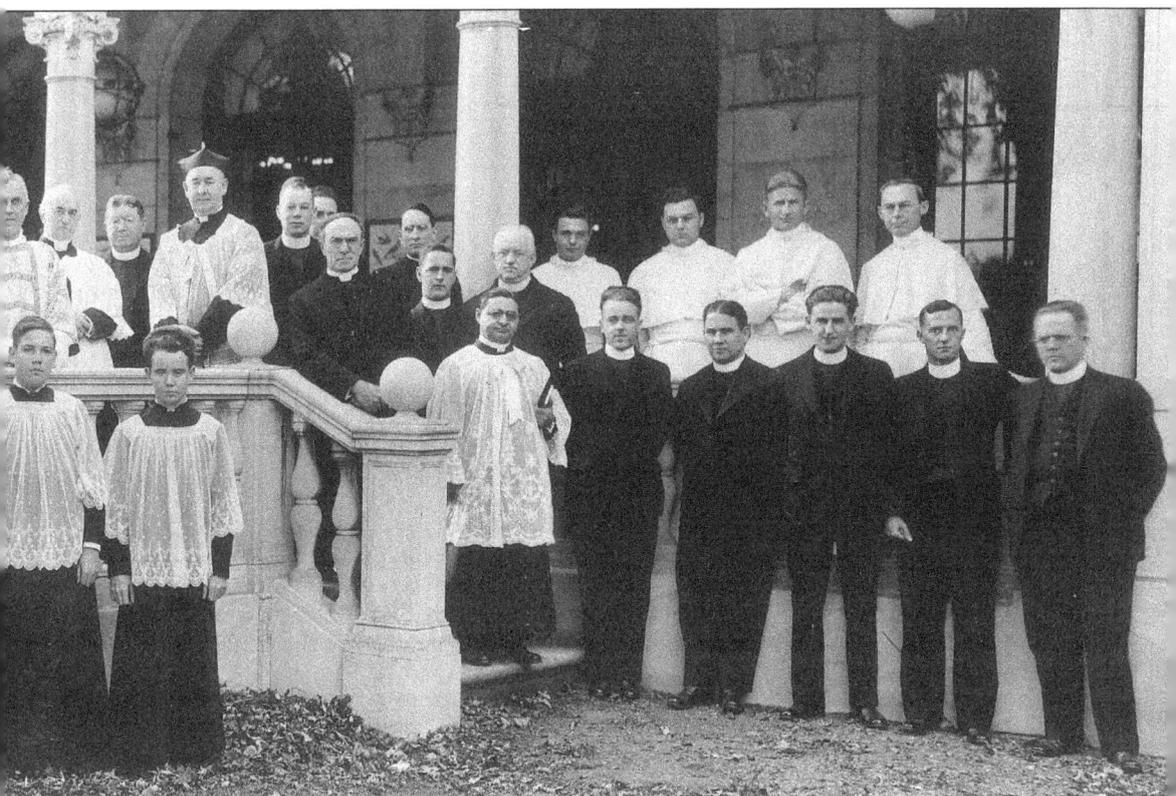

headmaster, and Abbot Bernard H. Pennings, clad in their religious habits, are to his immediate right. The servers in the foreground were among the first students of the school. (Lewis Studio photo courtesy of the Archmere Academy development office.)

With the porch removed and an entranceway installed, this view was familiar to generations of Wilmington-area residents until the school outgrew the building and became literally filled to capacity in the mid-1950s. (Courtesy of the Salesianum School development office.)

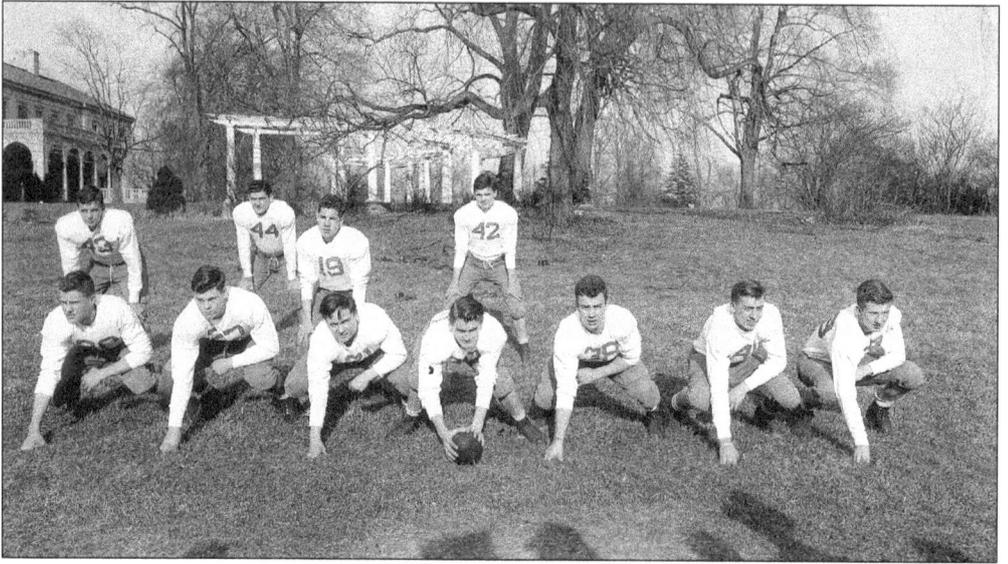

Although enrollment was small, Archmere gave a good account of itself in the world of interscholastic sports. This was the starting football team in 1945, when the same players lined up on both offense and defense. (Sanborn Studio photo courtesy of the Archmere Academy development office.)

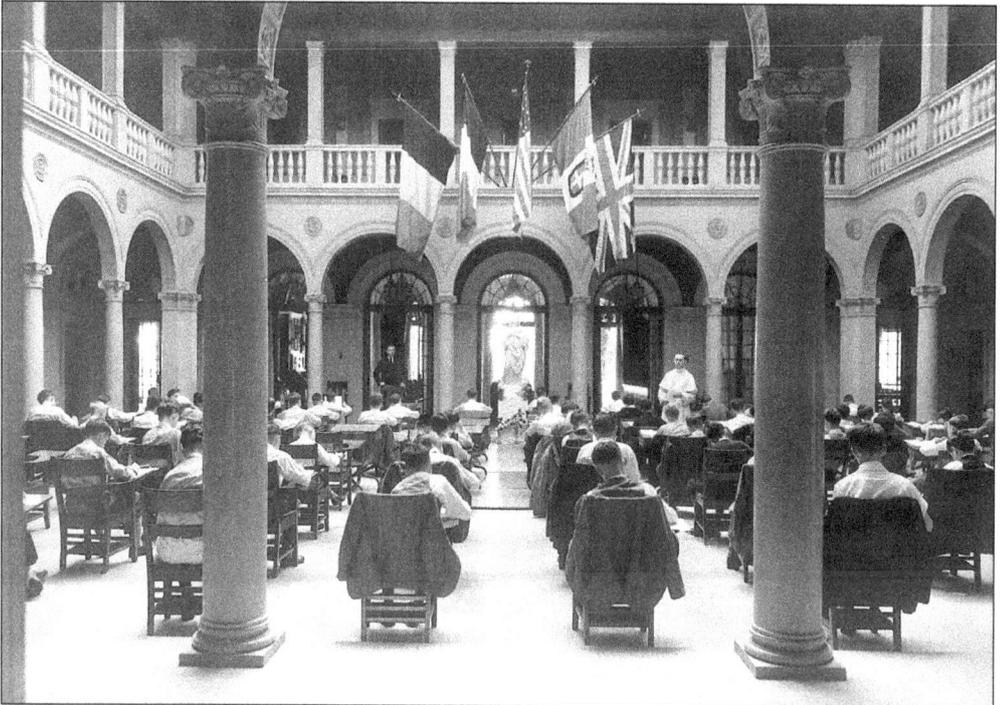

Eighth graders from schools throughout northern Delaware and southeastern Pennsylvania take an entrance examination in the Patio in the center of the former mansion. When this photograph was taken in 1940, Archmere's all-male student body included both resident and day students. Proctoring the exam in his white habit is Father Daniel Hurley, headmaster. (Courtesy of the Archmere Academy development office.)

30

The 1929 Salesianum School golf team, from left to right, are (seated) Harry Hill, Edward Tucker (team captain), and Francis Horisk; (standing) John Cabrey, Joseph O'Neill, James Tipka, Harry Hampel, and James Lutz. (Sanborn Studio photo courtesy of the Salesianum School development office.)

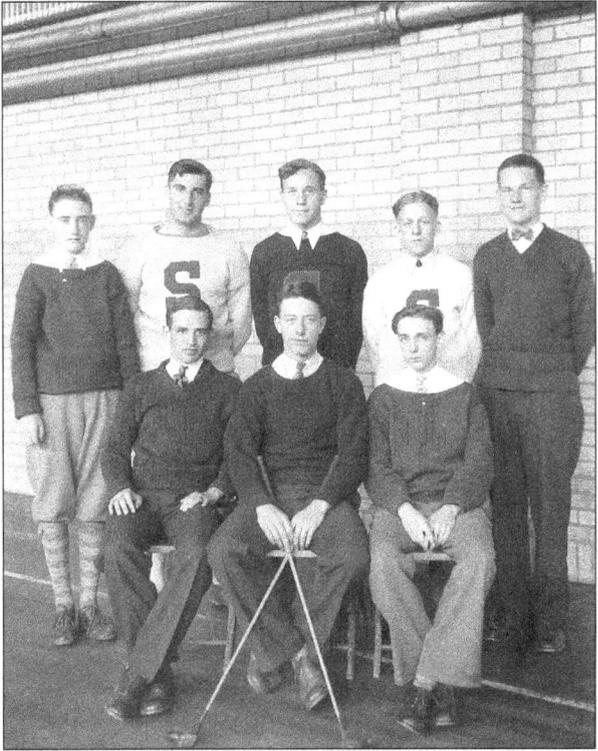

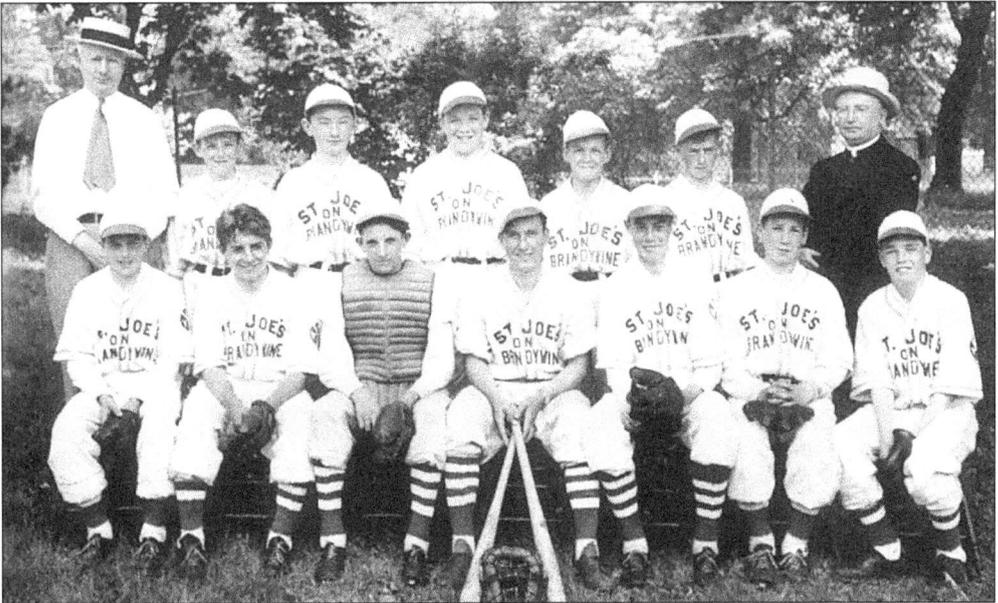

This team represented St. Joseph-on-the-Brandywine on the baseball diamond during the 1940 season. Members, from left to right, are (front row) Harry J. Connelly, John A. Corrozzo, William J. Hagee, John J. Clark, Francis X. Flanagan, Francis G. Beattie, and William Shields; (back row) Mr. Daniel F. Shields, William E. Craven, John McLaughlin, Edward M. Ryan, Philip Lynch, William J. Kuhn, and Father Patrick A. Brennan. (Photo from the parish's sesquicentennial book by Joyce Kettaneh Longworth and Marjorie Gregory McNinch.)

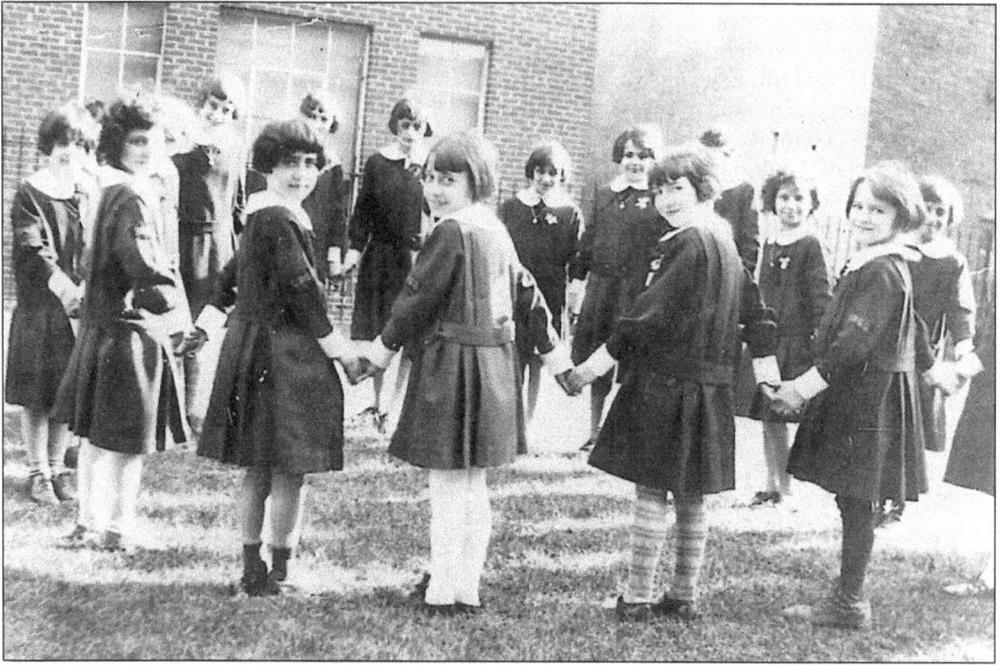

Fourth graders at St. Peter's Cathedral School pause during a game of "Ring O' Rosie" to check out the photographer. This photograph was taken in 1928. (Courtesy of Cathedral of St. Peter Parish.)

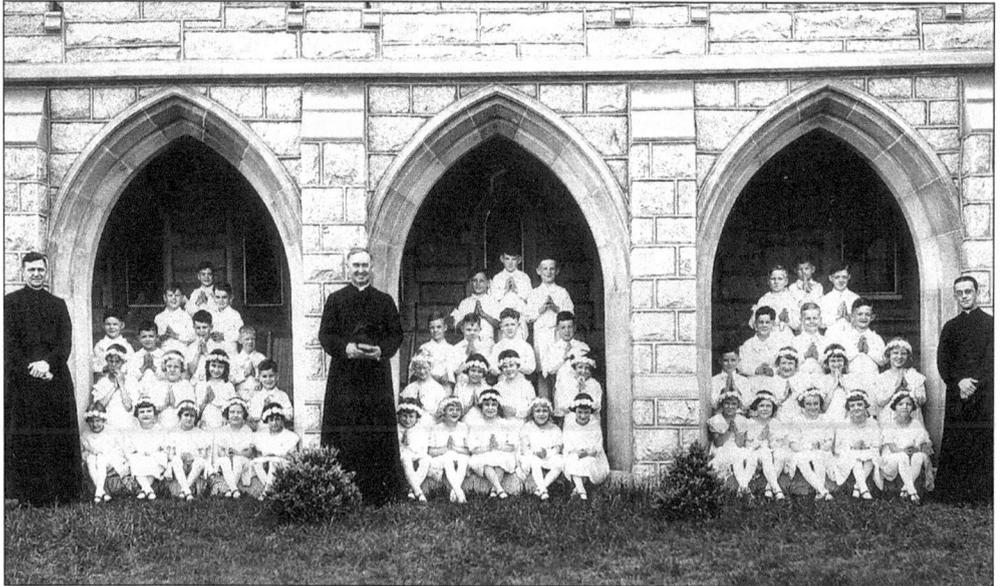

Christ Our King School's 1932 First Communion class poses in the cloister arches of the Sisters of St. Joseph convent. Father John J. Lynch, pastor of the north Wilmington parish, stands by the center group. The other priests are Fathers Ferdinand Schoberg, a visiting Jesuit missionary (left), and Eugene J. McCarthy, assistant pastor. (Courtesy of Christ Our King Parish.)

Father, later Monsignor, John S. Gulcz served 65 years as pastor of St. Hedwig Parish. Born in Poznan, Poland, he came to Delaware in 1896, to serve its Polish-American community. The parish, founded by the Benedictines six years earlier had a membership of about 200 families. That grew tenfold during Monsignor Gulcz's pastorate. He died in 1962 at age 96 and is buried by the church in the Hedgeville section of south Wilmington.

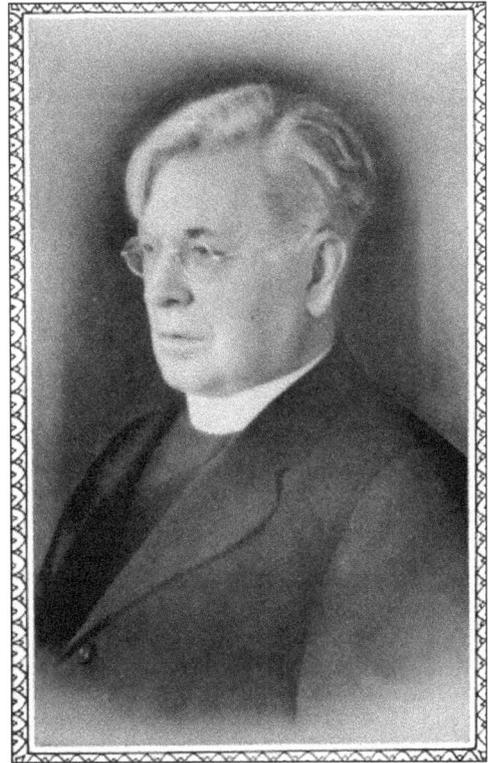

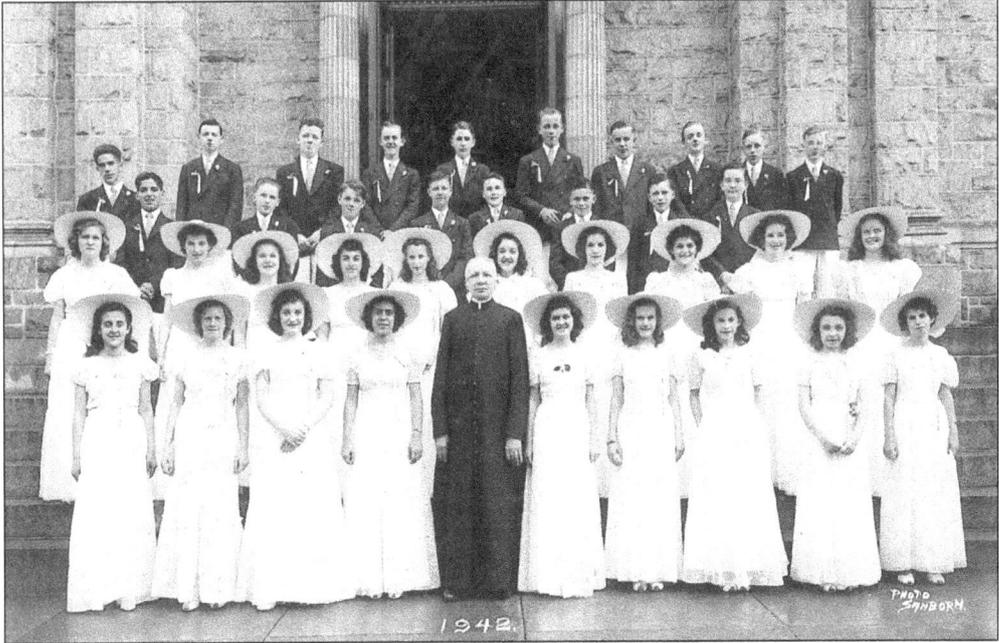

St. Paul Parochial School's 1942 eighth-grade graduating class poses with Father Joseph A. Lee, the pastor, on the steps of the church on Wilmington's near west side. Father, later Monsignor, Lee had grown up in the neighborhood and received his own elementary education at the same school. (Sanborn Studio photo courtesy of the diocesan archives.)

Pictured here are St. Hedwig altar boys (above) and school boys in the parochial school (below). The parish is renowned for the large number of youngsters—sons, daughters, and grandchildren of immigrants—who grew up in the close-knit community around the church on South Harrison and Linden Streets and went on to play responsible and respected roles in the local community and beyond. (Both photos courtesy of St. Hedwig Parish.)

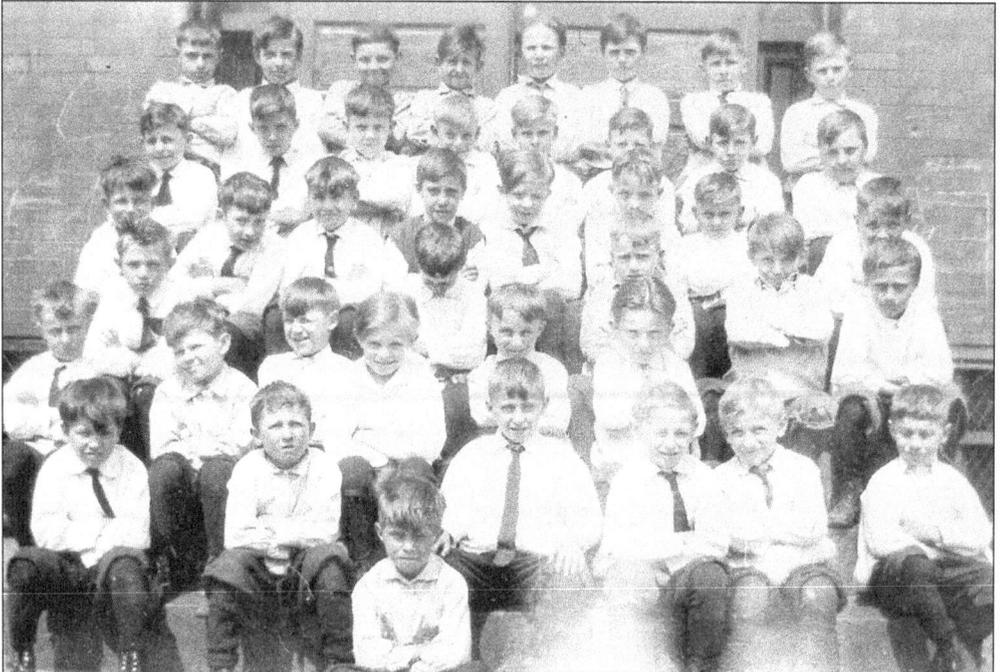

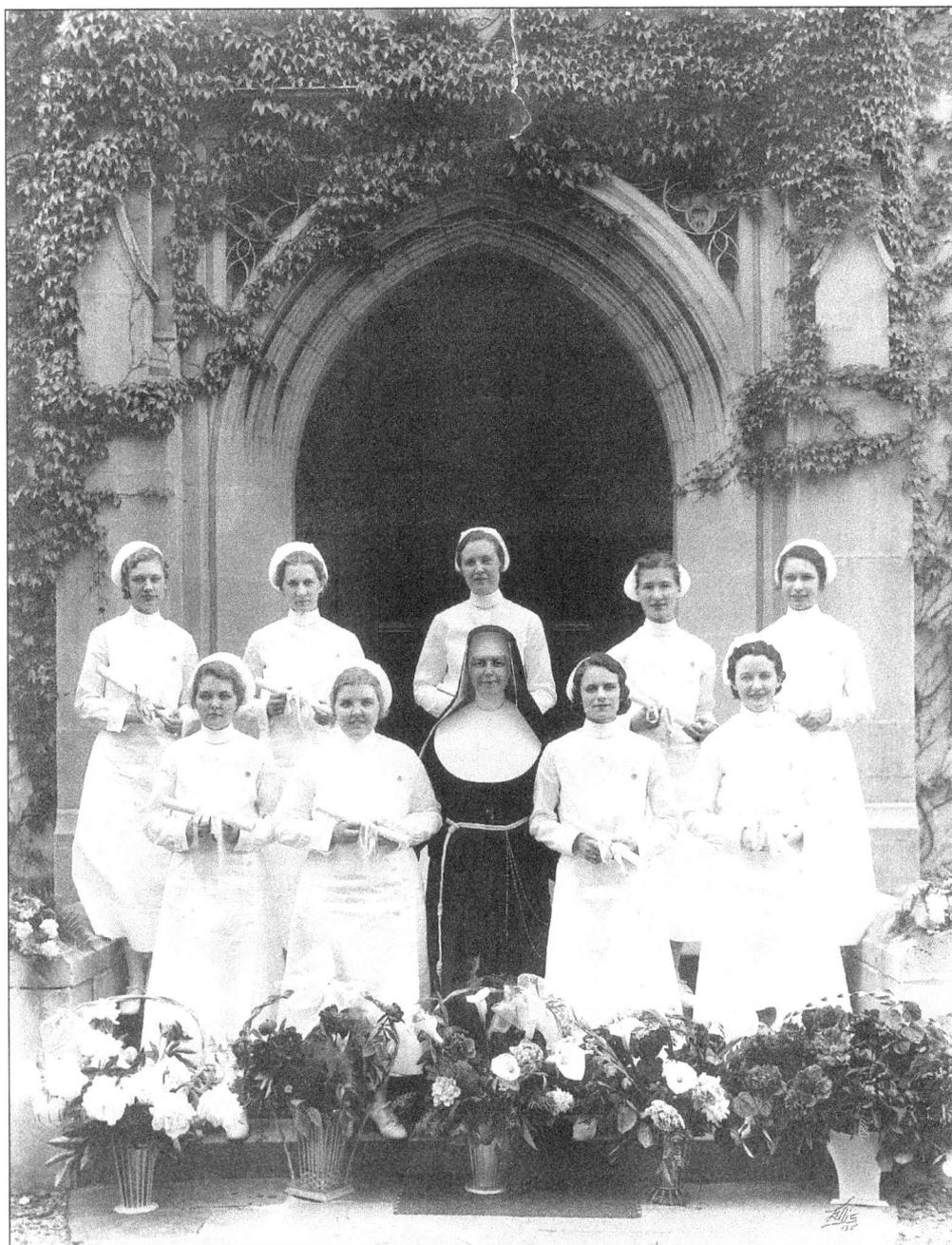

An early graduating class of St. Francis School of Nursing is shown here. The school was established in the former Hilles mansion at Seventh and Clayton Streets in west Wilmington soon after St. Francis Hospital was founded. It continued to train young women for the hospital staff and other health-care positions into the 1960s when the nursing profession began to require university degrees. (Photo from the commemorative booklet published for St. Francis Hospital's 75th anniversary in 1999.)

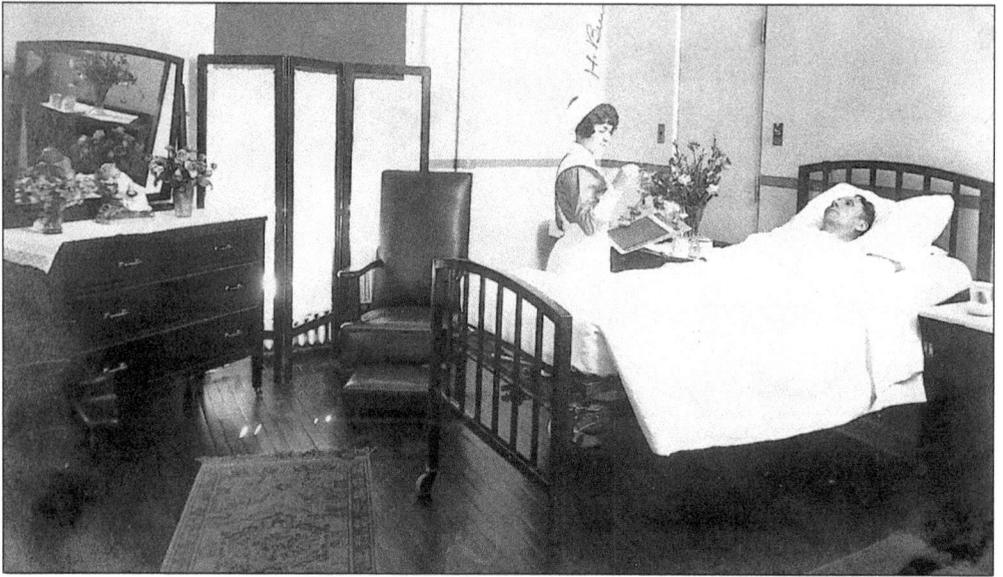

Nurse Helen Burke, Class of 1929, provides a heavy dose of T.L.C. (tender loving care) at the bedside of a patient in St. Francis Hospital. The uniform she is wearing and the furnishings in the room, not to mention the emphasis on personal care being provided, were standard in modern hospitals in the 1930s. (Photo from the commemorative booklet published for St. Francis Hospital's 75th anniversary in 1999.)

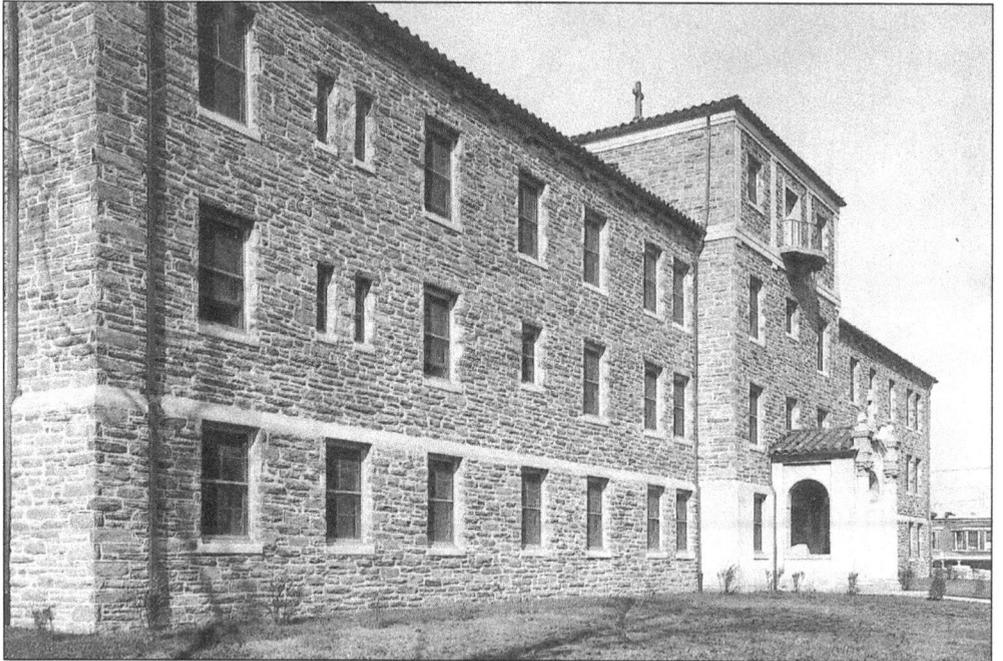

St. Francis Hospital appeared this way when it opened in October 1924. Situated at Seventh and Clayton Streets in Wilmington, at the top of a hill overlooking most of the city, the stone building was both a dominant landmark and a symbol of service rendered. Its appearance was greatly changed, but its stature not diminished, when a new front section was built along Clayton Street 50 years later. (Philip B. Wallace photo courtesy of F. Eugene Donnelly.)

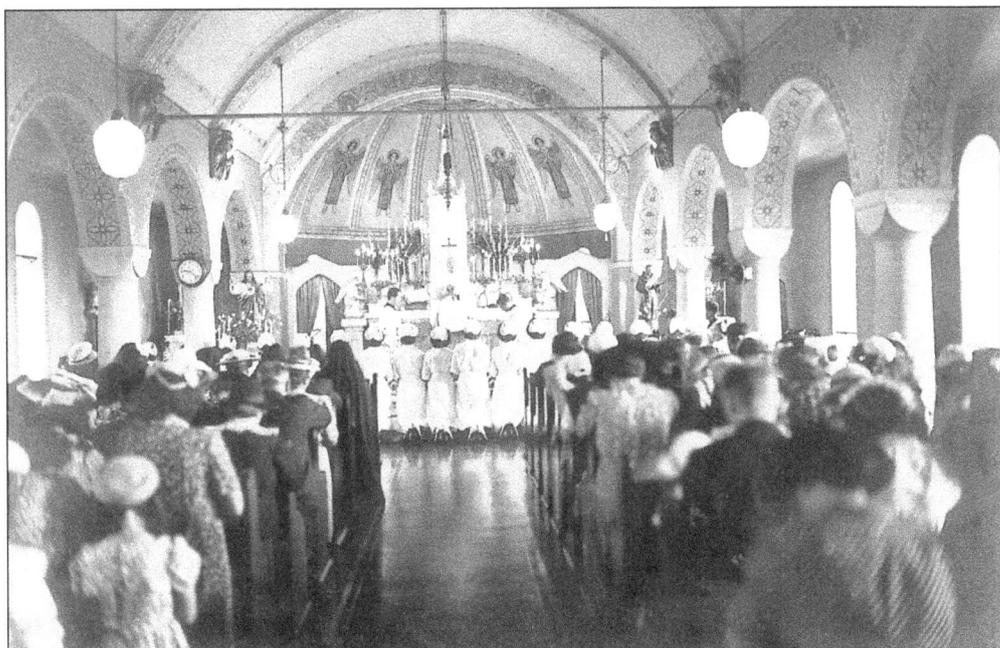

Bishop FitzMaurice presides at a traditional capping ceremony for graduating nurses in the hospital chapel. (Photo from the commemorative booklet published for St. Francis Hospital's 75th anniversary in 1999.)

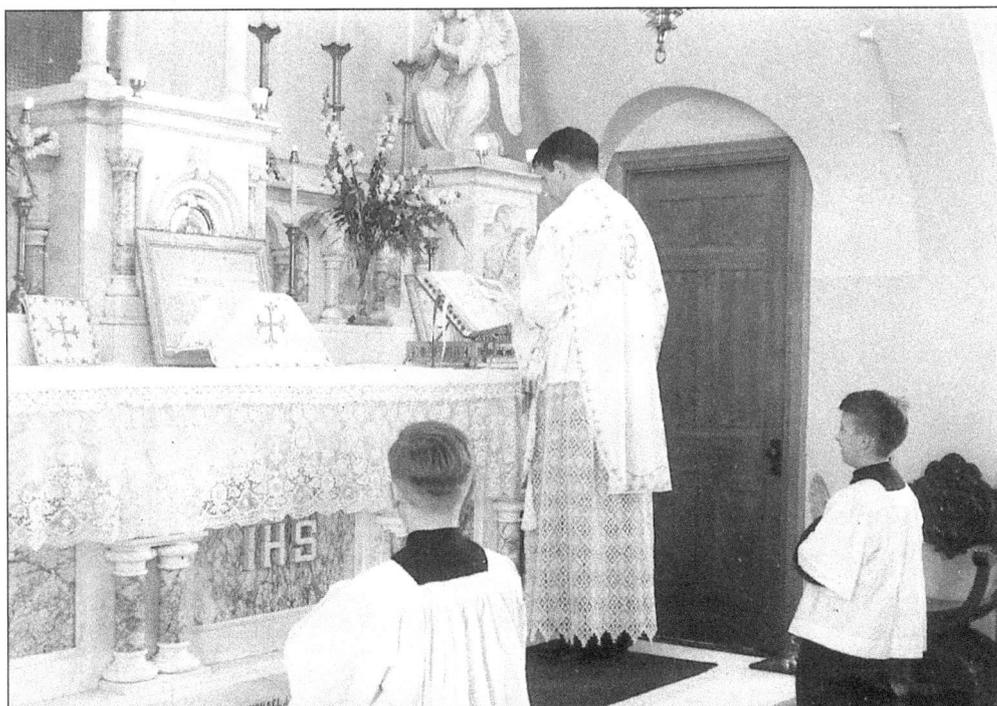

The celebrant reads the Epistle in Latin during Mass in the original St. Elizabeth Church. This is one of a set of photographs, dated 1939, that depict each part of the Mass. They evidently were used as a teaching tool in the parish school. (Courtesy of the diocesan archives.)

Ursuline Academy students walk in a May Procession in 1931 from the back of the combined grade and high school building at Pennsylvania Avenue and Franklin Street in Wilmington to the shrine of Mary of the Immaculate Conception, which then stood at the east end of the campus.

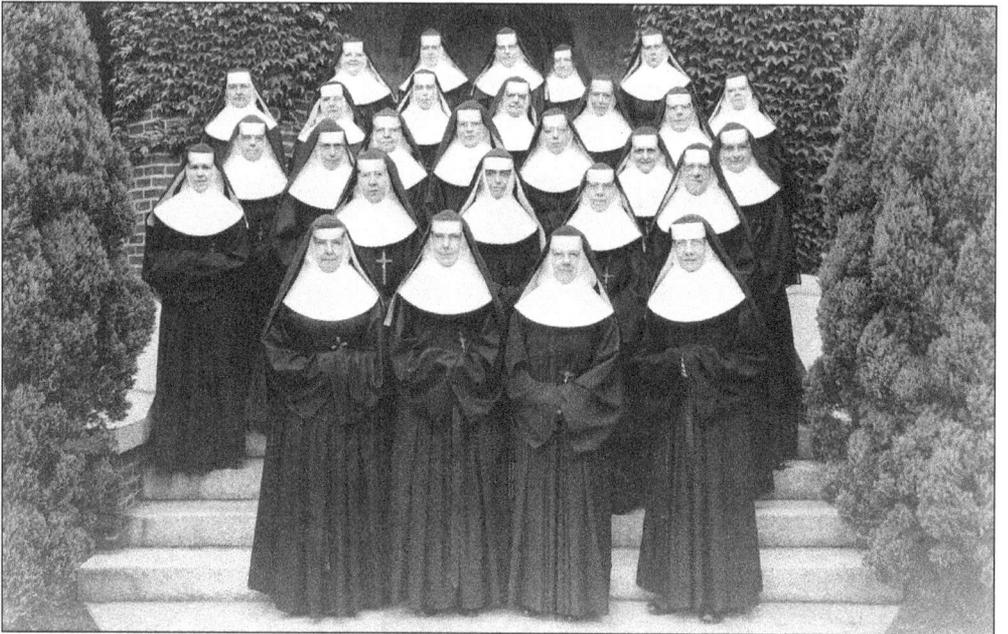

Members of the Ursuline community and academy faculty gather on the steps of the portico of the school in 1942. Although their religious order was officially semi-cloistered, the school under the sisters' tutelage produced several generations of graduates who wrote private and public success stories at a time when women were not considered likely leaders. (Both photos from the Ursuline Academy's 1993 centennial booklet.)

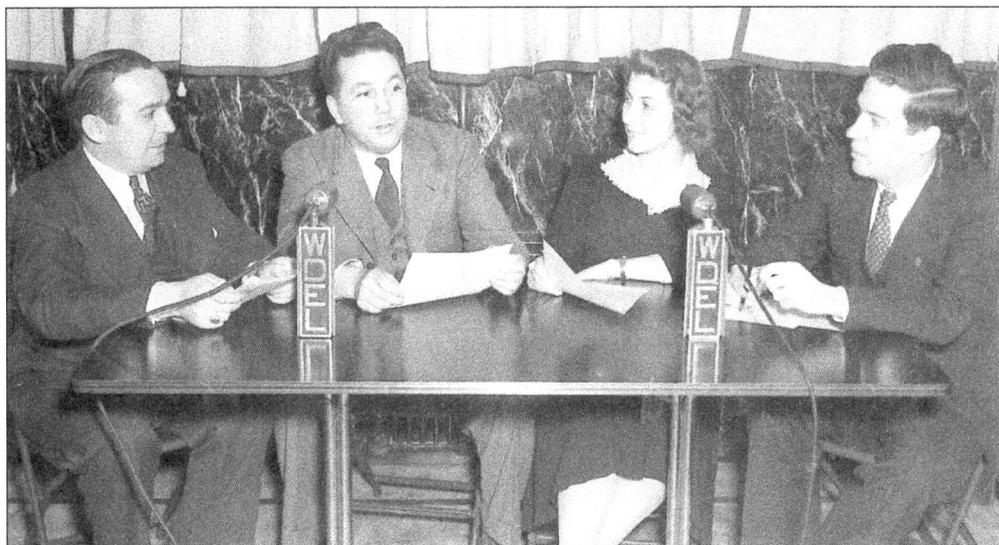

Original members of the Catholic Forum of the Air broadcast from the WDEL studio in downtown Wilmington. The lay organization, which grew out of the Diocesan Book Forum, was nationally recognized as a pioneer and innovator in Catholic religious radio broadcasting. It later gave rise to the Catholic Television Guild. Participating here are Mr. Joseph C. Desmond, Mr. Joseph A.L. Errigo, Miss A. Dorothy Arthur, and Mr. Paul J. Taggart. Mr. Taggart later became a priest, serving as vicar general and, three times between bishops, administrator of the diocese. (Courtesy of Miss Arthur.)

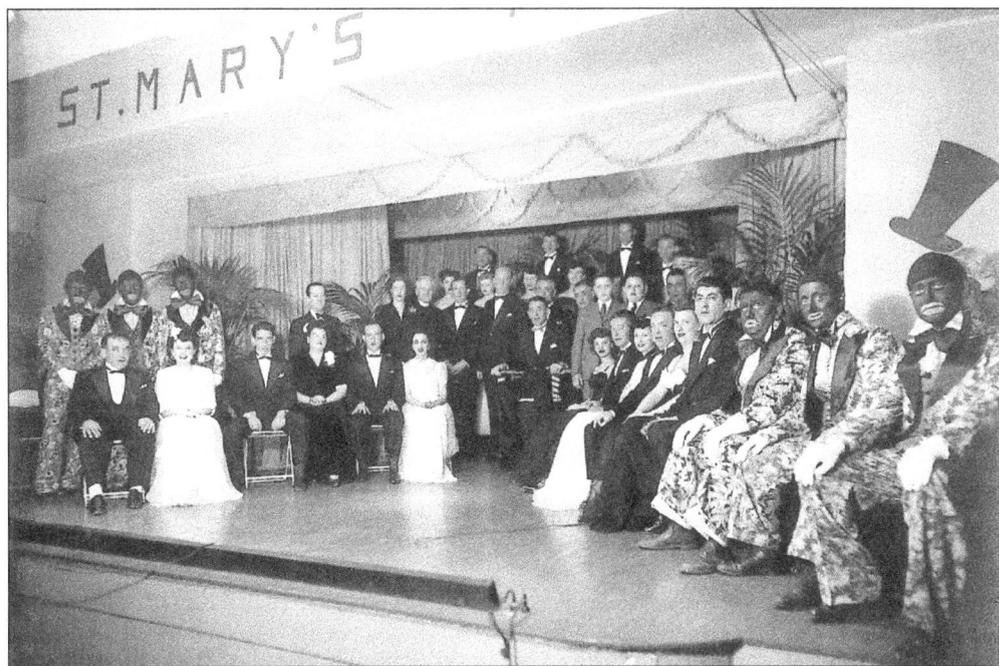

A popular attraction was the annual minstrel show presented by a troupe of St. Mary of the Immaculate Conception parishioners and friends. Song, dance, and comedy repartee made for a lively presentation. This is the cast of the 1945 production. (Courtesy of St. Mary of the Immaculate Conception Parish.)

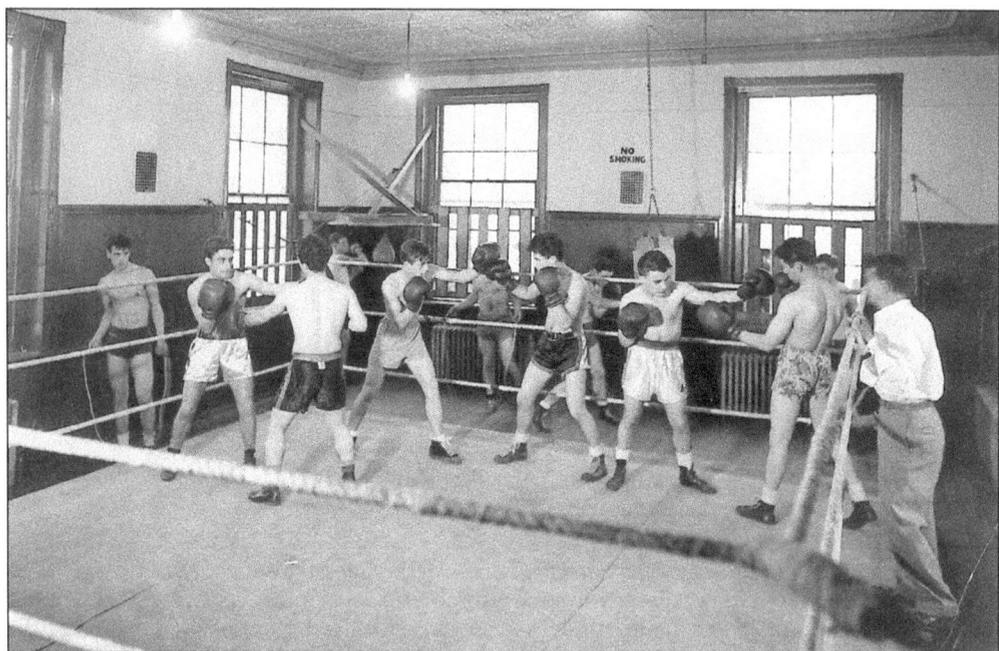

Boxing was a popular sport in the early days of the Catholic Youth Organization. The diocesan organization was modeled on one established in the Archdiocese of Chicago during the Great Depression. The idea was that young people's spiritual welfare would be served by providing them with recreational activity—primarily athletic in the beginning—in a wholesome environment. (Sanborn Studio photo courtesy of the Office for Catholic Youth Ministry.)

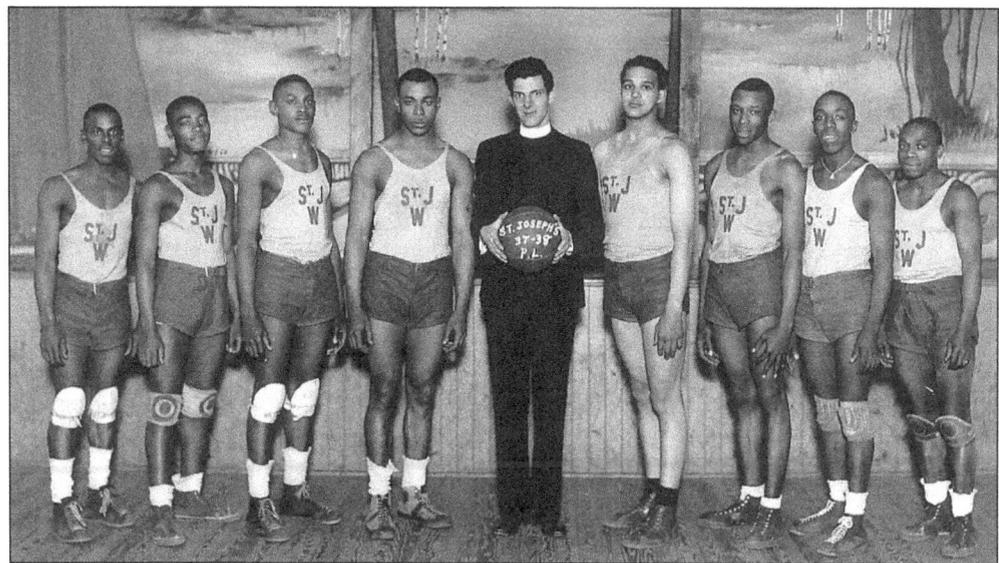

This team represented St. Joseph Parish, Wilmington, during the 1937–1938 basketball season. Father John J. Sheehy, its founder, insisted from the beginning that all C.Y.O. sports leagues be open to participation by the predominantly African-American parish at a time when most activities in the area were racially segregated. The coach is Josephite Father James Didas, whose order founded St. Joseph's as a "mission to colored people" in 1889 and served there for nearly a century. (Courtesy of the Josephite Fathers archives.)

40

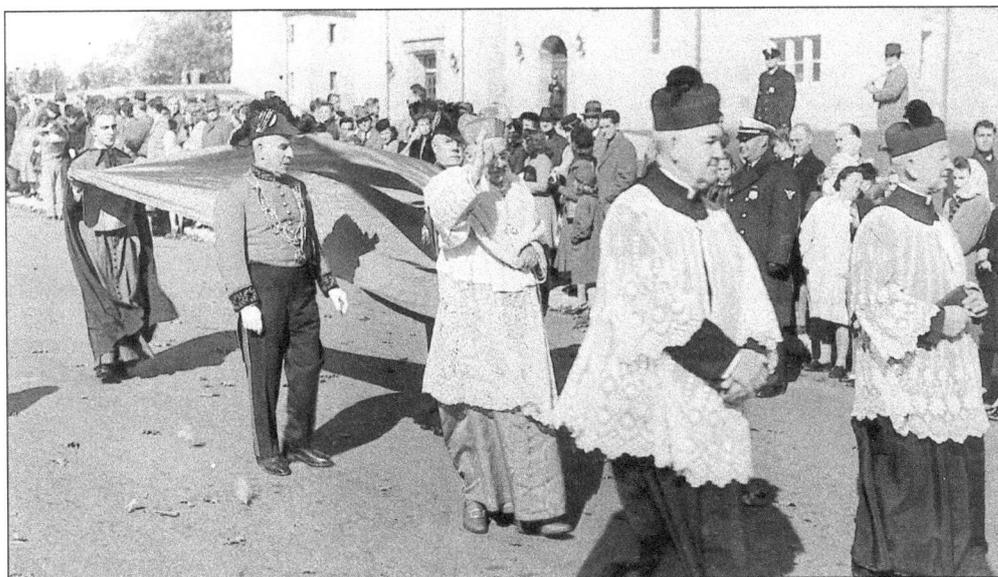

Samuel Cardinal Stritch, archbishop of Chicago, imparts his blessing as he processes to the dedication of St. Elizabeth Church at Cedar and Clayton Streets in south Wilmington in 1947. Preceding him are Fathers John J. Lynch and Patrick Brennan. The Papal Knight behind the cardinal is Mr. John J. Raskob. Robert Fontana is the trainbearer. Father James M. Grant, St. Elizabeth's pastor, was a classmate of the cardinal at the North American College in Rome. The striking building immediately became and has remained a prominent landmark. (Courtesy of St. Elizabeth Parish.)

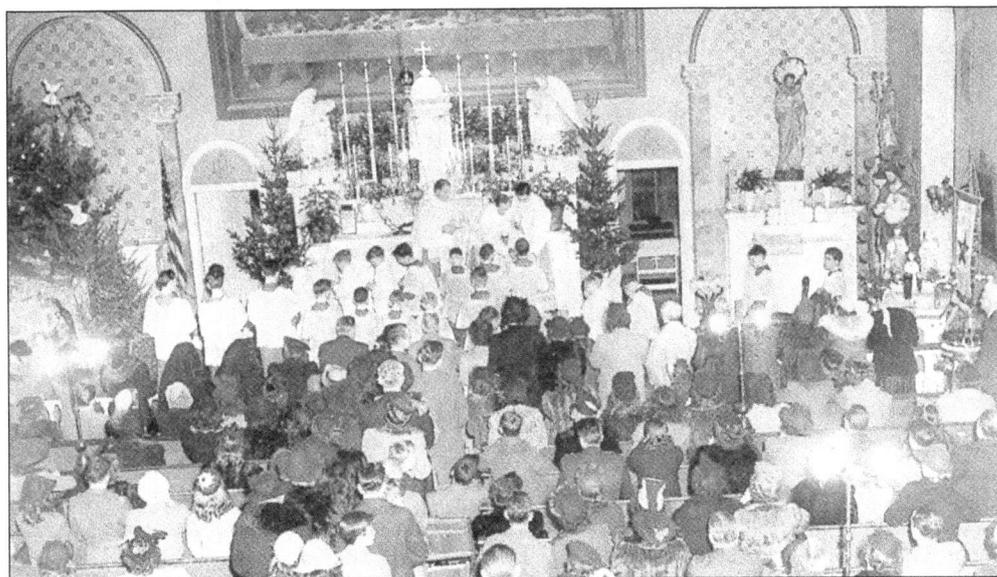

Parishioners crowd Immaculate Conception Church in Elkton for midnight Mass on Christmas 1942. Although World War II was raging and many young sons from the parish were facing danger overseas, the holiday spirit prevailed. During the war, Father George Cresswell, pastor, made the church basement available for use as a hospital after an explosion at the local ammunition plant and, later, for use as a Red Cross blood bank. (Photo from the Immaculate Conception sesquicentennial history.)

Elevation of the consecrated host was the focal point of the Latin Mass prior to Vatican Council II. On major feasts and special occasions, solemn high Mass, such as the one depicted here, was offered with priest and choir intoning Gregorian chant. Here the celebrant is assisted by a deacon, subdeacon, and acolyte. (Courtesy of St. Mary of the Immaculate Conception Parish.)

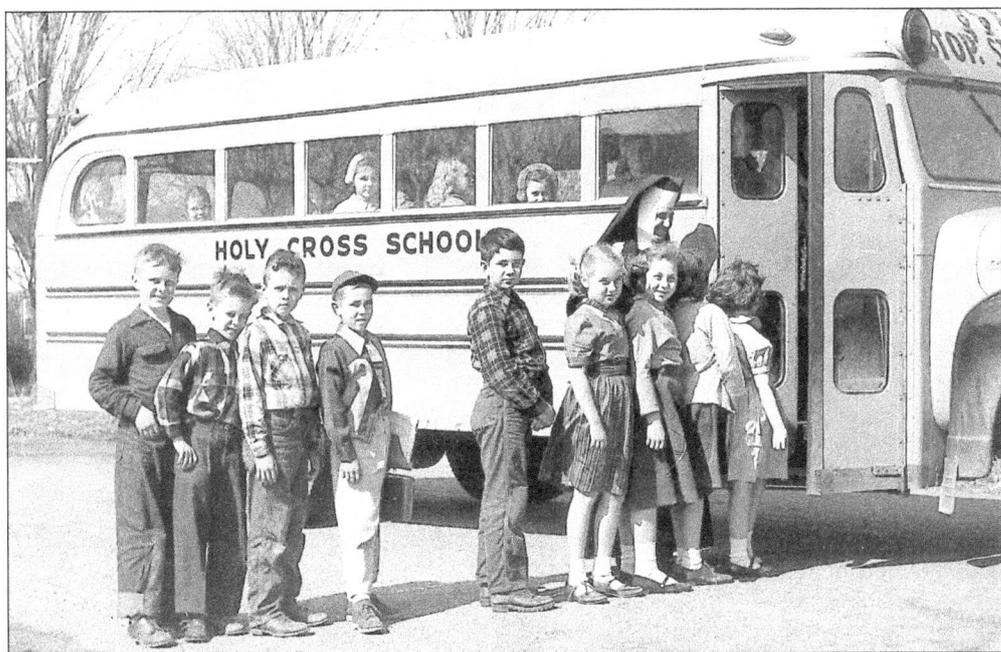

Youngsters board the bus after their day at Holy Cross Parochial School in Dover. The parish and school serve not only the state capital and its environs but also a large part of rural Kent County. (A. Ken Pfister photo courtesy of the diocesan archives.)

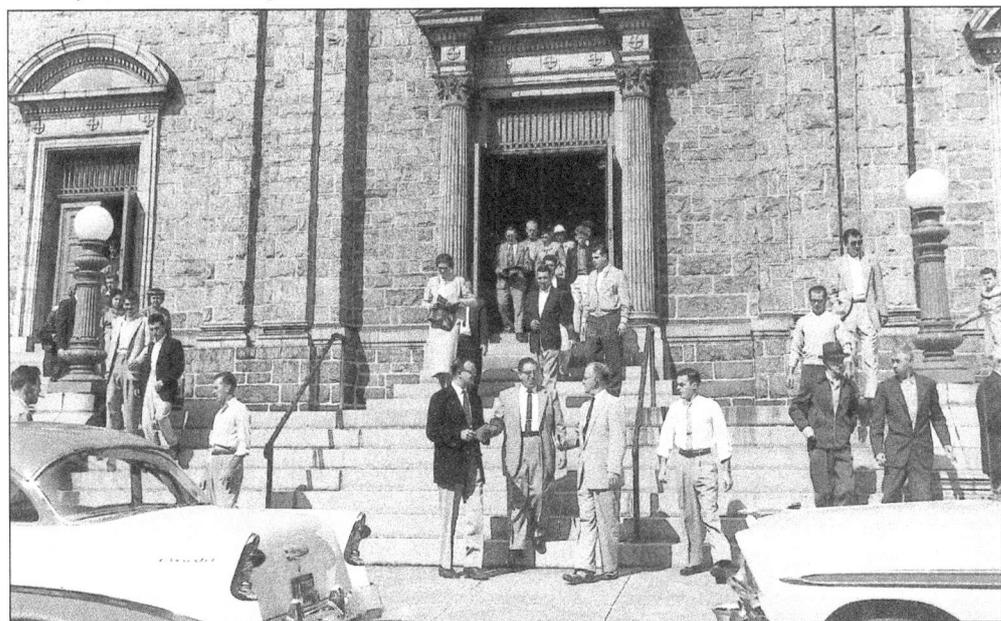

Parishioners leave St. Paul's Church, at Fourth and Jackson Streets in Wilmington, following Mass in the mid-1950s. The parish, founded in 1869, was split by the construction of the Interstate 95, literally at its doorsteps, soon after this photograph was taken. Anticipating its effect on the long-established neighborhood and the city, Father John H. Walsh, pastor, joined other civic leaders in a valiant but unsuccessful fight against the highway. (Ellsworth J. Gentry photo courtesy of the diocesan archives.)

Monsignor John J. Lynch wraps three Girl Scouts from Christ Our King Parish in the folds of the large cape that was his trademark. He was founding pastor of the north Wilmington parish and served from 1926 until his death in 1955. He died at age 74, just as construction of the present church was beginning. (Courtesy of Christ Our King Parish.)

Father, later Monsignor, Stanley W. Delikat is shown with First Communicants in the sanctuary of St. Stanislaus Kostka Church in 1962. Note the ornate high altar with missal stand and Mass cards, a common feature in pre-Vatican II churches. Also, the portable electric fan at the lower left was a usual warm-weather fixture when very few churches were air-conditioned. (Courtesy of St. Stanislaus Kostka Parish.)

Father J. Francis Tucker is shown in the pulpit at St. Anthony of Padua Church. He was asked in 1924 by Bishop Monaghan to establish a parish for Wilmington's growing Italian-American population. Obviously chosen more because of his fluency in languages rather than his Irish charm, "Father DeTuck" quickly endeared himself to the parishioners whom he served for 25 years. As a public and often controversial figure, he was well-known and respected in the broader community. (Conforti photo courtesy of the Oblates of St. Francis de Sales.)

Construction of St. Anthony of Padua School in the early 1950s followed the example established a quarter-century earlier with the building of the church. Italian-American artisans and other parishioners donated time, equipment, and labor, often working an additional shift, without pay, after a full day at their regular jobs. (Photo from the booklet published for the dedication of St. Anthony of Padua School.)

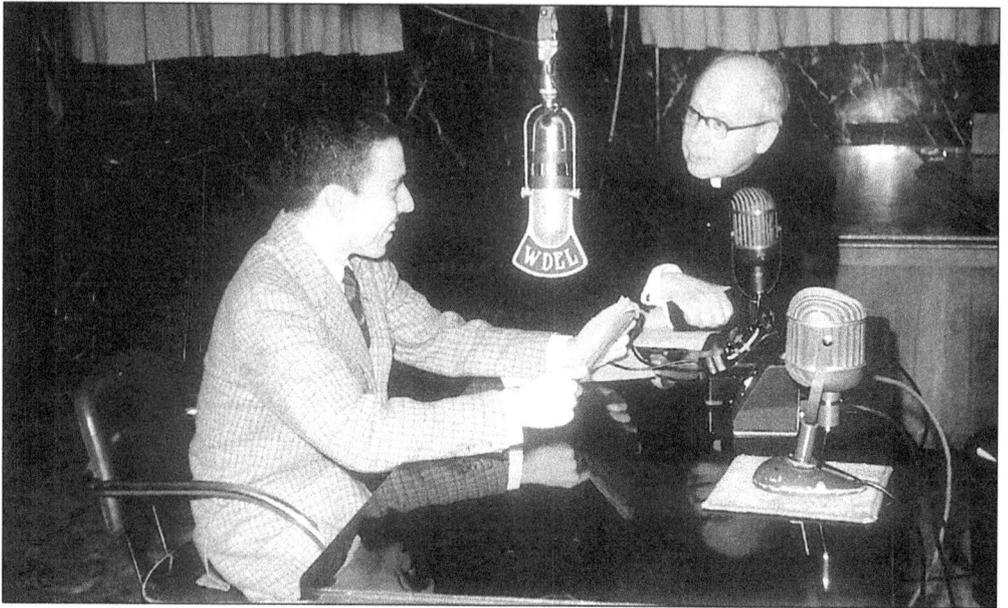

Canon Tucker is interviewed on the Catholic Forum of the Air by Mr. Jim Parks. The broadcast "scooped" the national media when Canon Tucker confirmed that his Christmas 1955 trip home accompanied by Prince Rainier of Monaco had a purpose other than to give the prince an opportunity to sightsee in Philadelphia. After attending midnight Mass at St. Anthony of Padua Church, the prince went to that city and proposed to movie actress Grace Kelly.

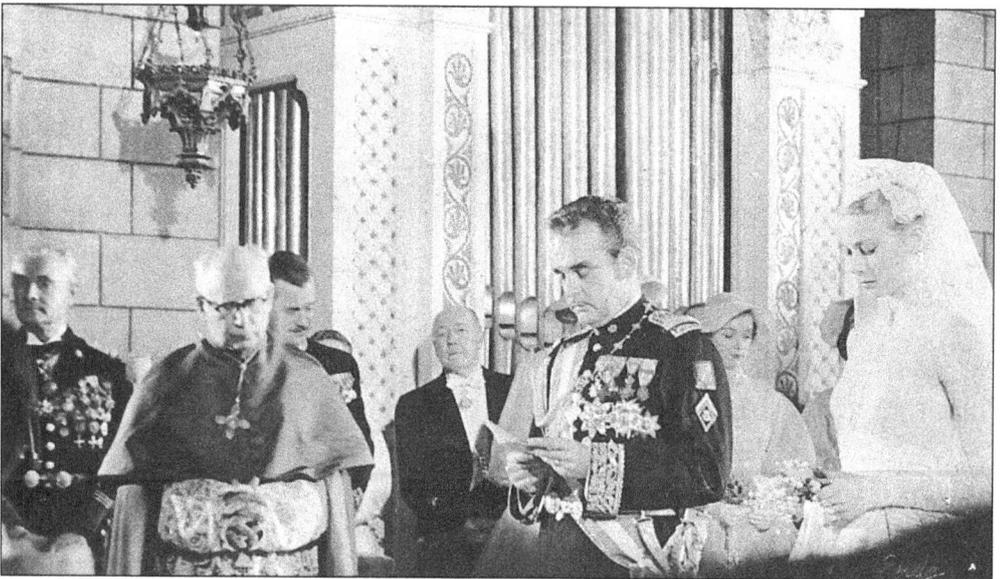

Canon Tucker's role as matchmaker, which was thoroughly documented by the *Saturday Evening Post*, earned him front-row status at the celebrated "wedding of the year" that followed. Canon Tucker, an Oblate of St. Francis de Sales, was pastor of the Cathedral of St. Charles in the tiny principality. In that position he not only befriended royalty but also the men of the U.S. Sixth Fleet, which often called at the French Riviera. (Courtesy of the Oblates of St. Francis de Sales.)

46

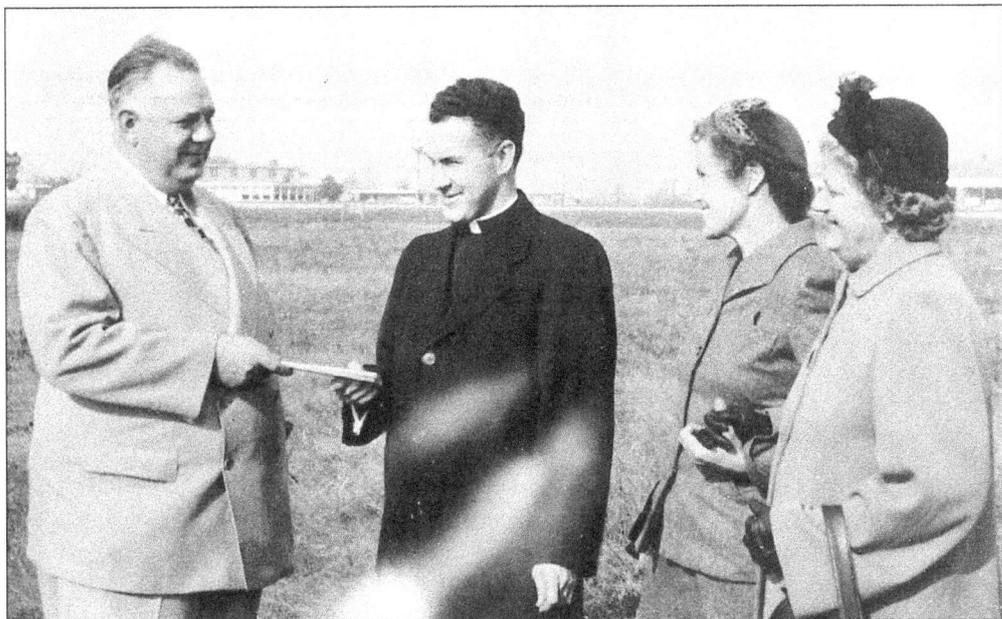

Mr. David Nichols presents the deed to three and a half acres of land in Harbor View in Chester, near the recently built Chesapeake Bay Bridge, to Father Columban McGough, pastor. Mr. Nichols donated the land in 1954 for St. Christopher Church. Witnessing the presentation are Mrs. Elizabeth Taylor and Mrs. Earnshaw Cook. (Courtesy of St. Christopher Parish.)

Father Henry Miller, the founding pastor, meets with members of the Sodality soon after the founding of St. Mary Magdalen Parish, near Talleyville, in the early 1950s. They are, from left to right, Mmes. Mary Pringle, Marguerite Lynch, Alice Healy, Marie Mayhart, and Betty Griffin. (Courtesy of St. Mary Magdalen Parish.)

The choir at St. Stanislaus Kostka Church on Wilmington's east side is pictured here. (Courtesy of St. Stanislaus Kostka Parish.)

An early First Communion class is pictured above at Our Lady of Lourdes Parish in Seaford. The parish was established in 1945 with Father Daniel M. Power as pastor and replaced a mission of St. John's in Milford that had been functioning since 1938. (Phillip Travetello photo from the parish's golden jubilee book.)

Catholic Youth Organization sports were equal-opportunity endeavors long before female athletes were expected to play with comparable ability and the same enthusiasm as their male counterparts. In the Diocese of Wilmington, both genders played a competitive brand of basketball and other games in season, which appealed to about equal numbers of avid supporters. The extensive program depended entirely on the services of volunteer coaches and mentors. (Both photos courtesy of the Office of Catholic Youth Ministry.)

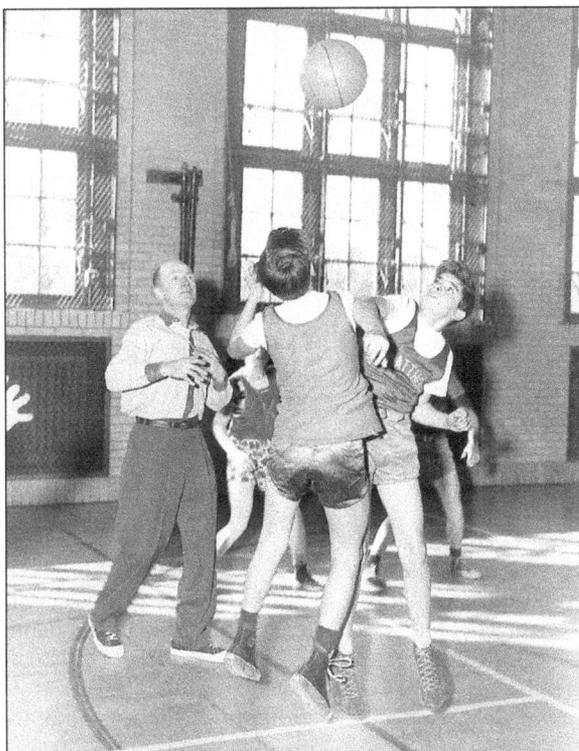

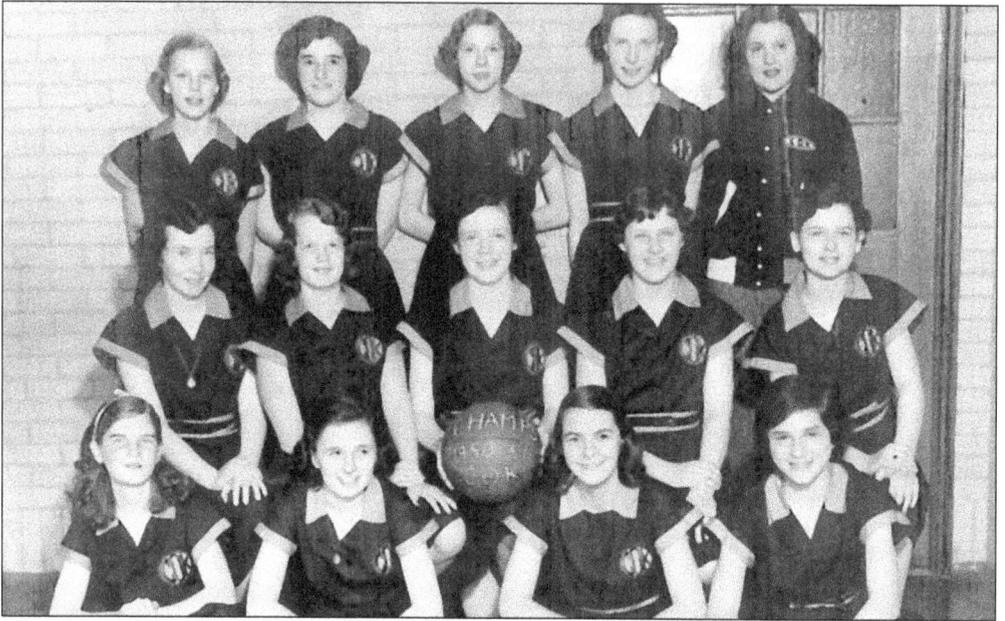

These young ladies were champions at a time when female sports took a back seat, except in Christ Our King Parish and the Wilmington C.Y.O. Team members are, from left to right, (front row) Amy McNulty, Joan Maloney, Margaret Forgoli, and Angie Durso; (middle row) Kathryn McLaughlin, Joanne Gilmore, Barbara Morgan, Christine Vogel, and Phyllis Schnekenberger; (back row) Connie Klezeko, Margaret Vogel, Joan Janulewicz, Marie Gormley, and Angela Longelaski. (Edward Cohen photo courtesy of Christ Our King Parish.)

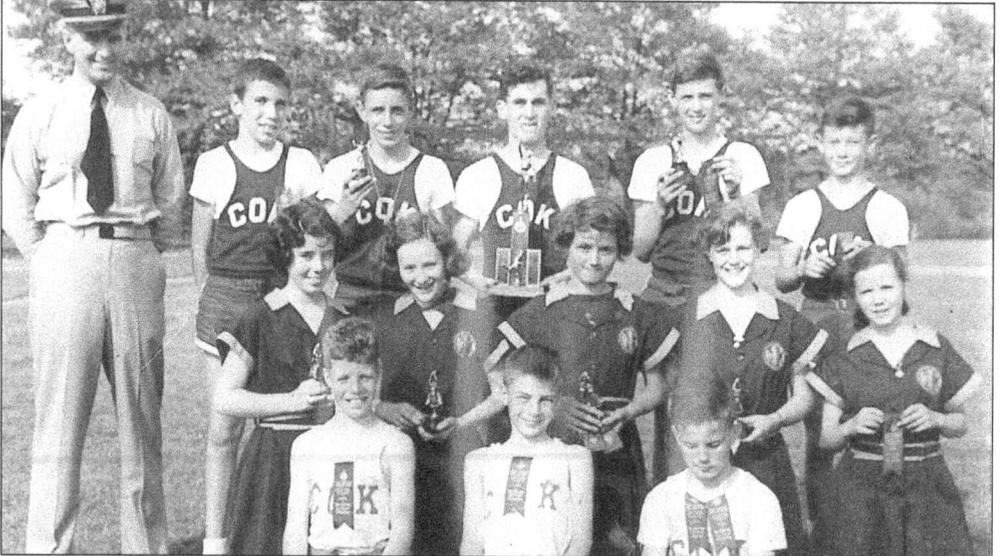

A sports powerhouse in the early 1950s, Christ Our King athletes of both genders also captured track and field honors. Coaching this team and moderating all parish youth activities was Father John M. Donohoe, wearing his uniform as a U.S. Navy Reserve officer. Team members include J. Bellanca, R. Akinson, H. Hughes, M. Thomas, R. Corcoran, J. Mulrooney, R. McCrea, T. Hadfield, M. Bishop, C. Housten, B. Kelleher, W. Bottiger, and C. Derrick. (Courtesy of Christ Our King Parish.)

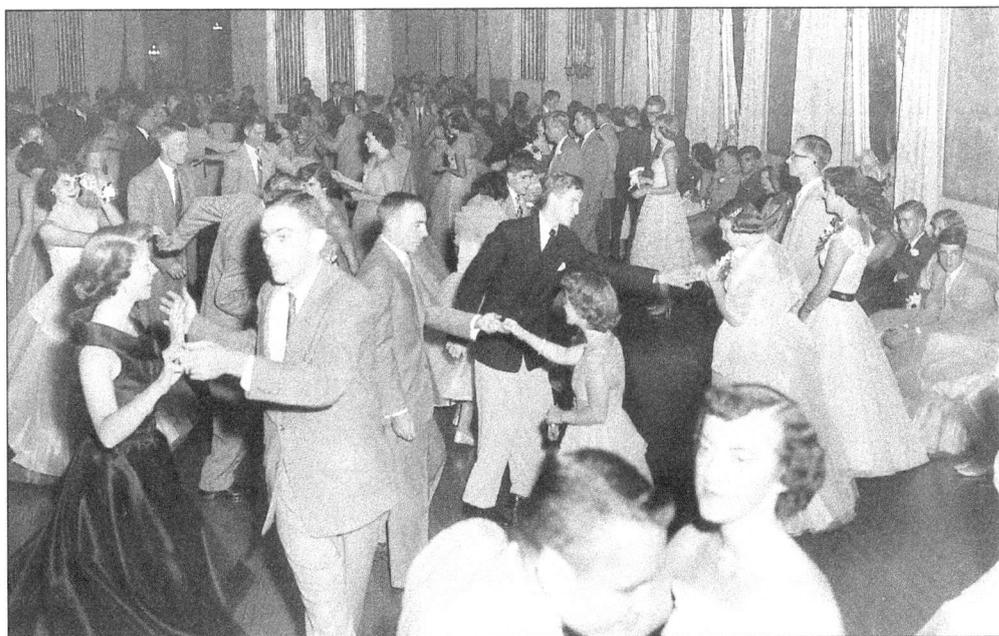

The C.Y.O. Harvest Ball was a social highlight in the 1950s and attracted a capacity crowd of teenagers from parishes throughout the diocese. They danced to the music of a live orchestra, and the fact that the annual event was held in the fabled Gold Ballroom of the Hotel du Pont testified that it was a first-class affair. (Gentrys Studio photo courtesy of the Office for Catholic Youth Ministry.)

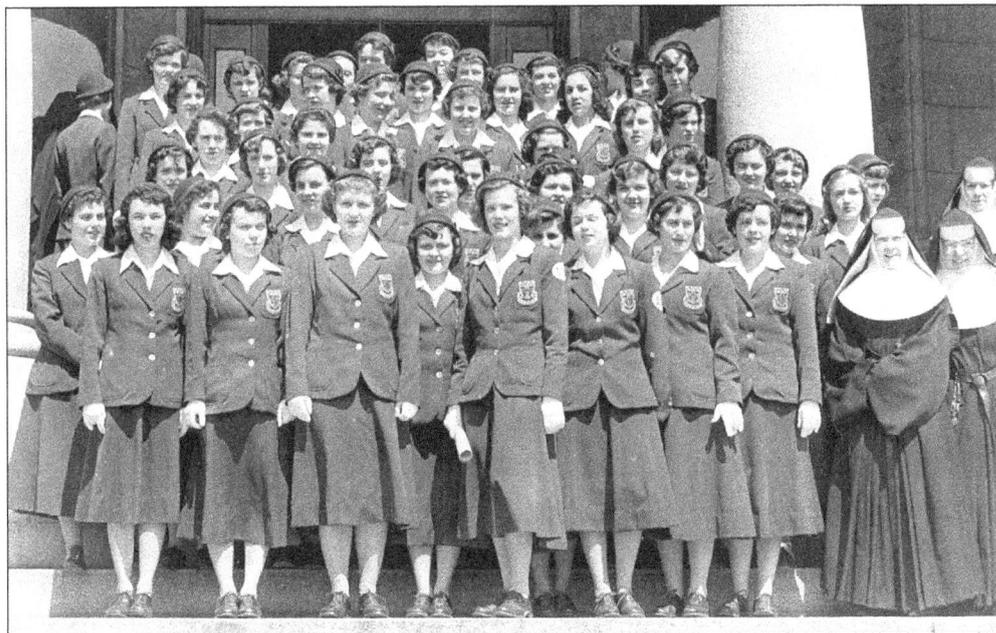

Members of the Ursuline Academy Glee Club wear their traditional high school uniforms during a competition at Catholic University of America in Washington, D.C. The group, under the direction of Sister Joanne Desmond, received a "superior" rating for its performance on that occasion. (Photo from the Ursuline Academy's 1993 centennial booklet.)

Father, later Monsignor, Joseph A. Enright came to Wilmington from Philadelphia immediately after ordination in 1929. Nine years later, he was assigned to St. Mary of the Immaculate Conception Parish on the east side, where he served for 25 years. He presided over the centennial of the historic church and was prominent in diocesan and community affairs. (Courtesy of St. Mary of the Immaculate Conception parish.)

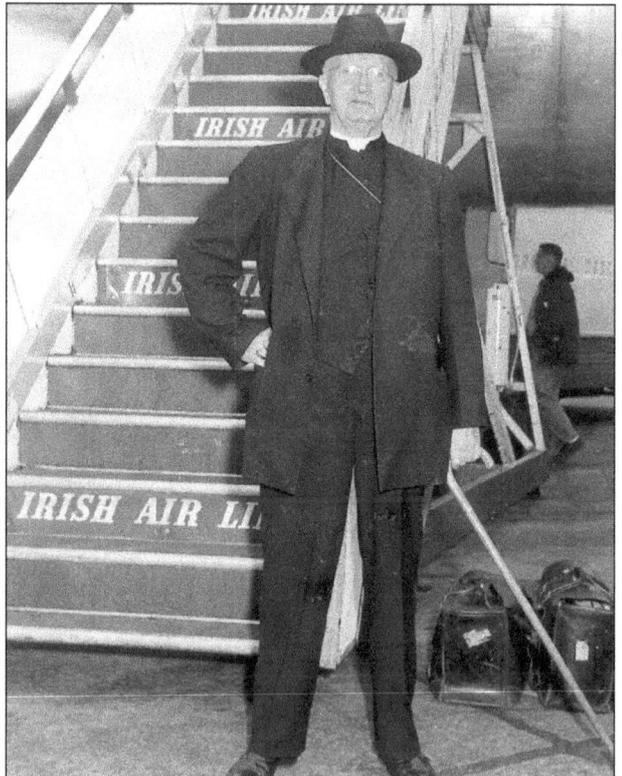

Bishop FitzMaurice strikes a proud pose before boarding an Aer Lingis airplane for a flight to his native Ireland. A true son of the Ould Sod, the bishop never severed his County Kerry roots. His cultured Irish brogue and the wit that went with it were familiar to all who knew him from the many diocesan, parish, and civic events in which he participated during his long episcopate. (Courtesy of the diocesan archives.)

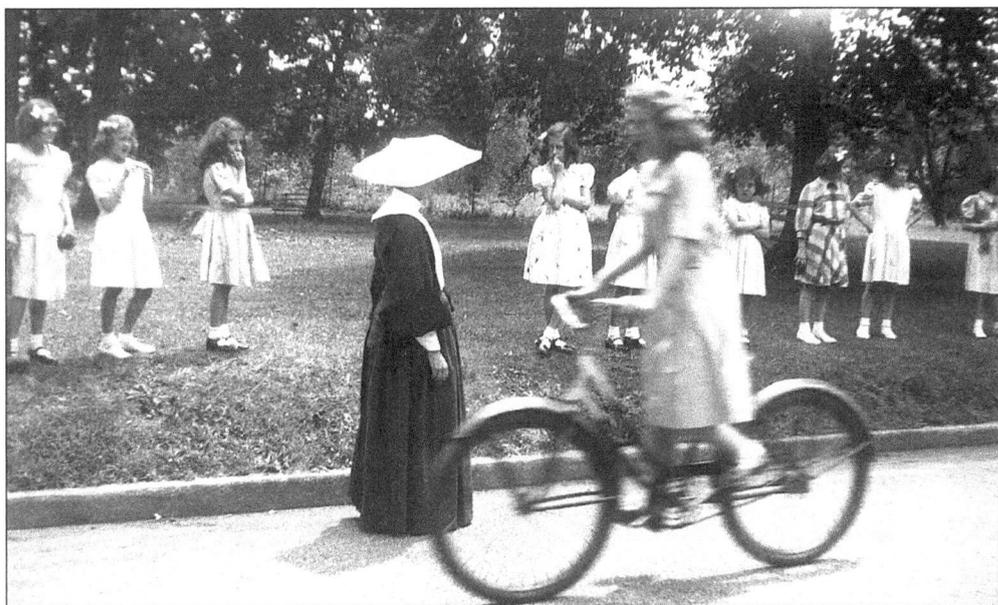

A Daughter of Charity supervises a bicycle-riding lesson at Seton Villa, near Bellefonte. The order, founded by Mother, later Saint, Elizabeth Ann Seton, was invited to Wilmington in the mid-1800s to operate an orphanage for girls at the cathedral. Until the habit was modified following Vatican II, the sisters were distinguished by their large coronets. Seton Villa, the successor to the St. Peter's orphanage, is now operated by Catholic Charities. (Photo from the Daughters of Charity archives.)

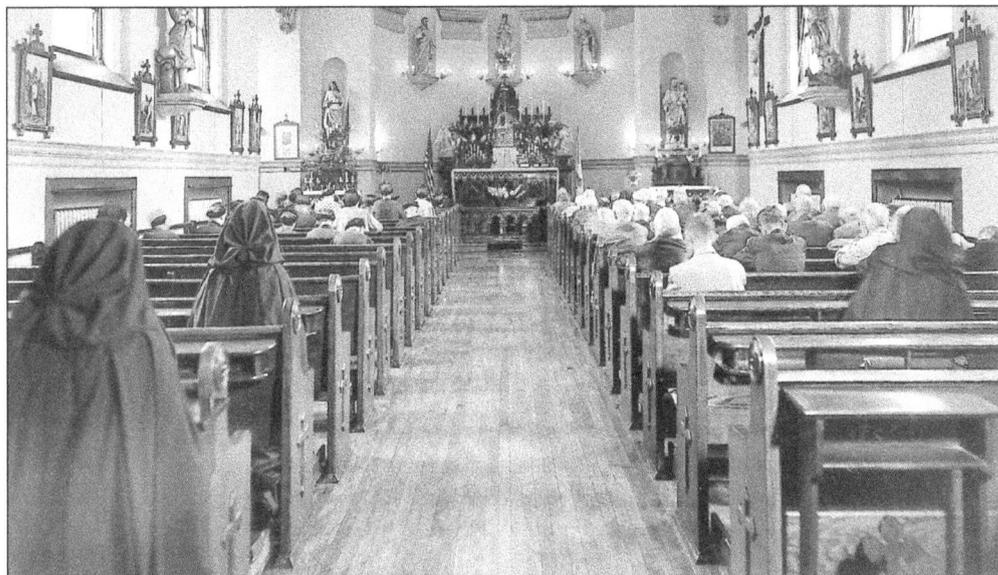

Residents and guests are pictured in the chapel at St. Joseph Home for the Aged on Bancroft Parkway between Fourth and Fifth Streets in west Wilmington. The Little Sisters of the Poor staffed the home for many years, long before elder living facilities became common. To a large extent, the sisters—most of whom, it seemed, were, indeed, short in stature—financed it with alms collected during frequent tours of stores and other business establishments in the city. (Courtesy of the Little Sisters of the Poor.)

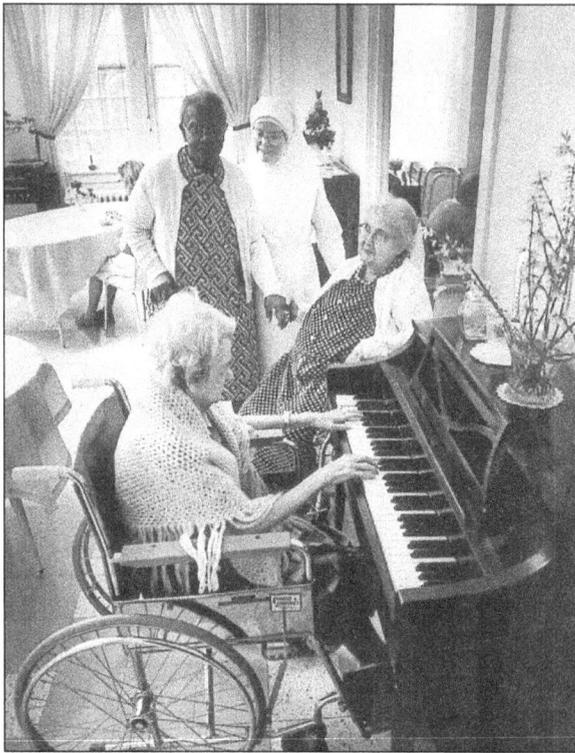

Piano playing was just one of many activities at St. Joseph Home, where the Little Sisters provided as much of a family atmosphere as possible. The home was the predecessor of the present Jeanne Jugan Residence on Salem Church Road near Newark. Jeanne Jugan, whose cause for canonization as a saint is now under consideration, was foundress of the order. (Courtesy of the Little Sisters of the Poor.)

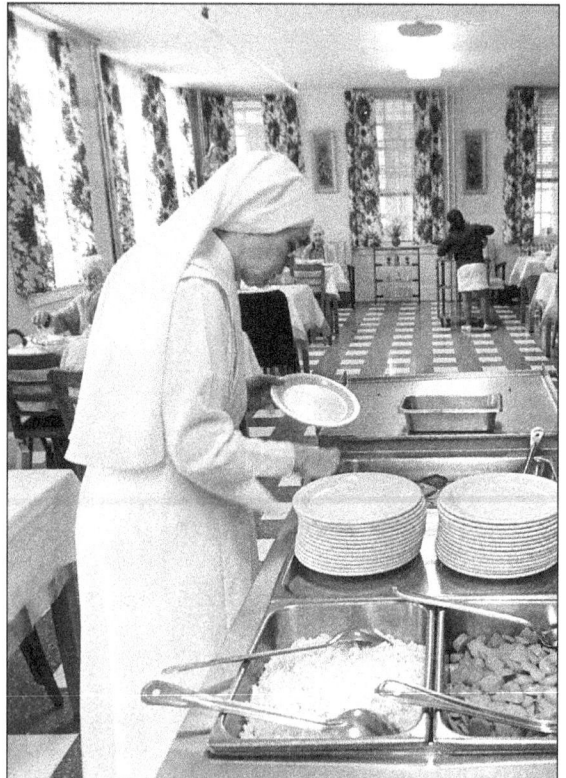

Sister Angela Edwards prepares to serve a meal in the dining room at St. Joseph Home. (Action photo courtesy of the Little Sisters of the Poor.)

Monsignor Joseph D. Sweeney converses with Delaware Governor, later U.S. Senator, J. Caleb Boggs at a 1957 vocations exhibit. Both men were widely known public figures recognized for their ability to relate to people on a one-to-one basis. Monsignor Sweeney was chancellor of the diocese from 1944 until 1962 and its vicar general from 1949 until 1962. It is said that he and Bishop FitzMaurice worked so closely in tandem that they were able to handle the entire administrative needs of the diocese in short telephone conversations or visits to each other's residence. (Elsworth J. Gentry photo courtesy of the diocesan archives.)

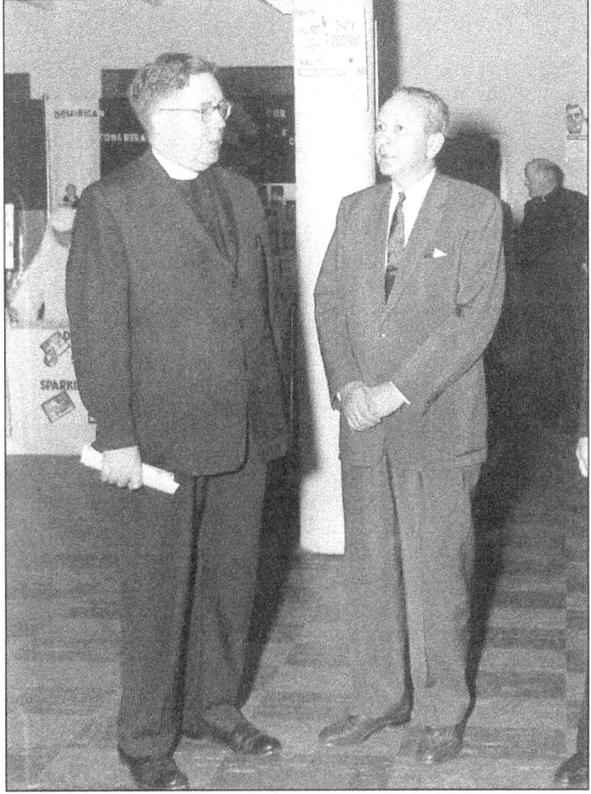

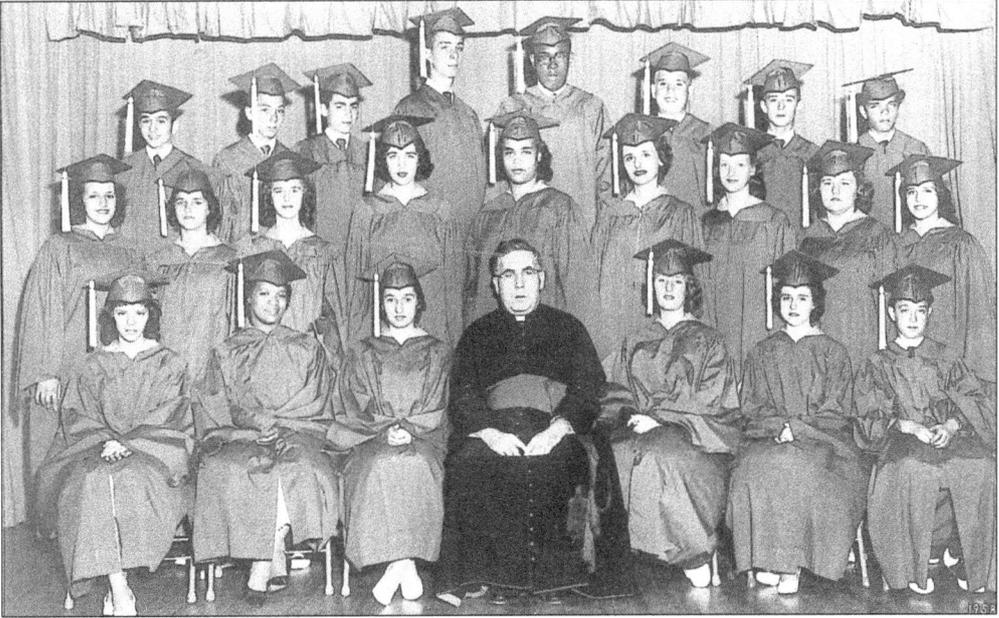

Monsignor Sweeney, rector of the Cathedral of St. Peter, is pictured with the parish school's 1958 graduating class. In addition to his diocesan duties, he served as rector from 1949 until 1969. A native Wilmingtonian who grew up in St. Elizabeth Parish, Monsignor Sweeney died in 1984 at age 74, a half-century after his ordination. (Courtesy of Cathedral of St. Peter.)

Although the high wall and notion of a cloistered life seemed forbidding to many people, the Sisters of the Visitation, who served in the diocese for many years, are warm and friendly. Here, they welcome a postulant at the door of their enclosure in the monastery in the Highlands section of west Wilmington. Following the rule of St. Francis de Sales, they try to truly "Live Jesus" in all that they do.

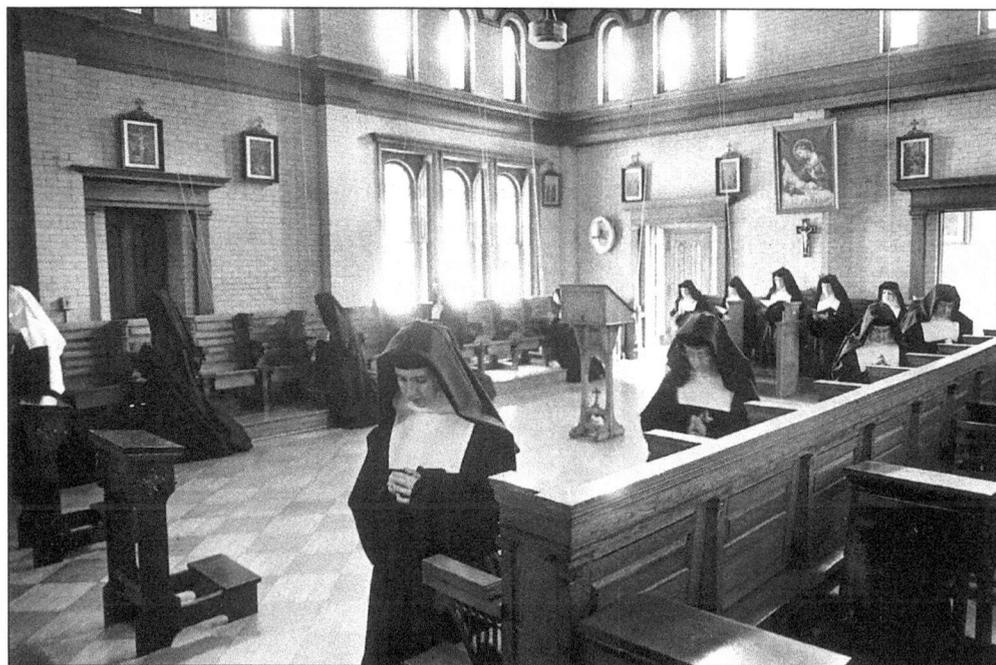

At prayer in their plain chapel in the monastery, the sisters are both removed from the world and a part of it. A common practice for many years was for people to telephone requests for prayer, confident that the sisters, whom most callers had never met or even seen, would intercede for them. (Both photos courtesy of the Visitation archives.)

Bishop Hubert J. Cartwright, a native Philadelphian, was appointed coadjutor bishop of Wilmington with the right of succession of Bishop FitzMaurice in 1956. Bishop Cartwright proved a tireless worker, serving not only as pastor of Christ Our King Parish but also traveling throughout the diocese on liturgical and administrative missions for the aging bishop. Bishop Cartwright visited every parish, school, and diocesan institution during the 16 months that he served, and his warm friendly manor endeared him to all he met. (Courtesy of the diocesan archives.)

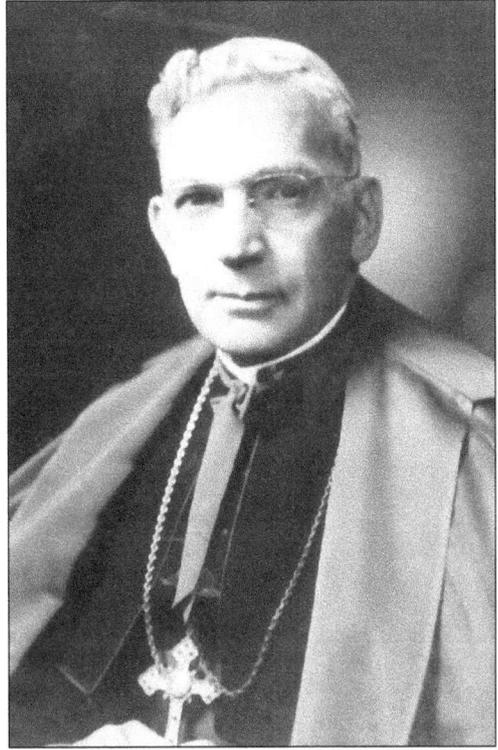

Mourners gather outside the nearly completed Christ Our King Church for Bishop Cartwright's funeral and interment. His sudden death in March 1958, at age 57, greatly saddened the diocese. His remains rest beside the entrance of the north Wilmington church. (Okoniewski Studio photo courtesy of Christ Our King Parish.)

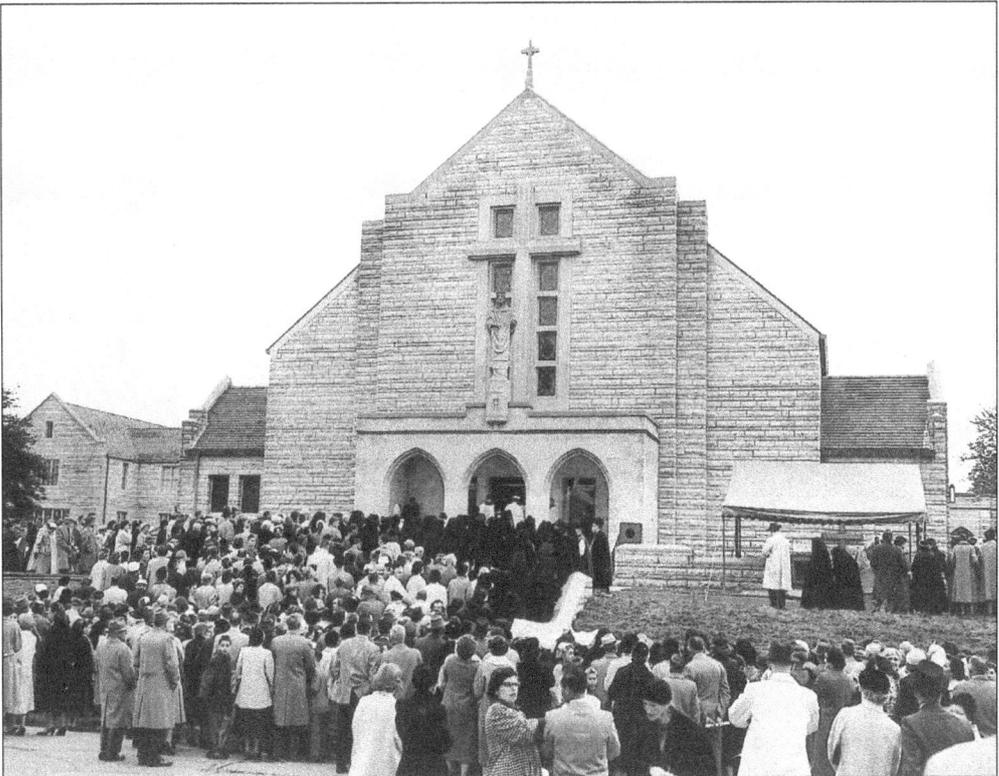

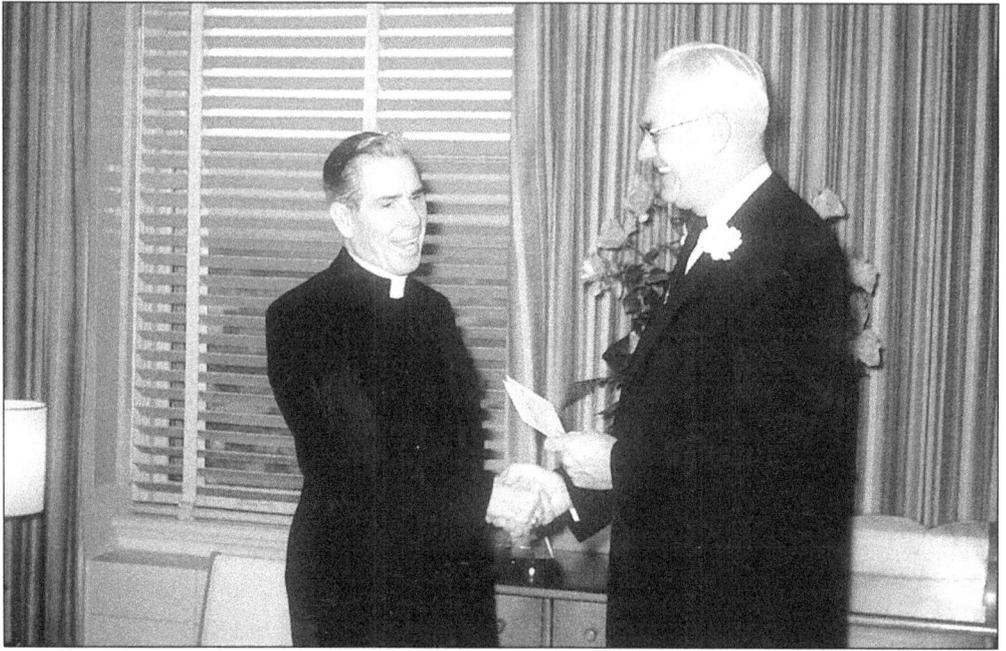

Bishop Fulton J. Sheen, in Wilmington for a Mission Sunday event, is greeted by Mayor Eugene Lammot. When this photograph was taken in the 1950s, the bishop was a national phenomenon. His weekly lectures were among the most watched network television programs. Earlier in his career, Monsignor Sheen was a frequent visitor to the city while on the faculty of Catholic University of America in Washington, D.C. (Photo by Jim Parks.)

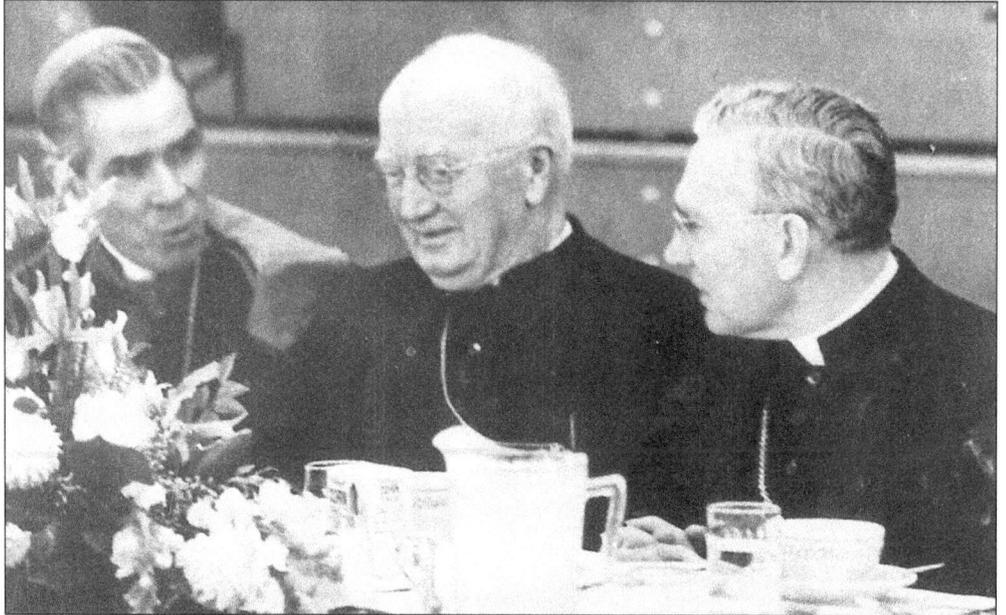

Bishop FitzMaurice holds the attention of Bishop Sheen and Coadjutor Bishop Hubert J. Cartwright at the Communion "Breakfast of Champions," an annual fund-raising event for the diocesan Society of the Propagation of the Faith. Bishop FitzMaurice delighted in reminding those in attendance that no one, including bishops, got in without buying a ticket.

Norbertine Father Justin Diny, headmaster, confers with students James Thompson and Ed McHugh. During his long tenure at the school, Father Diny made it a point to get to know his charges well and relate to them not only as an educator and counselor but also as a personal friend.

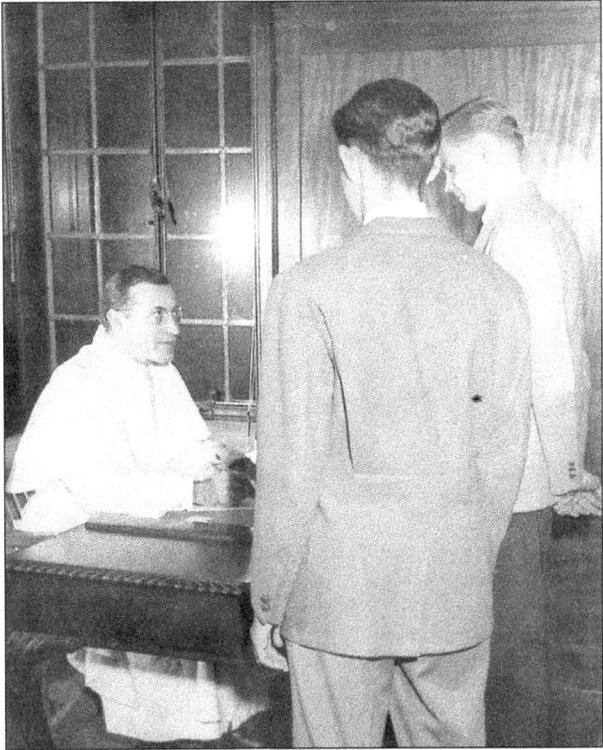

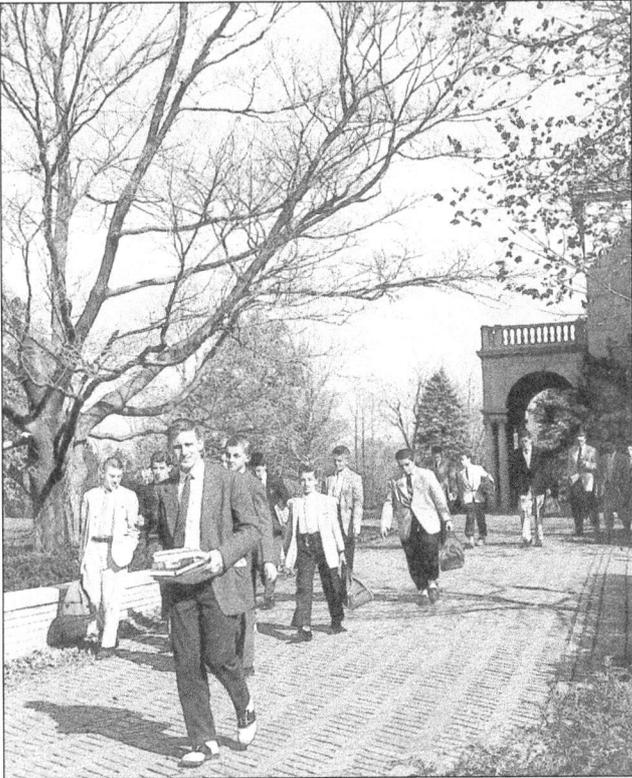

Archmere Academy students head for home after a day in classes in the mansion on the former John Raskob family estate in Claymont during the mid-1950s. (Both photos courtesy of the Archmere Academy development office.)

Oblate Father Thomas A. Lawless, the second American to enter the Oblate order, was the man most responsible for the building of the present Salesianum School. He made history by racially integrating the original school in 1950, when "separate but equal" was still the law of the land and accepted practice in Delaware. (Courtesy of the Oblates of St. Francis de Sales.)

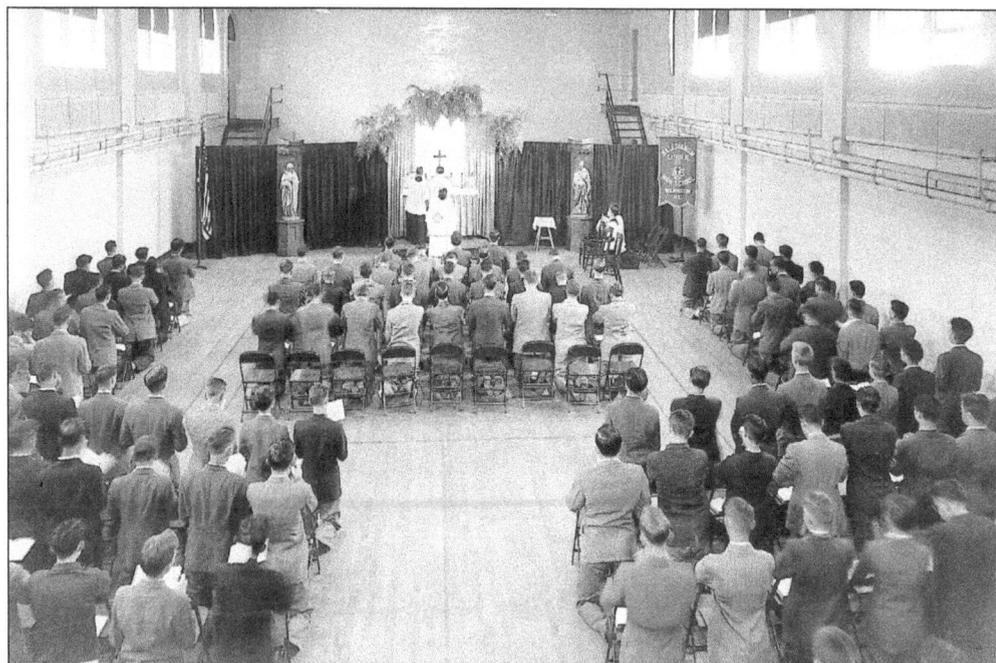

The all-purpose gymnasium in Salesianum at Eighth and West Streets could be quickly converted, as the occasion demanded, into an auditorium, cafeteria, study hall, or chapel. Here students clad in their traditional coats and ties participate in the weekly Wednesday morning Mass. (Sanborn Studio photo courtesy of the Salesianum School development office.)

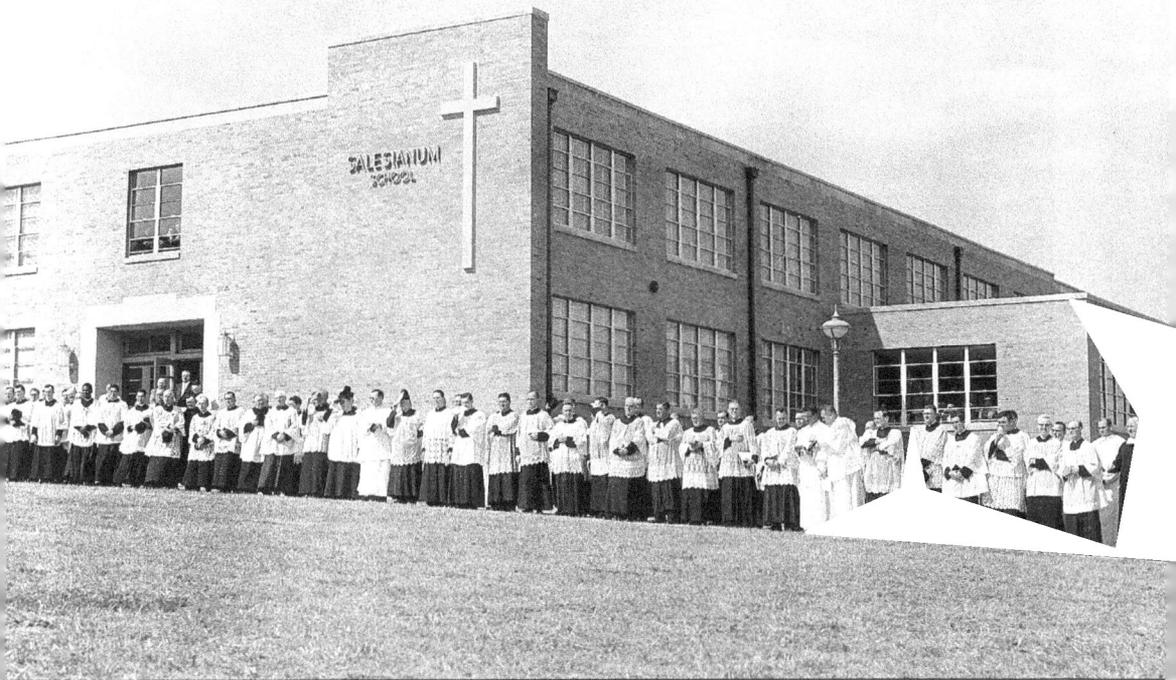

Oblates of St. Francis de Sales and diocesan clergy gather in 1957 at the dedication of the new Salesianum School in the Ninth Ward section of Wilmington. As the school prepares to celebrate its centennial in 2003, it is constructing a laboratory and science wing at this side of its campus. (Courtesy of the Salesianum School development office.)

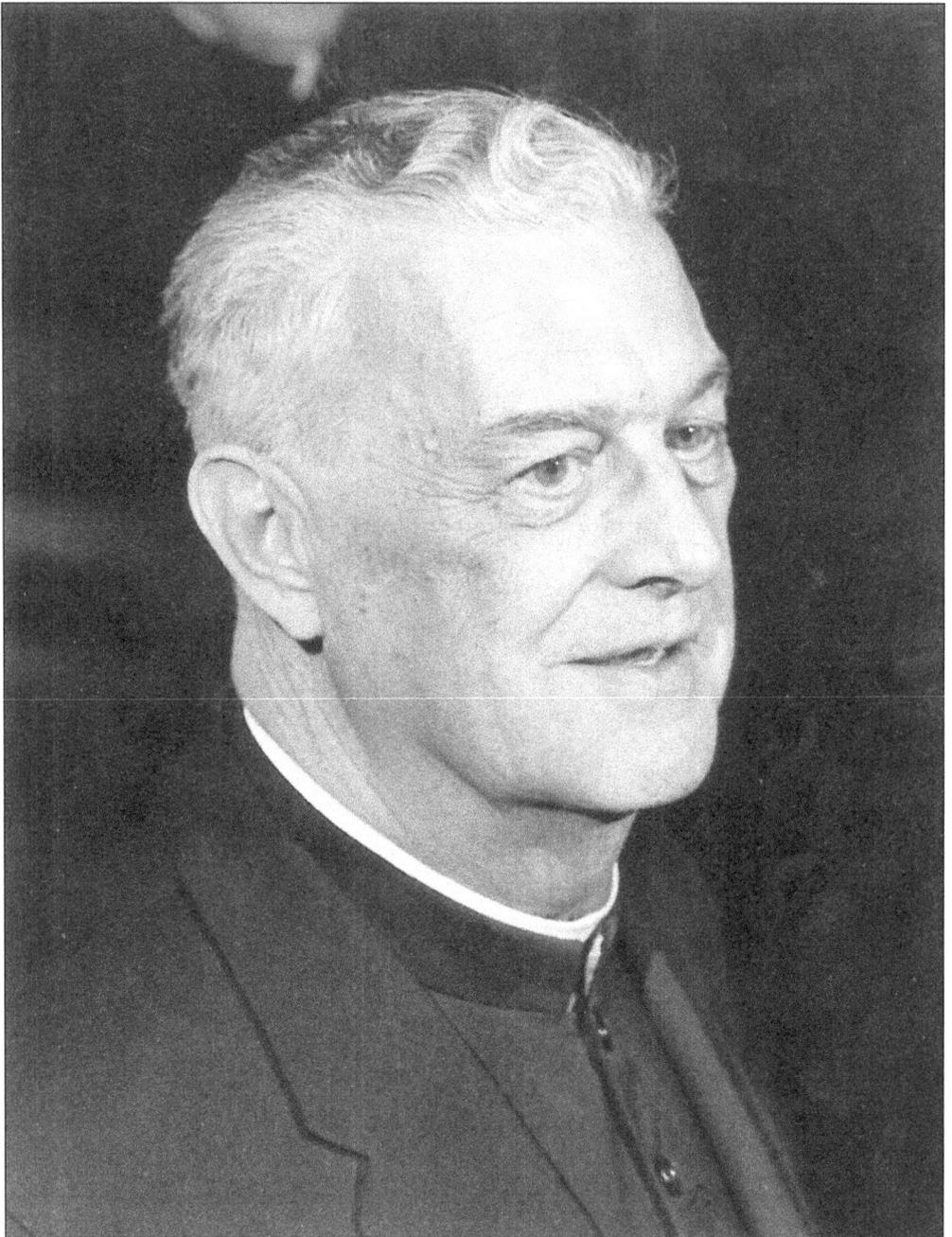

Bishop Michael William Hyle was born in Baltimore, Maryland, on October 13, 1901. He was ordained in Rome, Italy, on March 12, 1927 and consecrated as coadjutor bishop of Wilmington and titular bishop of Christopolis on September 24, 1958. On March 2, 1960, he was installed as fifth bishop of Wilmington. He died on December 26, 1967.

Three

COMING OF AGE

Bishop Hyle visits in the summer of 1966 with young men studying at the minor (high school) seminary in Baltimore in the early years of preparation for the priesthood. (Courtesy of the diocesan archives.)

An idealized portrayal of St. Joseph-on-the-Brandywine Church, rectory, and school as they appeared in 1960, this painting was done by Mr. W. James McGlynn. It was commissioned in connection with the parish observance in 1991 of the 150th anniversary of its founding.

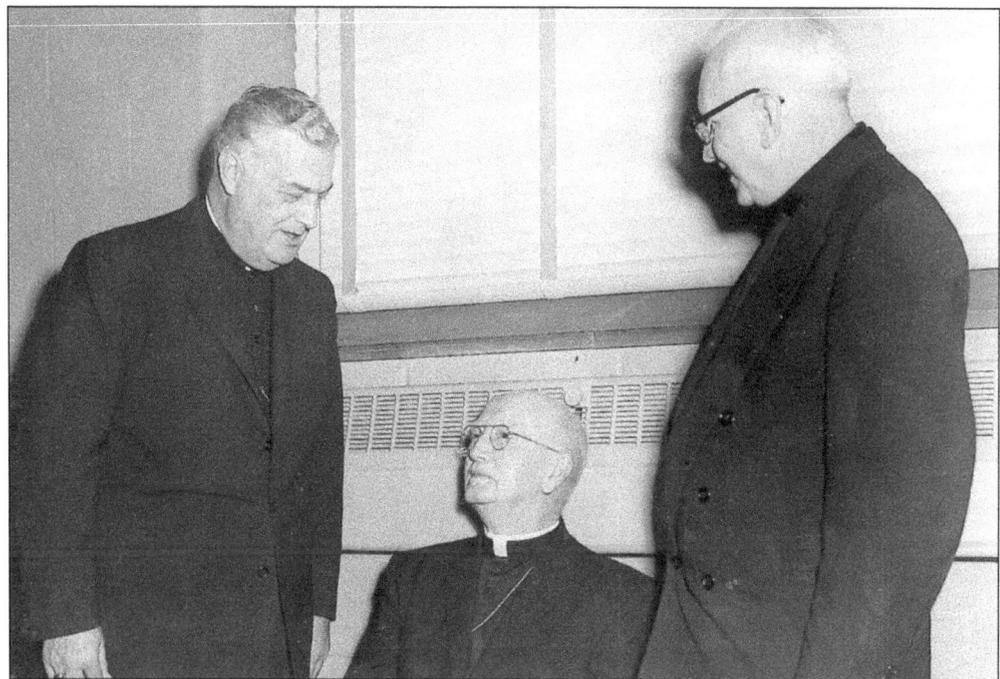

Bishop Hyle is pictured here with Bishop FitzMaurice and Father Joseph Enright. This photograph was taken at St. Mary's of the Immaculate Conception Church shortly before Bishop FitzMaurice retired and Bishop Hyle succeeded him. Father Enright was a longtime pastor of St. Mary's. (Lubitsh & Bungarz photo courtesy of the St. Mary of the Immaculate Conception Parish.)

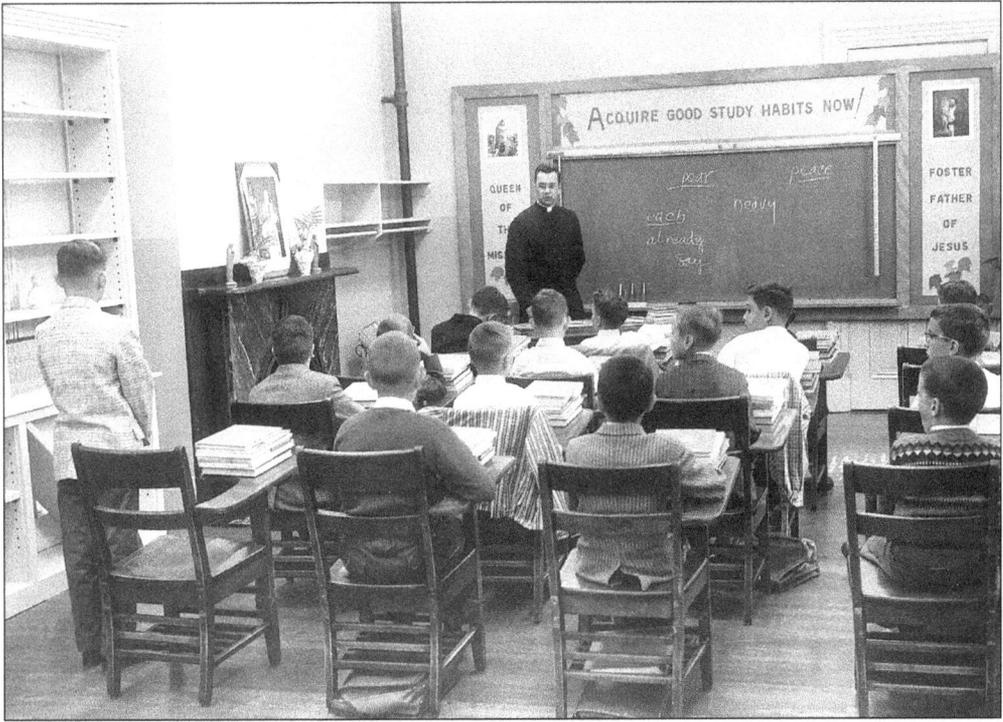

This class, in session in the early days of St. Edmond's Academy, is being taught by Holy Cross Brother Christopher. The elementary school was established, primarily as the result of a parental effort, shortly after Bishop FitzMaurice's death in his former residence at Delaware Avenue and Franklin Street in Wilmington.

Appearances and equipment have changed, but the same spirit prevails today in the up-to-date classrooms and laboratories on the academy's campus on Veale Road just outside of Ardencroft. The student at the computer is eighth-grader Nathan Walker. (Both photos courtesy of St. Edmond's Academy.)

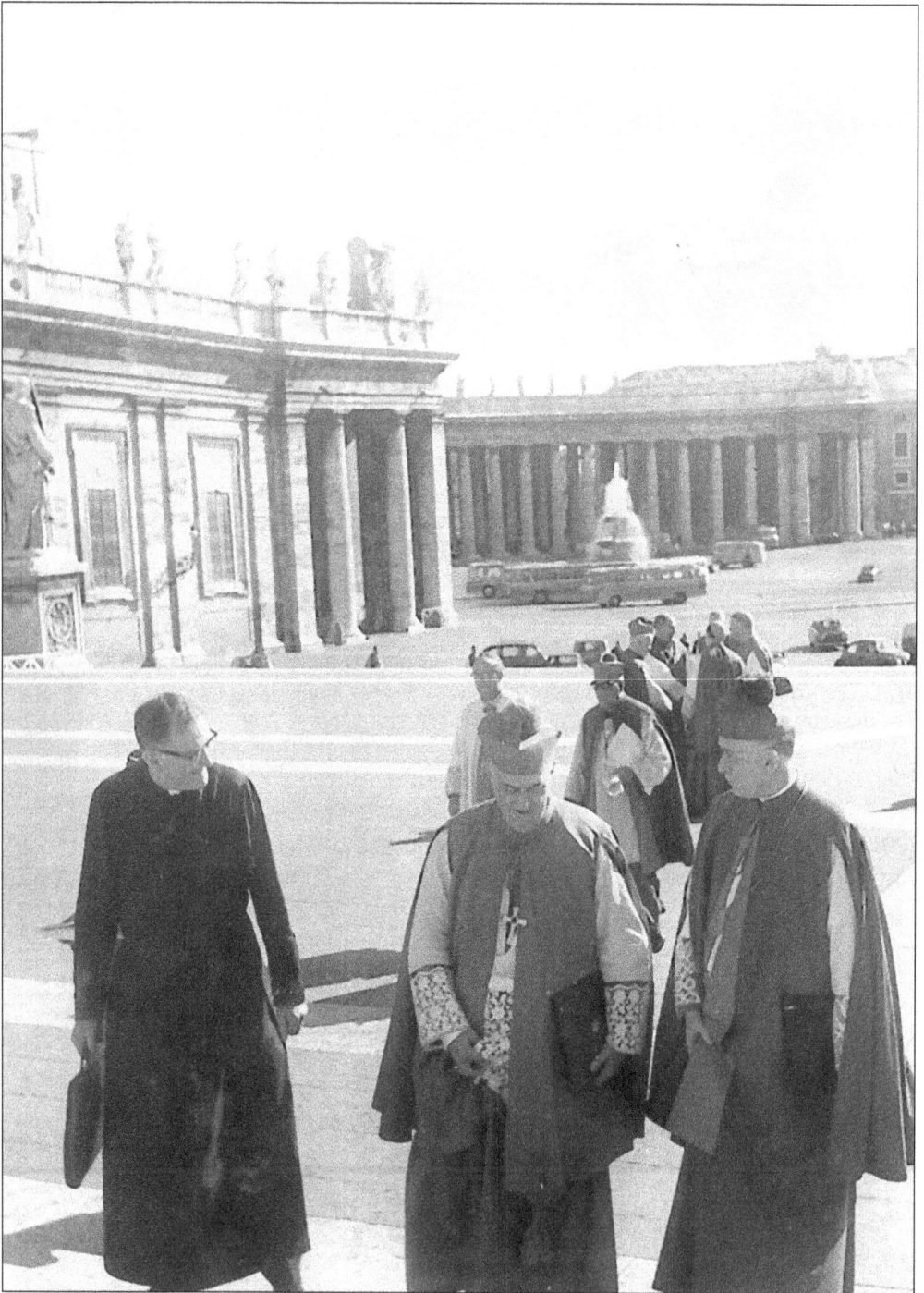

Bishop Hyle (center foreground) enters St. Peter's Basilica in Rome during the Second Vatican Council. This photograph was taken in September 1964. The Wilmington bishop attended all four sessions of the historic council and, upon its completion, was enthusiastic for quickly implementing its liturgical, governance, and ecumenical reforms. (Courtesy of the diocesan archives.)

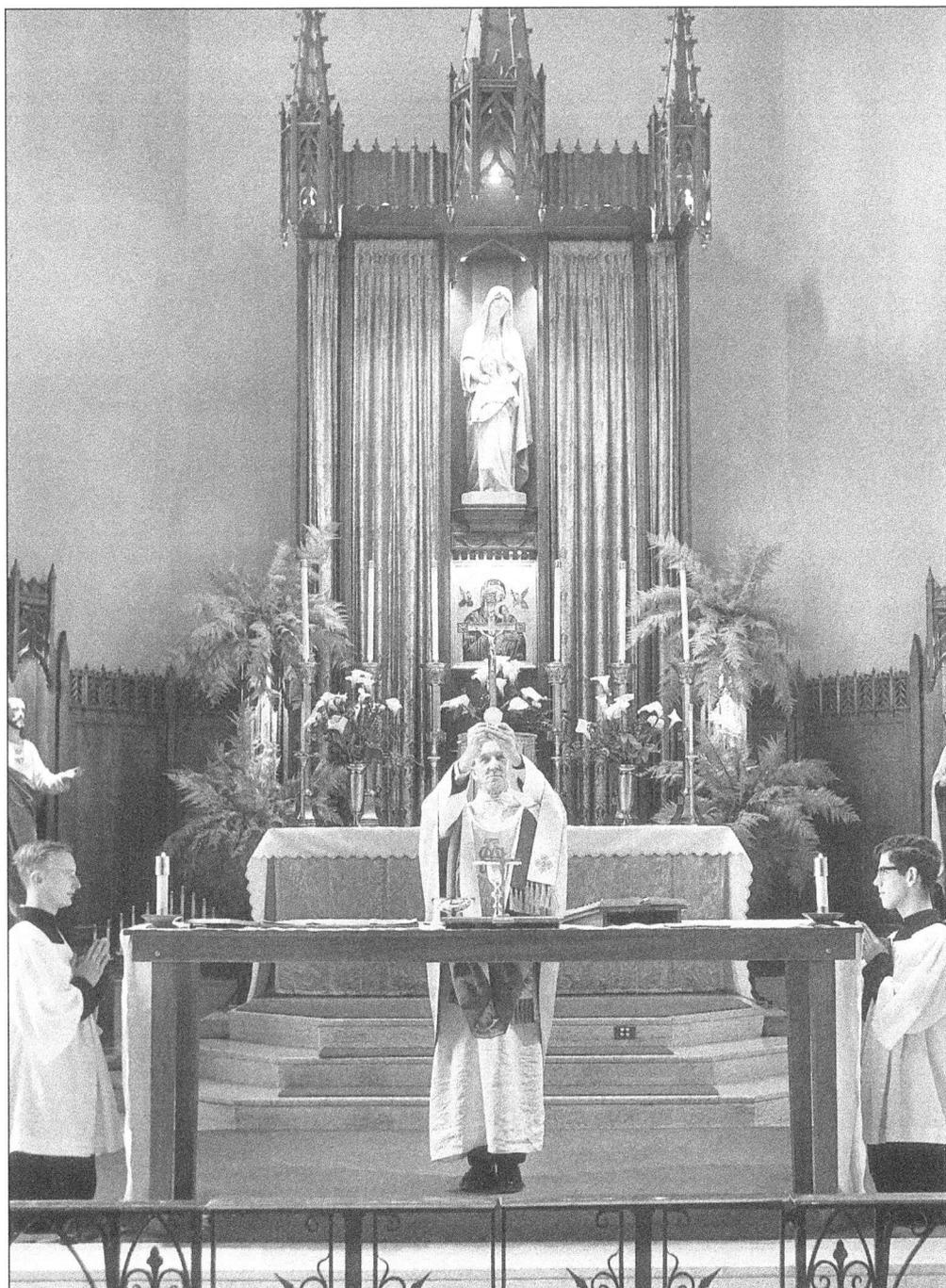

Father Edward B. Carley offers the "new Mass" in St. Ann Church in west Wilmington. Liturgical reforms instigated by Vatican Council II were, for the most part, enthusiastically received in the Diocese of Wilmington thanks in large measure to Bishop Hyle's support and enthusiasm. Administering the sacraments in English and other languages of the people was, no doubt, the most far-reaching of the many reforms to come out of the council. (Courtesy of the diocesan archives.)

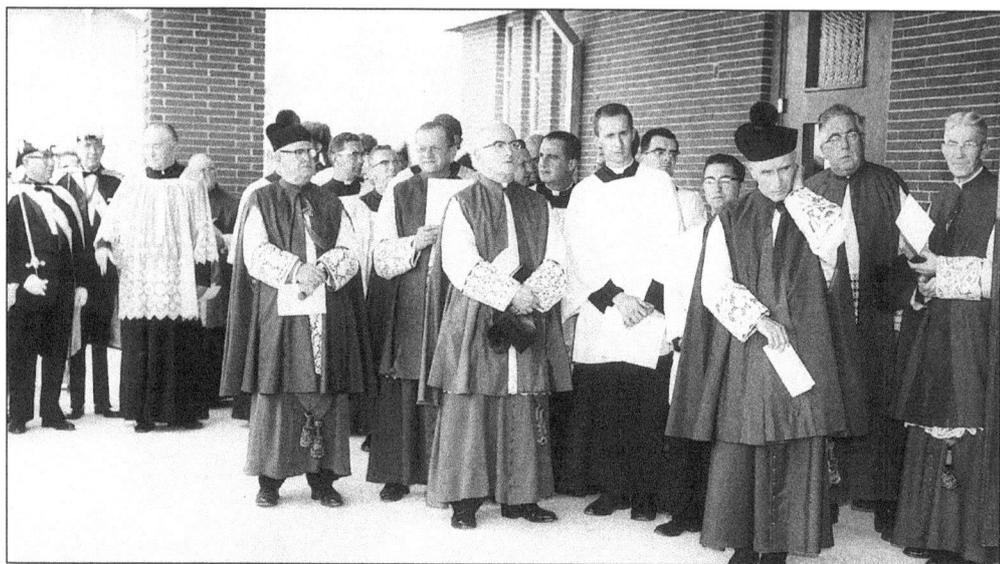

Diocesan clergy gather for the first Mass at St. Mary of the Assumption Church in Hockessin. It is the successor church and parish to the original Catholic establishment in Delaware. The lineage began in 1747. St. Mary's was moved from Coffee Run to Ashland and renamed in honor of St. Patrick. It became St. John the Evangelist when moved to Hockessin in 1882. The original name was restored in 1965. (Courtesy of St. Mary of the Assumption Parish.)

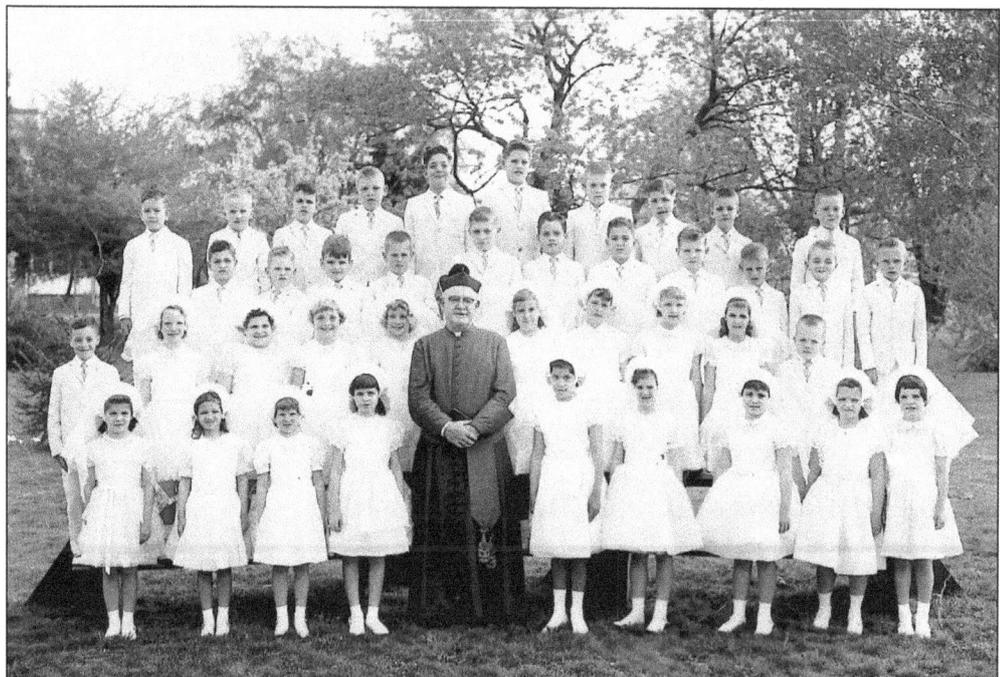

Monsignor Francis J. Desmond, pastor, poses in 1962 with First Communicants at Our Lady of Fatima Church on Du Pont Parkway in Wilmington Manor. Monsignor Desmond was responsible for the building not only of Our Lady of Fatima but also St. Ann in Bethany Beach, St. Jude near Lewes, and St. Michael the Archangel in Georgetown. (Courtesy of Our Lady of Fatima Parish.)

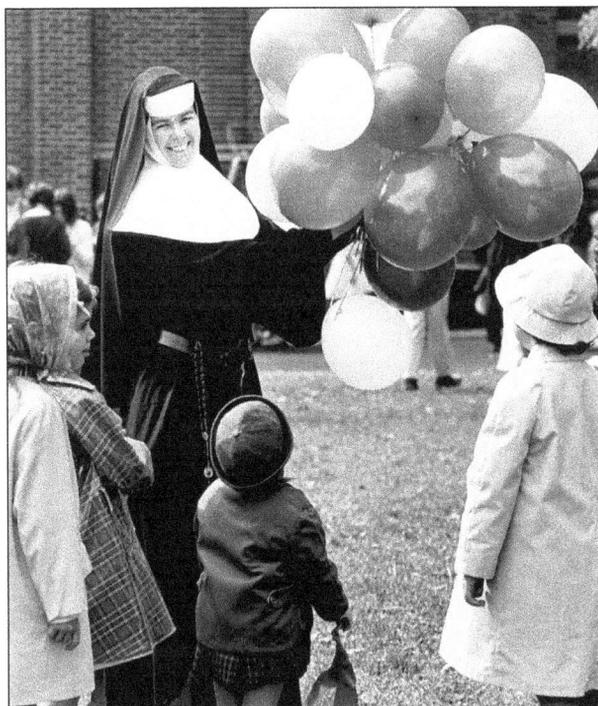

Ursuline Sister Ann Walsh was the balloon lady on Mission Day in 1965. The fund-raising fair was a popular annual event at Ursuline Academy for many years. (Photo from the Ursuline Academy's 1993 centennial booklet.)

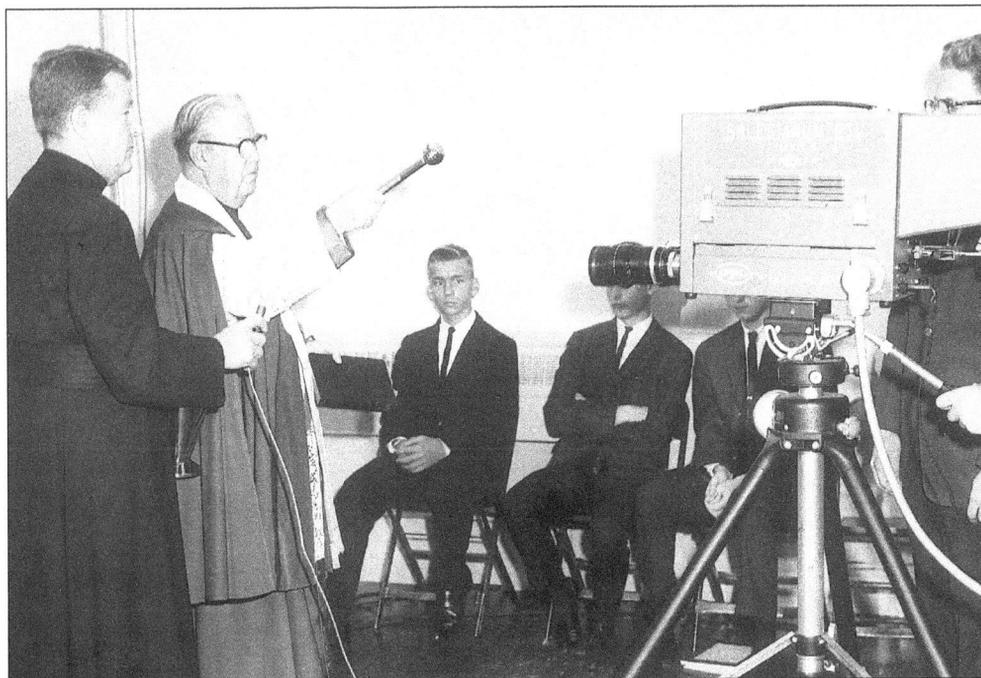

Oblate Father John Heckel and Monsignor Roderick B. Dwyer bless the equipment in the television studio at Salesianum School in 1963. Student John Kelly is the cameraman. Salesianum was among the first high schools anywhere to employ the then new technology of closed-circuit television on a regular basis. Student-operated WSAL is still functional. (Courtesy of the Salesianum School development office.)

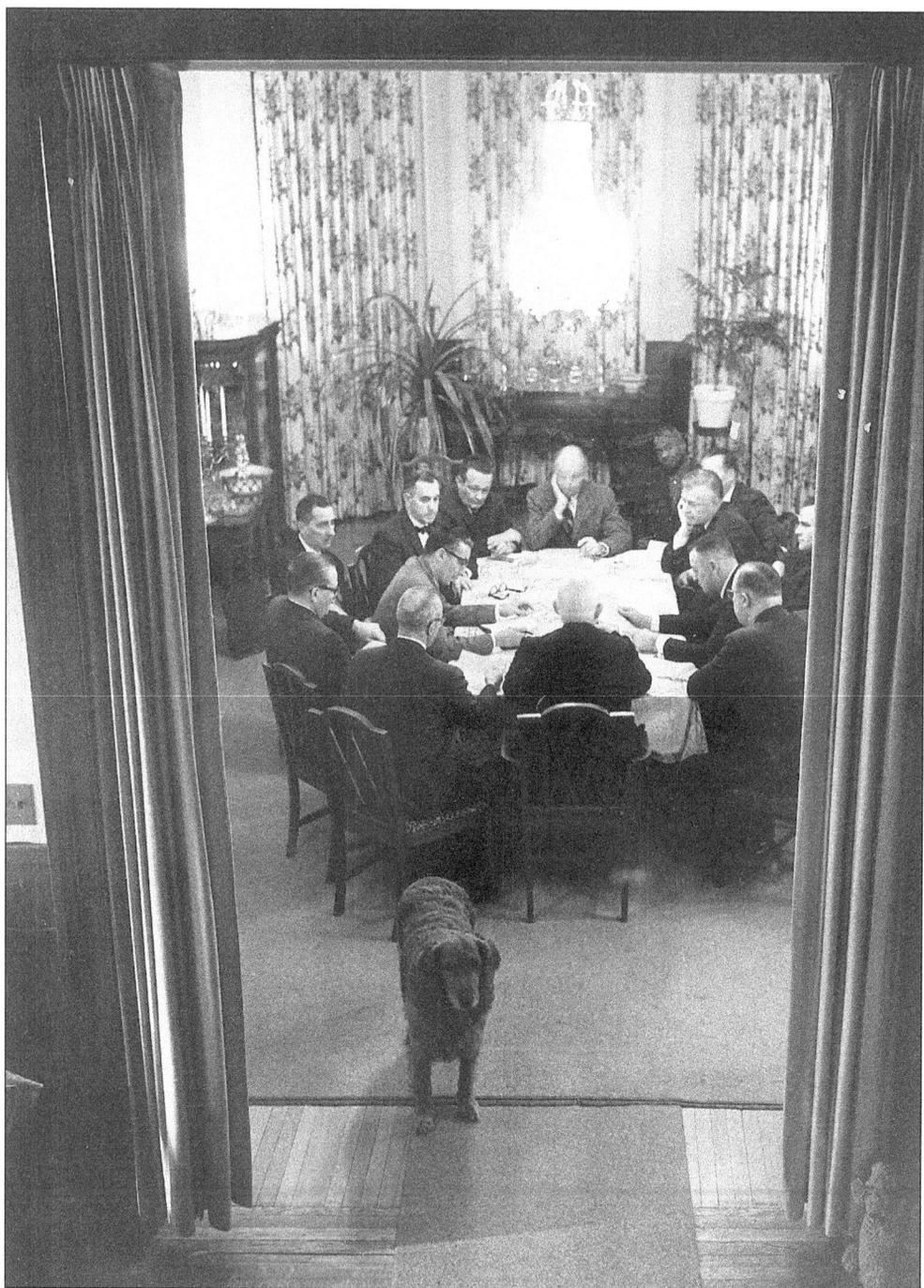

Next to the new liturgy, the most significant Vatican II reform quickly adopted in the Diocese of Wilmington was the establishment of parish councils, which greatly enhanced the role of the laity. Here Monsignor Eugene T. Stout's pet dog stands guard at the door as his master (with white hair, back to the camera), then one of the diocese's longest-tenured pastors, as he convenes one of the first council meetings in the rectory dining room at St. Francis de Sales in Salisbury in early 1967. (Photo by Action.)

The first Mass at St. Catherine of Siena Parish was offered in 1960 in the Cranston Heights Fire Company hall on Kirkwood Highway. Reading the Gospel is the celebrant, Father James W. Lutz, the founding pastor. (Henry Szymanski photo courtesy of St. Catherine of Siena Parish.)

Five Benedictine Sisters comprised the first faculty at St. Catherine of Siena Parochial School. Their first venue was a barracks at the former New Castle Air Base, which was converted into classrooms by parishioners. Arriving by station wagon are Sisters Mary Andrew, Mary Jude, Aloysius, Annunciata, and Darla. (Courtesy of St. Catherine of Siena Parish.)

Father James W. Lutz (left), Mr. Nick Harkins (second from left), and Mr. Dave Iannone (right), St. Catherine of Siena Parish's first trustees, welcome Father James T. Delaney on his arrival in 1962 as assistant pastor. Father Delaney went on to teach at Mount St. Mary's College in Emmitsburg, Maryland before returning to the diocese as a teacher at St. Elizabeth High School and first principal of St. Mark's High School. (Courtesy of St. Catherine of Siena Parish.)

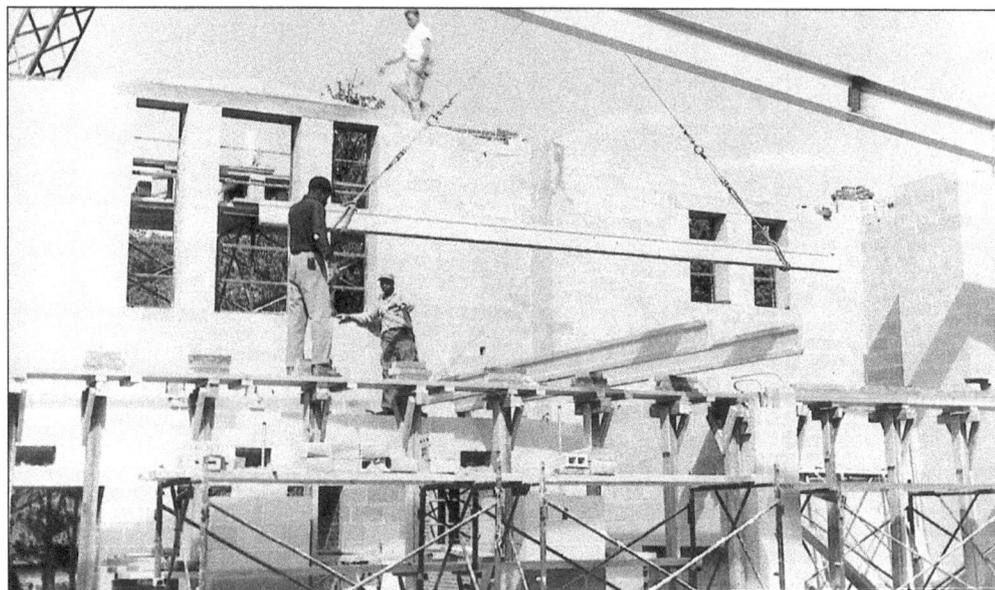

Construction takes place at Holy Cross Church on South State Street in Dover. Founded in 1850 as a pastoral center serving Kent County, Holy Cross has been a parish since 1870. (A. Ken Pfister photo courtesy of the diocesan archives.)

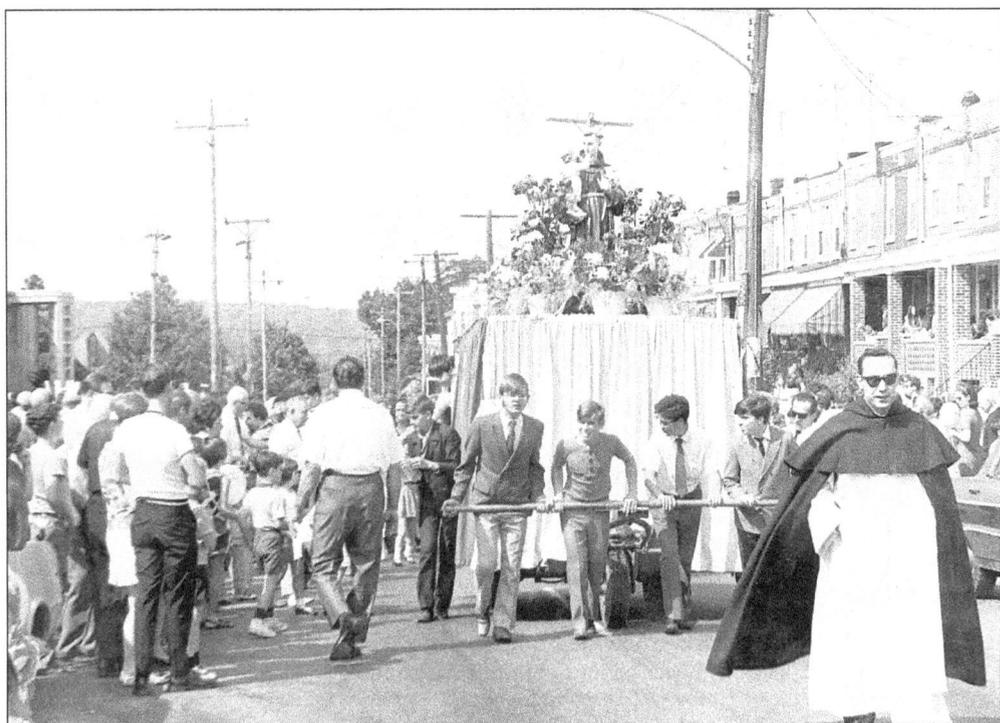

Members of St. Anthony of Padua Parish carry a statue of their patron saint through the streets of the Little Italy section of Wilmington. The annual procession on the Sunday nearest the saint's feastday in June closes the parish's week-long Italian festival, which dates from the 1930s and has become a major civic activity. (Photo from *The Dialog*.)

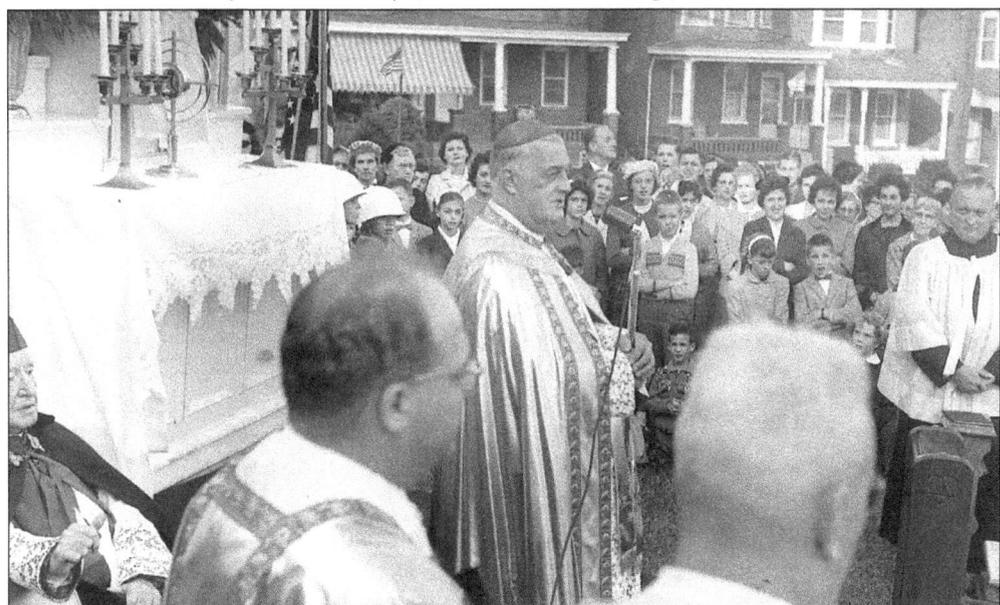

Bishop Hyle presides at an outdoor ceremony in 1961 marking the dedication of a new St. Elizabeth convent in south Wilmington. Benedictine Sisters have served the parish and its grade and high schools since they were established. (Courtesy of the diocesan archives.)

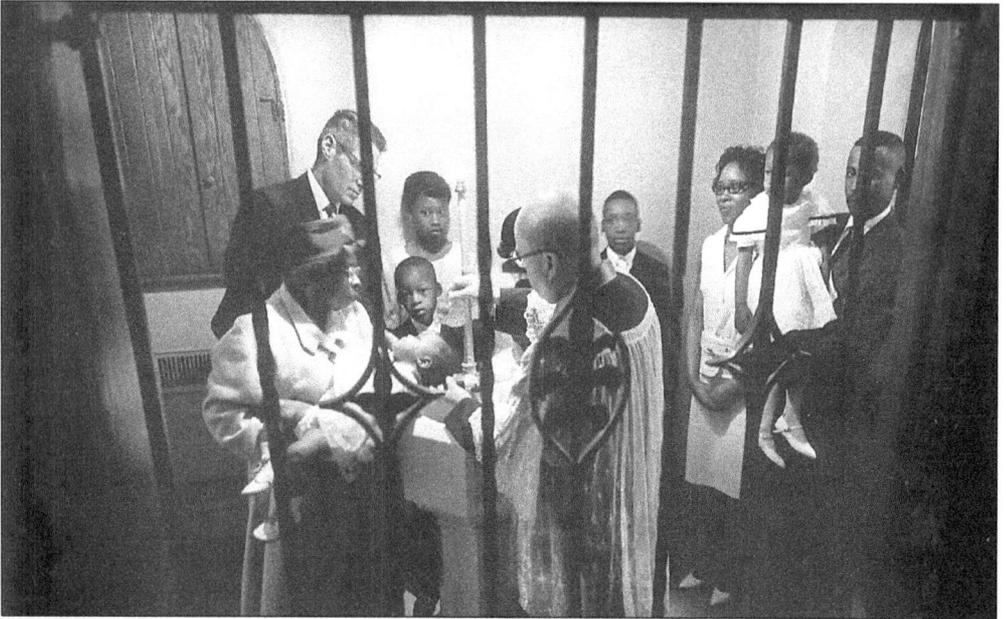

A new member is received into the Church through the sacrament of Baptism at St. Dennis Church in Galena. (George W. Gardner photo from *The Dialog*.)

Monsignor Paul J. Taggart (left), pastor of St. Paul Parish, Wilmington, and Father John R. Flinn (right), diocesan director of the Society for the Propagation of the Faith, talk with Maryknoll Bishop John Walsh outside the Visitation Monastery in west Wilmington. Bishop Walsh visited the sisters to thank them for their prayers during the many years he was imprisoned in Communist China. Before coming the diocese, Father Flinn also served as a Maryknoll missionary. (Courtesy of F. Eugene Donnelly.)

Monsignor Thomas J. Reese, a native Wilmingtonian ordained in 1948, was a staunch champion of equal rights and equitable treatment for all people regardless of race or economic status. He was shown in the national media marching arm-in-arm with Rev. Dr. Martin Luther King Jr. in the historic trek from Selma, to Montgomery, Alabama, in 1965. Monsignor Reese served as director of Catholic Social Services and the diocesan Social Concerns Department, taught at St. Mary's Seminary in Baltimore, and was a pastor. He died suddenly at Christmas time in 1988 at the age of 67.

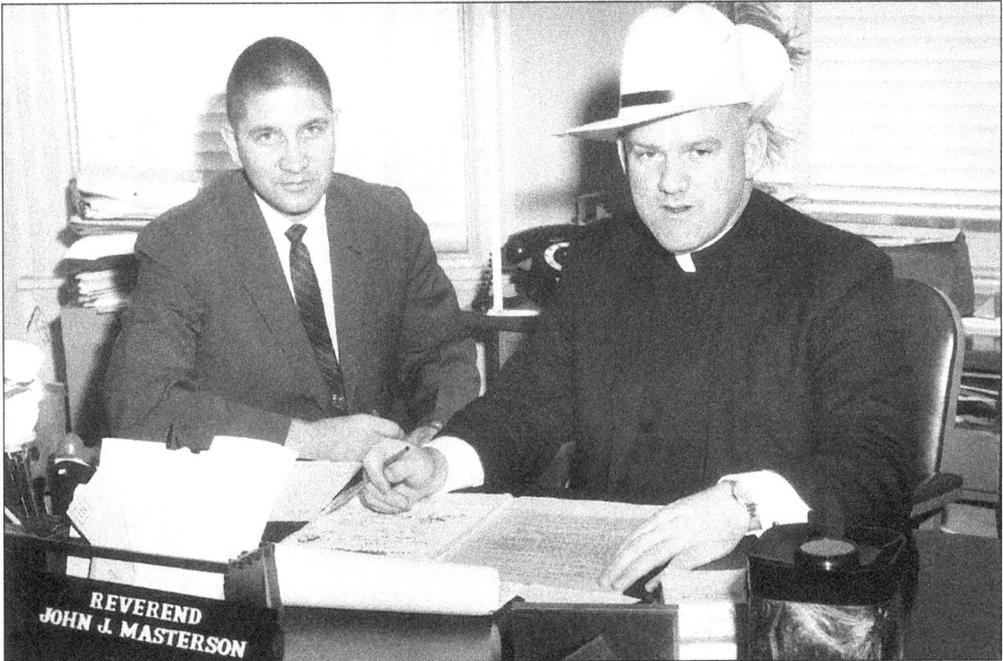

REVEREND
JOHN J. MASTERSON

Mr. William Kappa (left), program director, and Father John J. Masterson, diocesan director of the Catholic Youth Organization, are shown together in the 1960s. As a team, they greatly expanded the scope of the C.Y.O. Mr. Kappa, a St. Hedwig parishioner, went on to a long public service career as parks and recreation director for both the city of Wilmington and New Castle County. (Courtesy of the Office for Catholic Youth Ministry.)

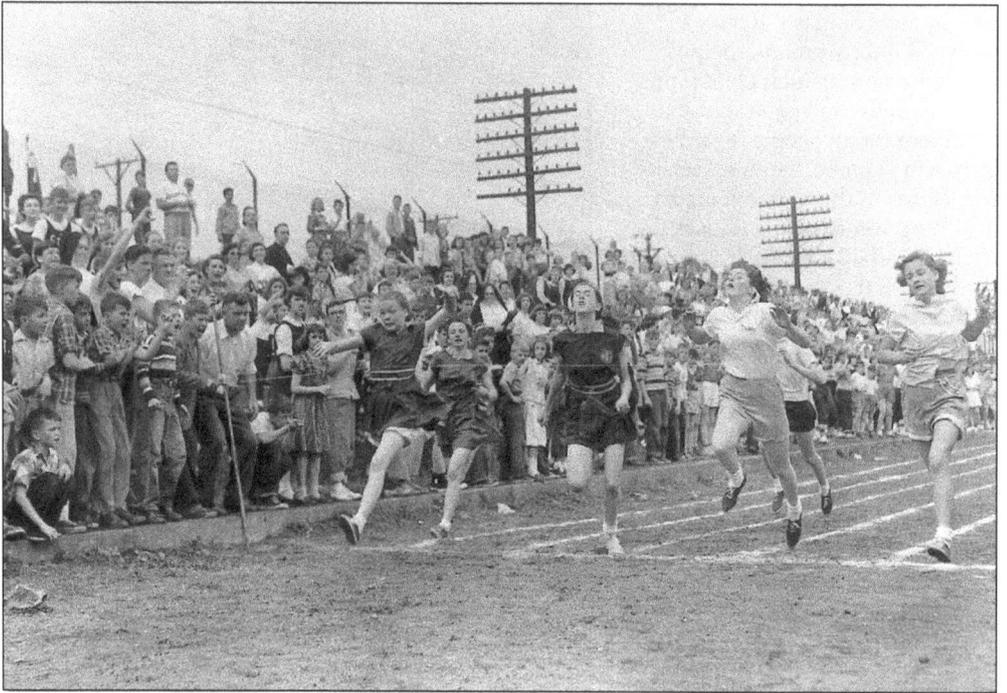

Girls representing several parishes and parochial schools put forth a final burst of energy at the finish line during a C.Y.O. track meeting in Baynard Stadium in Brandywine Park, Wilmington.

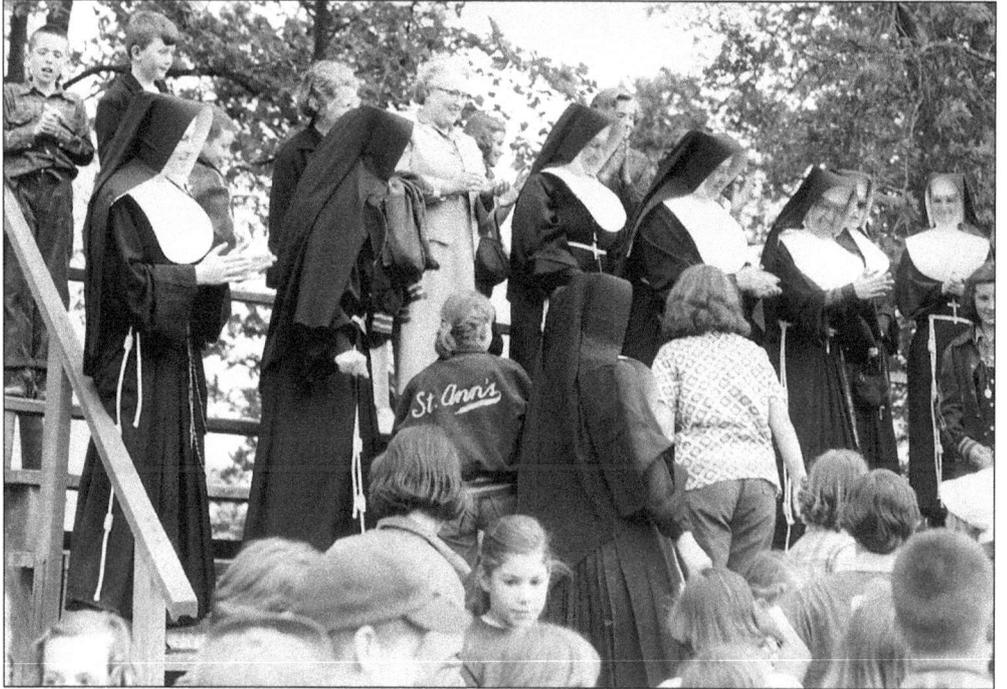

Up in the stands, Franciscan Sisters make up the core of an enthusiastic rooting section. (Both Gentrys Studio photos courtesy of the Office for Catholic Youth Ministry.)

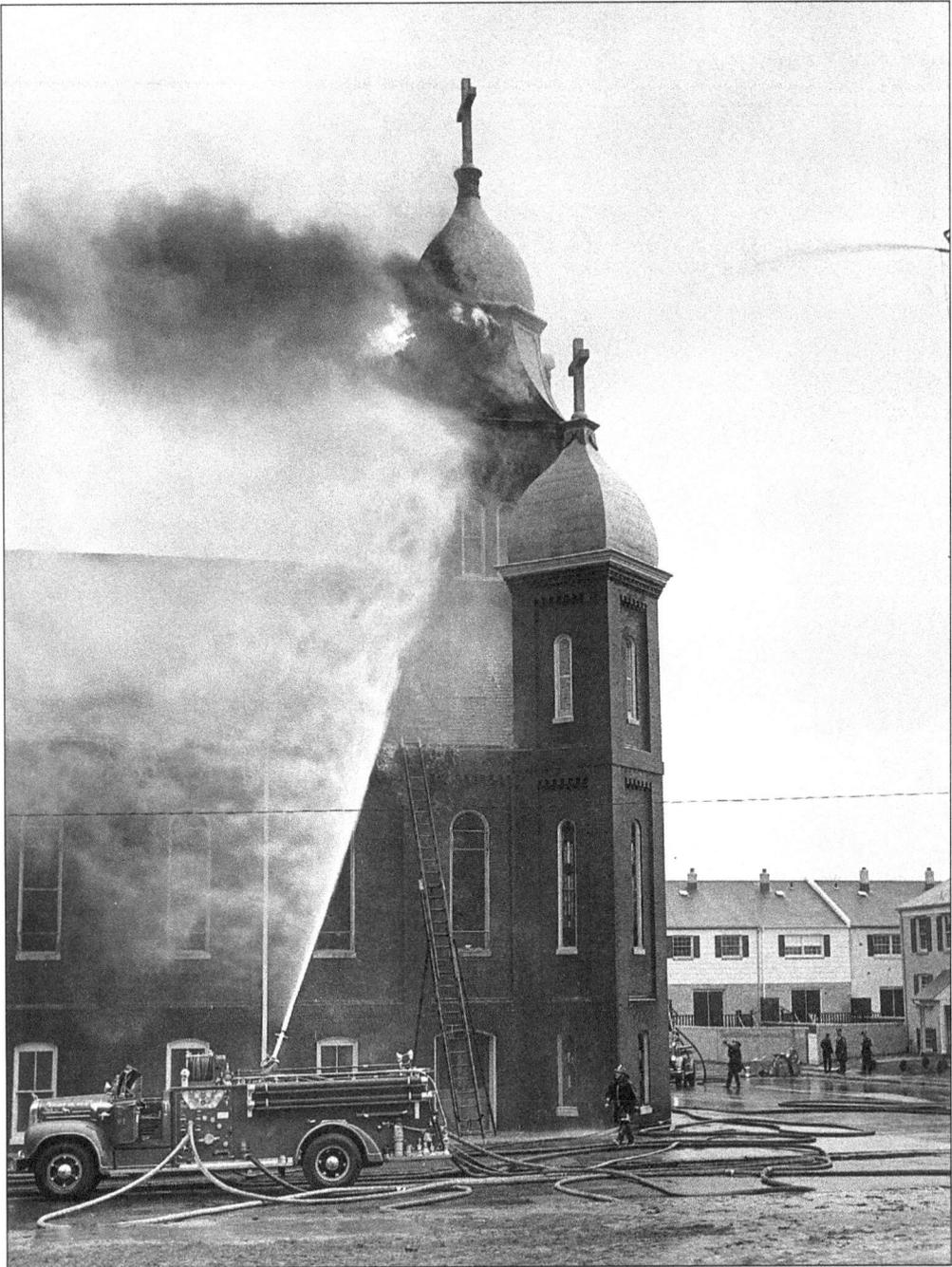

Wilmington firefighters battle a blaze in the steeple of historic St. Mary of the Immaculate Conception on the city's east side in the late 1960s. Although extensively damaged, the structure was saved. St. Mary's was consecrated in 1858 by St. John Neumann, then bishop of Philadelphia. In addition to having that distinction, the parish is believed to be the only one that boosts two parishioners who earned the Medal of Honor, the nation's highest decoration for valor. They were James P. Connor in World War II and Bernard McCarren in the Civil War. (Photo by Action.)

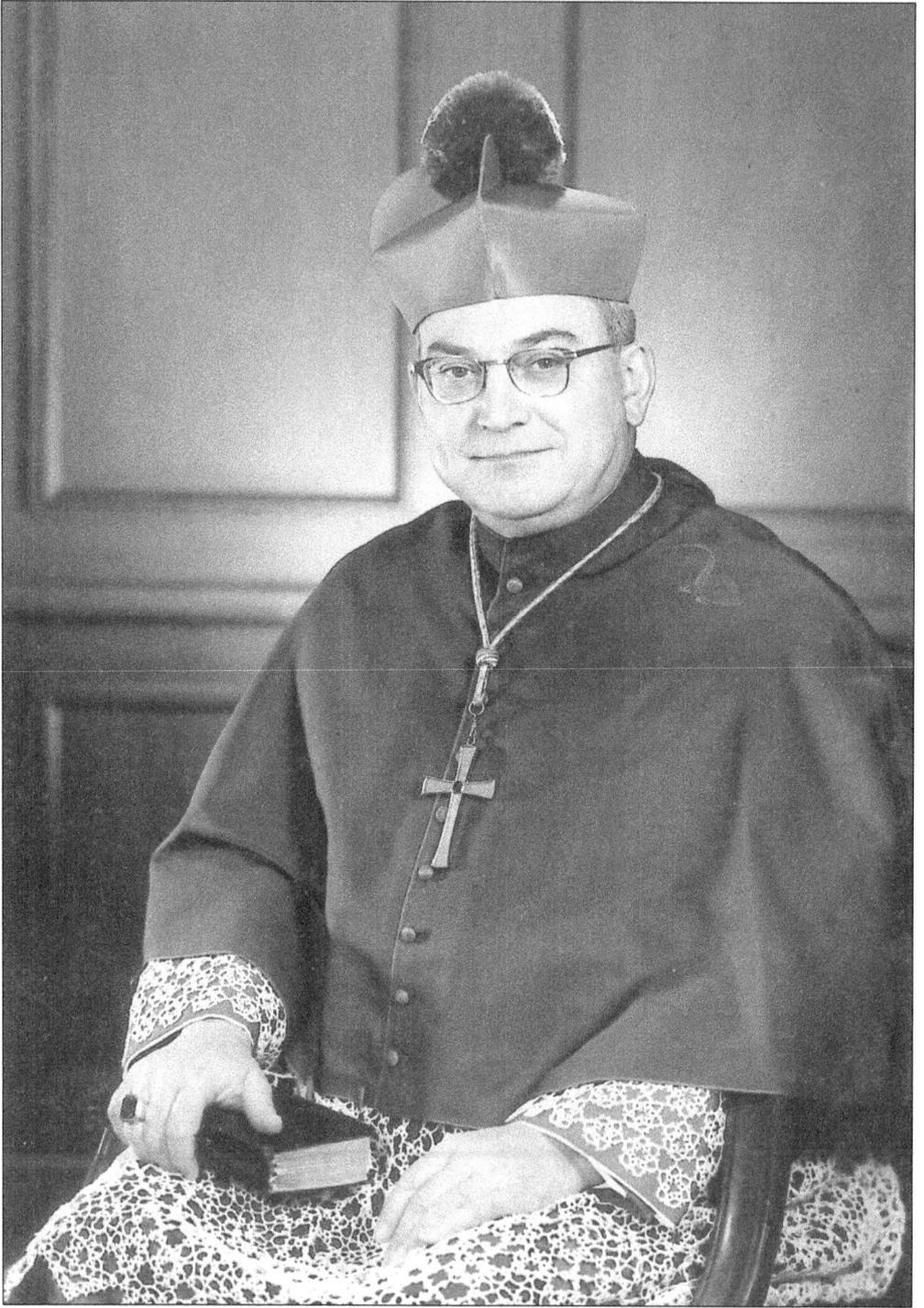

Bishop Thomas Joseph Mardaga was born in Baltimore, Maryland, on May 13, 1913, and ordained in Baltimore on May 14, 1940. Consecrated as auxiliary bishop of Baltimore and titular bishop of Mutugenna on January 25, 1967, he was installed as sixth bishop of Wilmington on April 6, 1968. He died on May 28, 1984. (Photo by Willard Stewart.)

Four

A TIME OF CHANGE

Bishop Mardaga bestows the blessing during a celebration of Benediction of the Blessed Sacrament in St. Mary Magdalen Church near Talleyville. (Philip A. Toman photo courtesy of the diocesan archives.)

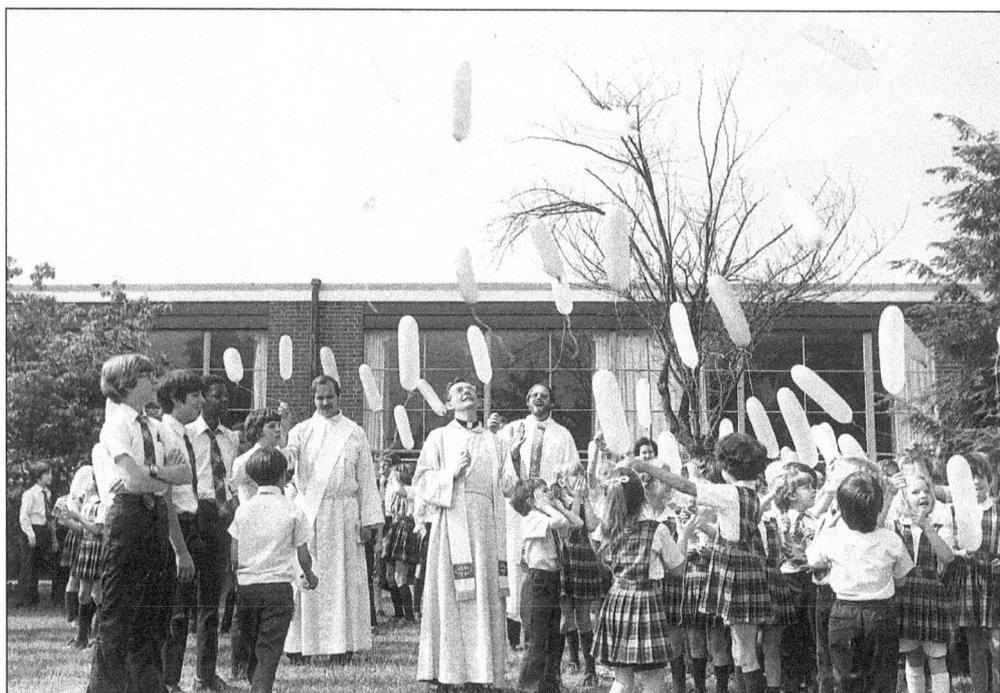

The Gospels don't say that Jesus returned to His Father in this way, but He might have. First-and second-grade students at Ss. Peter and Paul School in Easton allow helium-filled balloons to ascend skyward following their Ascension Thursday liturgy in 1977. Each balloon contained a "Good News" message the children had written. (Gene Donnelly photo from *The Dialog*.)

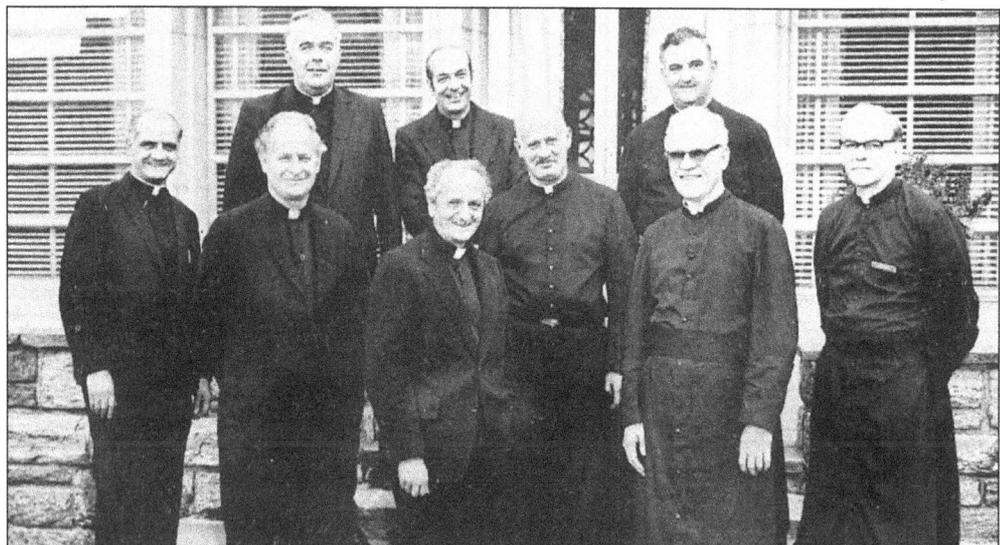

These Oblates of St. Francis de Sales staffed St. Anthony of Padua Parish and schools at the time of the 1979 celebration of the 50th anniversary of the parish's founding. Pictured are Fathers Roberto Balducelli, pastor; William J. Keech, religious superior; Vincent de Paul Burke; Joseph F. Niedermaier; James V. O'Neill; Mario Buguliosi; and John Gavin; and Brothers Michael Rosenello and Francis Konstanty. (Photo from the St. Anthony of Padua Parish golden jubilee booklet.)

A Catholic church wouldn't be truly catholic unless it hosted a Bingo game now and then. This one, for senior citizens, took place at St. Catherine of Sienna, near Prices Corner. (Photo from *The Dialog*.)

Father Daniel W. Gerres, pastor, explains the significance of Mardi Gras as a prelude to Lent at a paraliturgical service at Resurrection Parish. The 1977 celebration for pre-school and kindergarten children was held the evening before Ash Wednesday and included songs, a film, prayers, and a parade. It was organized by the Christian Formation Program at the Mill Creek Hundred parish. (Photo from *The Dialog*.)

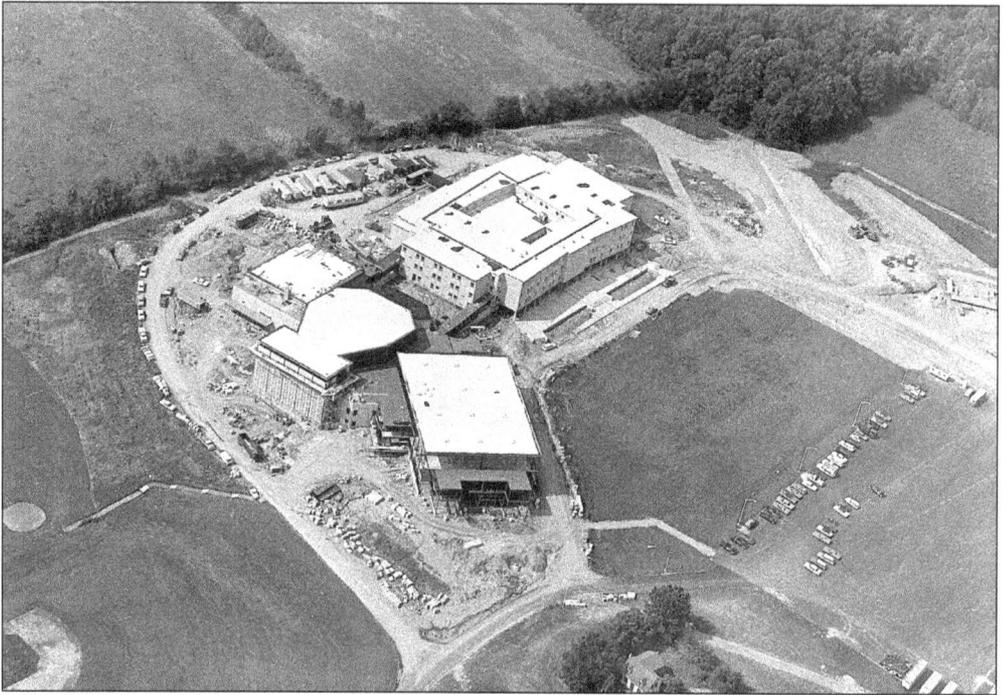

The nearly finished St. Mark High School is pictured here in 1969. It was the first secondary school to be conducted under diocesan auspices and was staffed by members of several religious orders as well as laypersons. It opened with few amenities, which led students to adopt a sports nickname which reflected their "Spartan" existence. (Photo from *The Dialog*.)

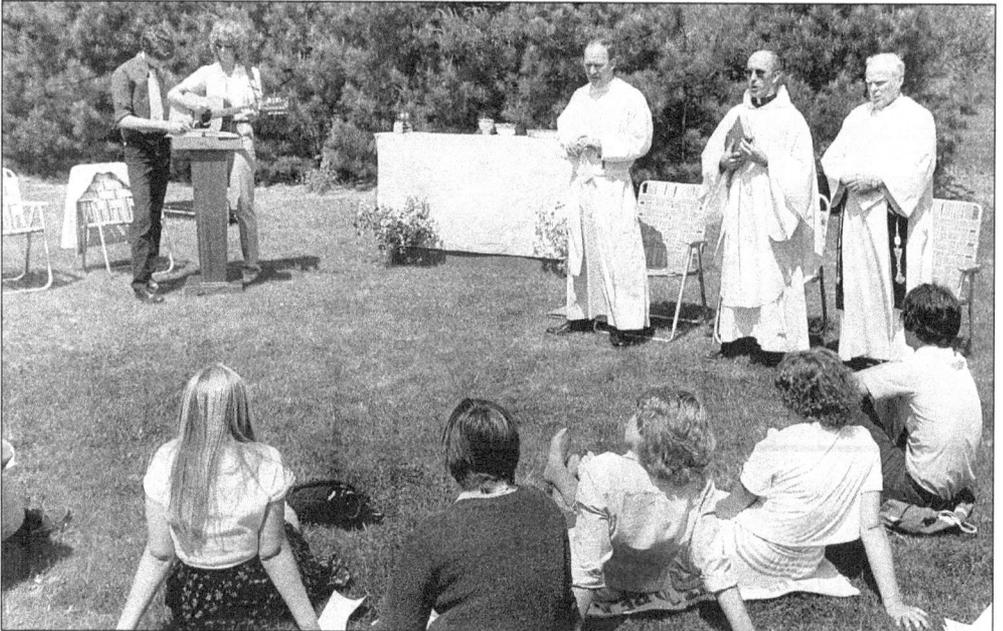

St. Mark's students participate in an outdoor Mass on the spacious campus behind All Saints Cemetery off Kirkwood Highway in Mill Creek Hundred soon after the school opened. (Photo from *The Dialog*.)

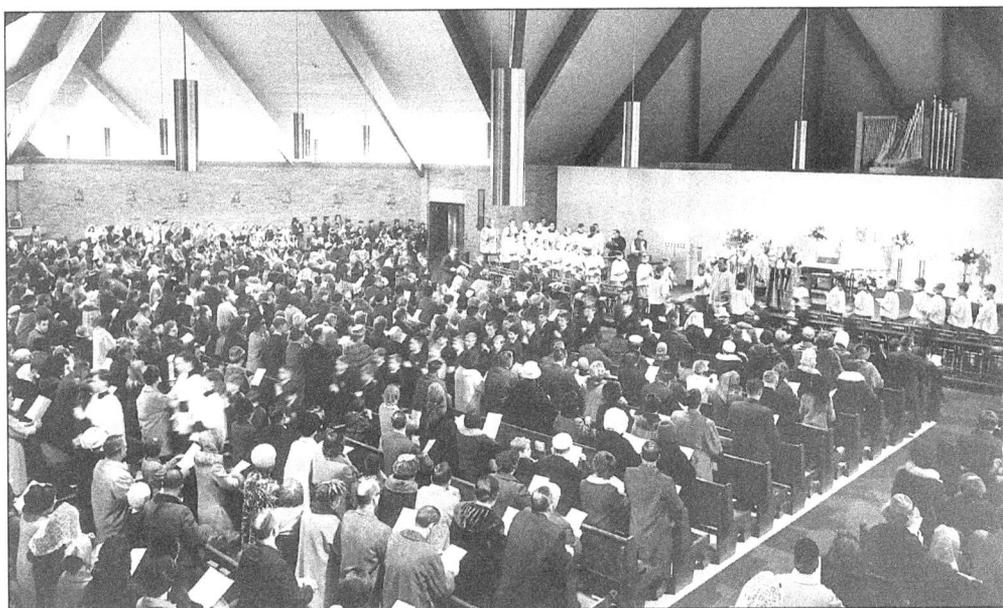

The dedication of St. Mary Magdalen Church on Concord Pike near Talleyville took place in 1968. Built soon after Vatican II, the church was the first in the diocese designed to conform with the new liturgical practices promulgated by the ecumenical council. (Photo by Action.)

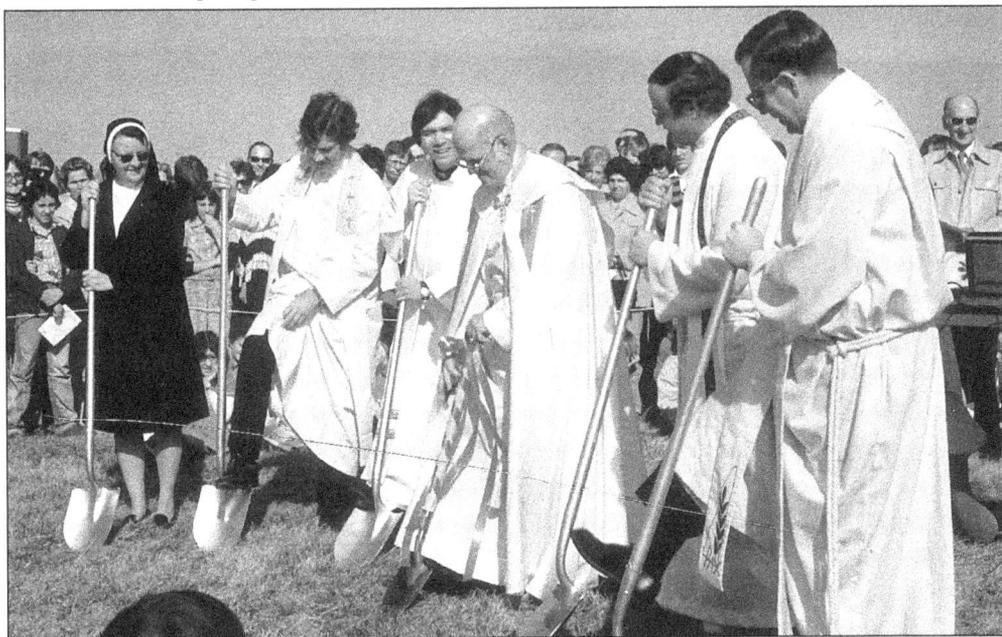

Father John J. Masterson, center, pastor of St. John the Baptist-Holy Angels Parish, breaks ground for Holy Family Church at the intersection of Chestnut Hill and Gender Roads, near Newark, in 1977. Assisting are, from left to right, Franciscan Sister Rita Mary and Fathers John M. Hynes, Michael Angeloni, Clemens D. Manista, and Clement P. Lemon. Established as an extension of St. John-Holy Angels to serve the Bookside-Ogletown area, Holy Family was designated as a separate parish 1979 and became independent of the mother parish in 1983. (Courtesy of Holy Family Parish.)

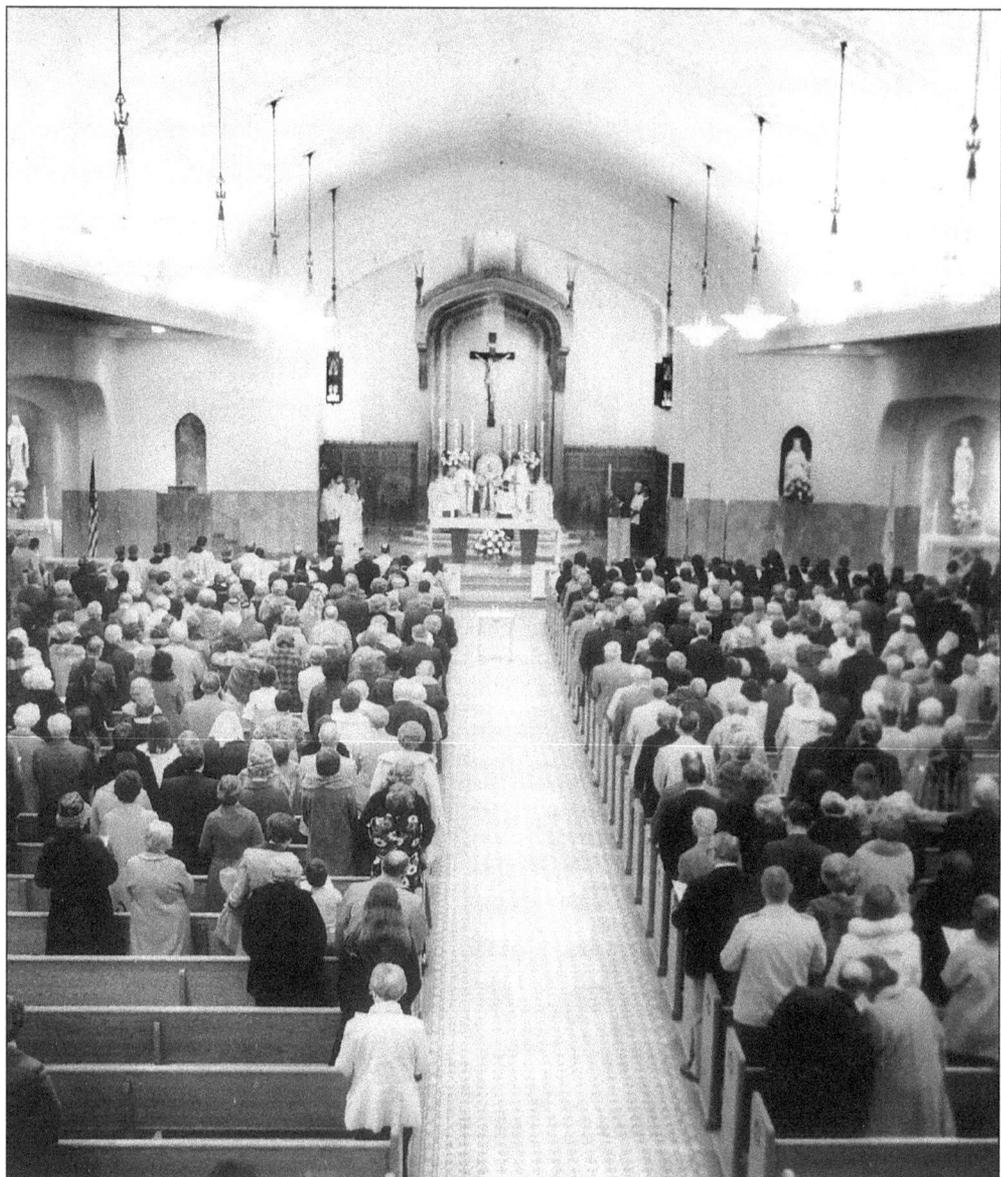

Parishioners, present and past, assemble in 1976 for Mass commemorating the golden jubilee of the founding of Christ Our King Parish. (Courtesy of Christ Our King Parish.)

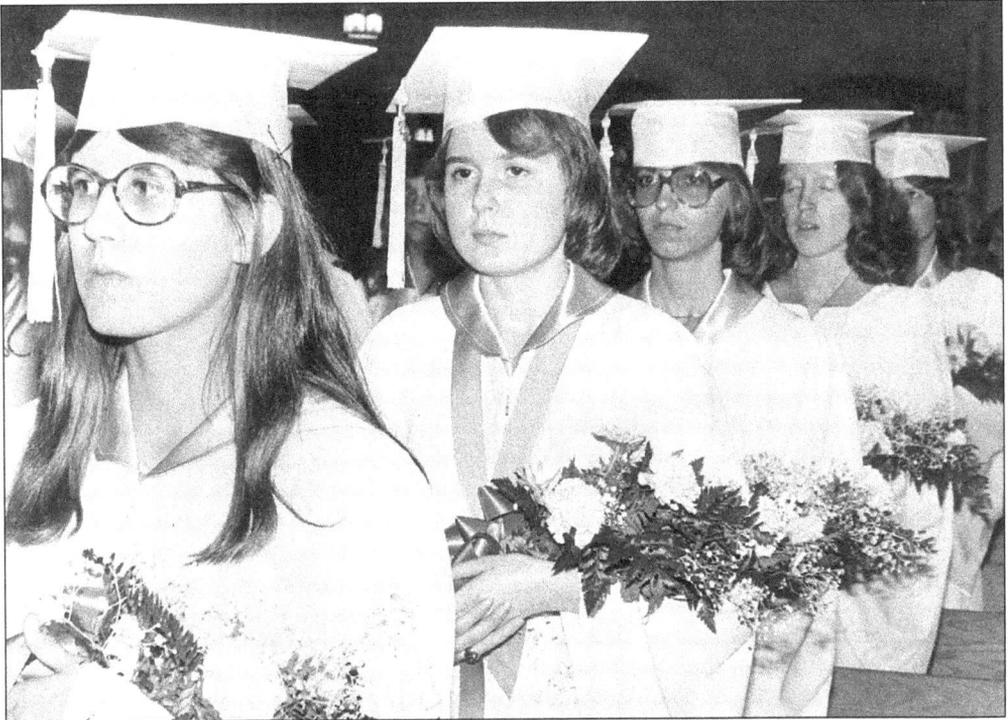

Members of the last graduating class of St. Hedwig High School process to their commencement in 1978. Eighteen young ladies received diplomas, and Sister Mary Michaelita, principal, presented academic awards. Miss Theresa Okoniewski was valedictorian; Miss Linda Mondzelewski was salutatorian. (Photo from *The Dialog*.)

Co-education reached Archmere Academy in 1975, and young ladies quickly found their niche on the formerly all-male Claymont campus. Here they participate in a session in the Spanish language laboratory. The faculty also became gender-neutral at about that time. (Courtesy of the Archmere Academy development office.)

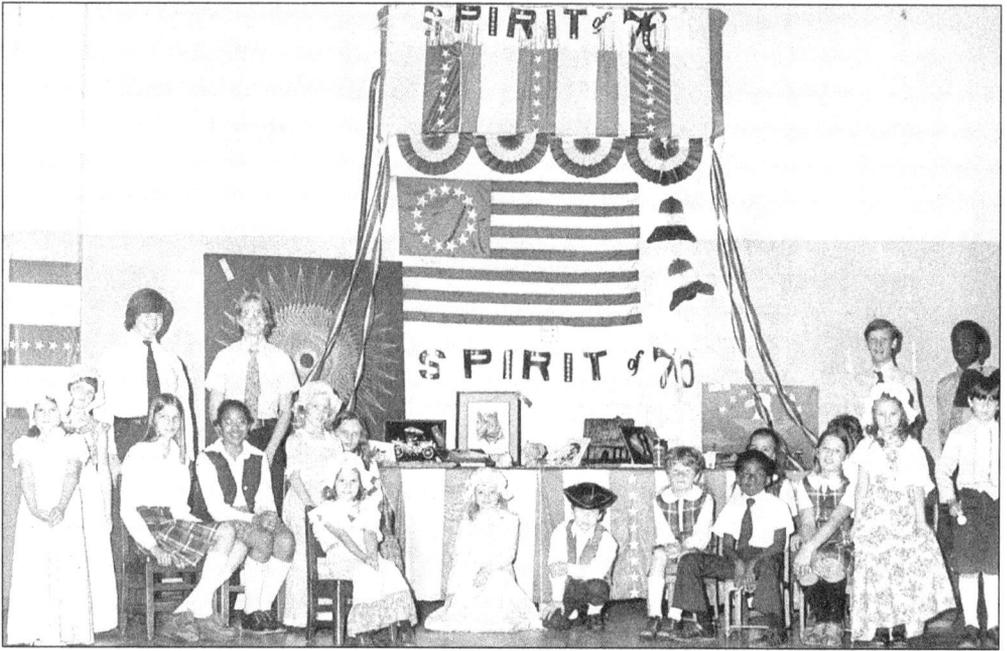

The 1976 Bicentennial of the Declaration of Independence and birth of the nation provided the occasion for celebrations of all kinds. Students at Holy Spirit Parochial School in Garfield Park presented a colorful costumed pageant. (Photo from *The Dialog*.)

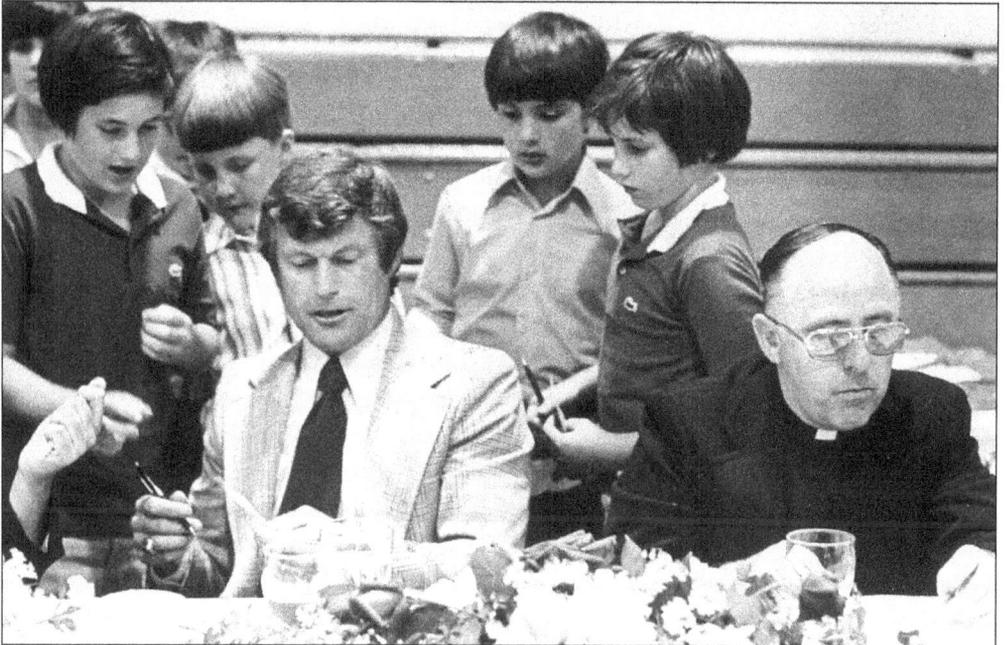

Autograph-seeking boys descend on Philadelphia Eagles head coach Dick Vermeil at the 1977 St. Edmond's Academy sports banquet. The affair was sponsored by the Dad's Athletic Association, which provides volunteers for an extensive extracurricular sports program. Mr. Vermeil, then at the height of his professional football prominence, brought an inspirational message to the dinner. (Photo by Keith Brofsky.)

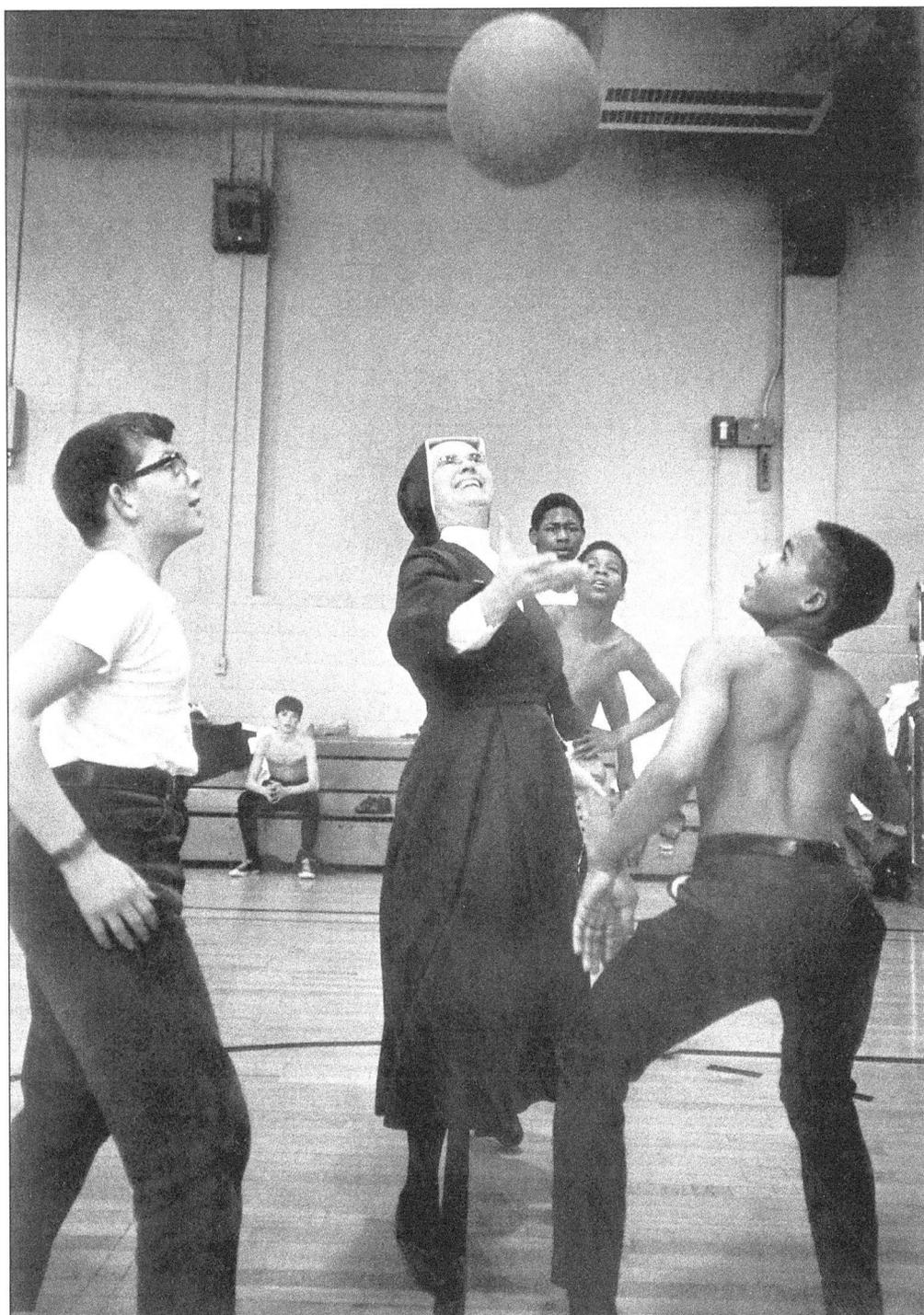

Sister Zoe Wheeler tosses a jump ball while refereeing an intramural basketball game at St. Peter's Cathedral School. A Daughter of Charity, Sister Zoe was a first-grade teacher when this photograph was taken. She returned to the school in the 1980s as principal. (Photo from the Daughters of Charity archives.)

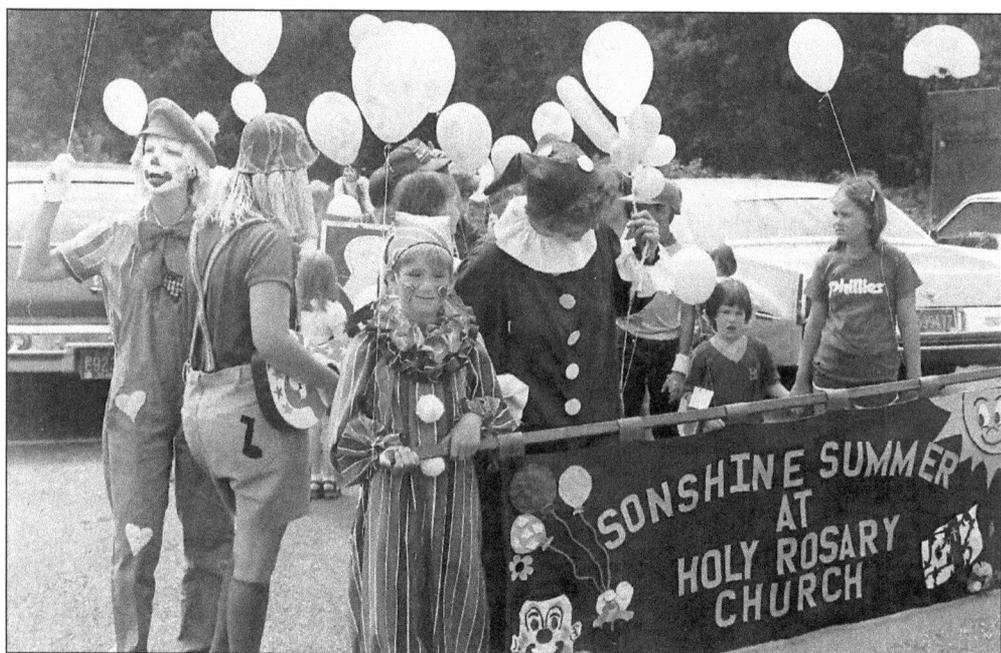

Children dressed as their "favorite thing" paraded through the neighborhood at the end of Sonshine Summer, a two-week Bible school at Holy Rosary Church in Claymont in 1981. (Photo from *The Dialog*.)

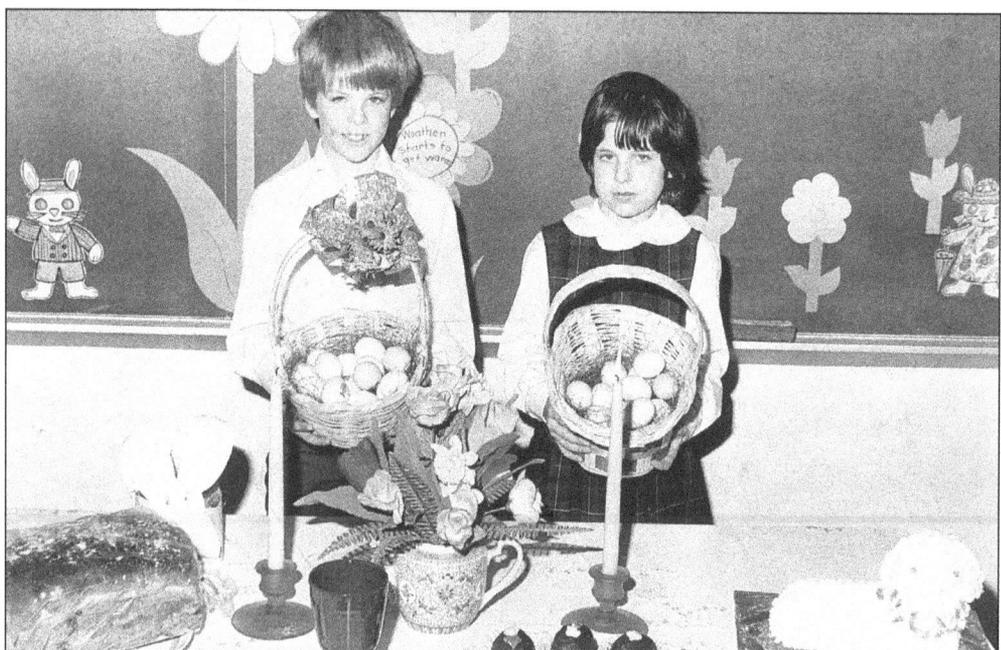

Thomas Dukes and Paula Oliva, students at St. Thomas the Apostle School, display baskets of dyed eggs, a significant component of a 1982 "Celebration of New Life" at the school. During the traditional Easter event, first- and second-graders adorned a table with as many signs of new life as they could find. Along with the eggs were a cake designed to portray a lamb and sweet bread. (Photo from *The Dialog*.)

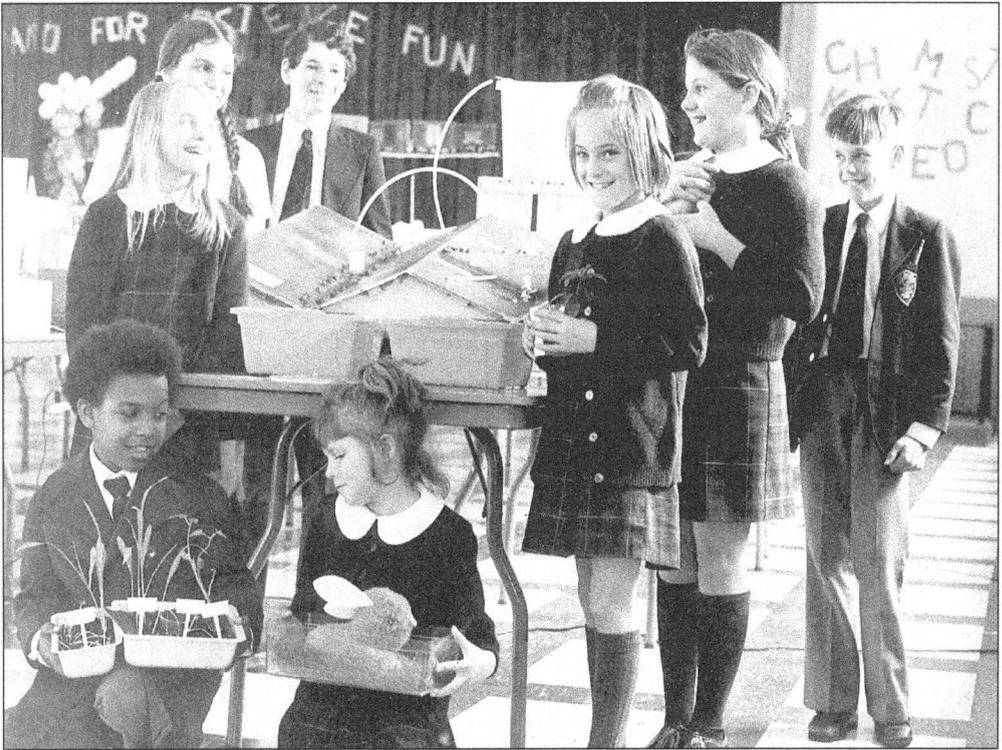

Students of St. John the Beloved School, Sherwood Park, show off some of the winning exhibits during a 1975 science fair. Every youngster from kindergarten through eighth grade participated and all received a certificate for doing so from Sister Rita Thomas, principal. The array of subject matter was impressive, including as it did studies on vibration, tornadoes, optical illusions, and tree prints. (Photo from *The Dialog*.)

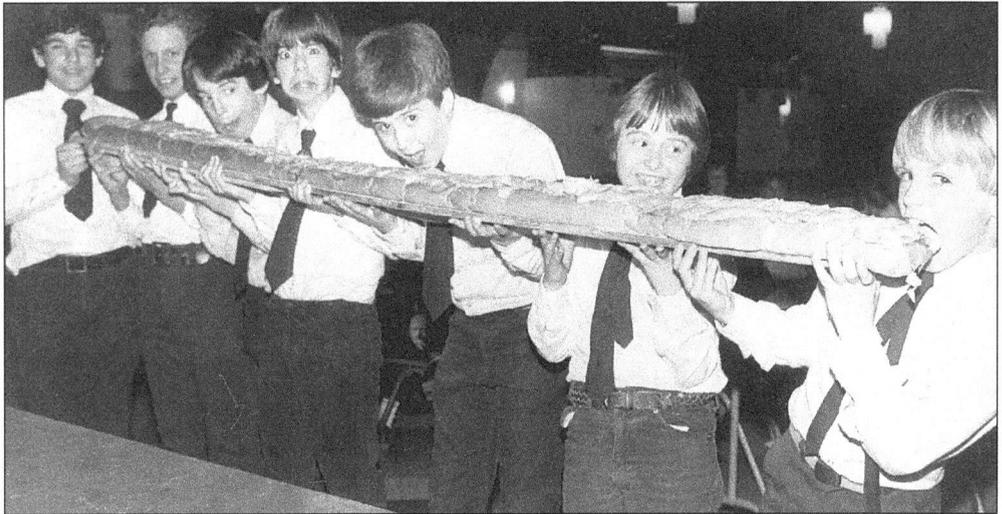

Submarine sandwiches are a time-honored culinary icon in Delaware. While they come in various sizes to match the consumer's appetite, when they get to be this long, they require sharing with the crowd. These students at a 1980 St. Ann's Parochial School fund-raiser demonstrate one way to do that. (Photo from *The Dialog*.)

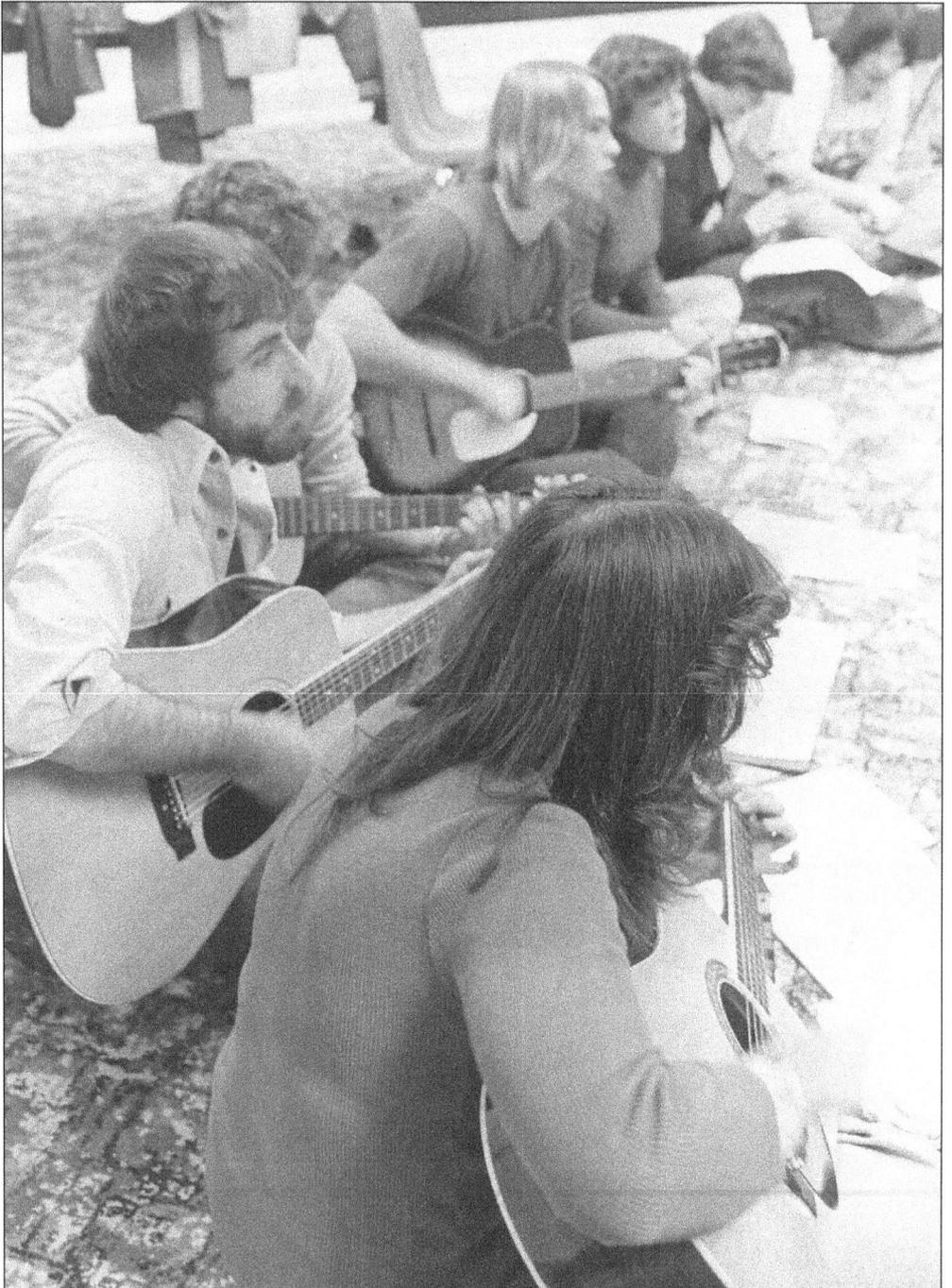

Guitars and sharing were the major elements at weekly gatherings of St. Matthew Parish's Confraternity of Christian Teens during the 1970s. Led by coordinator Mrs. Toni Pennington and assistant pastor Father Sean Turley, the young men and women devoted their get-togethers at the Woodcrest parish to chatting, laughing a lot, singing, praying, and learning. The confraternity also took on several community service projects. (Kathleen M. Graham photo from *The Dialog*.)

Parishioners and friends of St. Mary, Refuge of Sinners, Parish, ages 12 to 27, rehearse a scene from *Godspell* prior to a 1983 staging of the rock musical. When approached by Mr. Gregory Lenz, who supervised care of the church lawn, Father James P. Eckrich, pastor, agreed that the project would be a good way to raise money for the Cambridge parish's youth program.

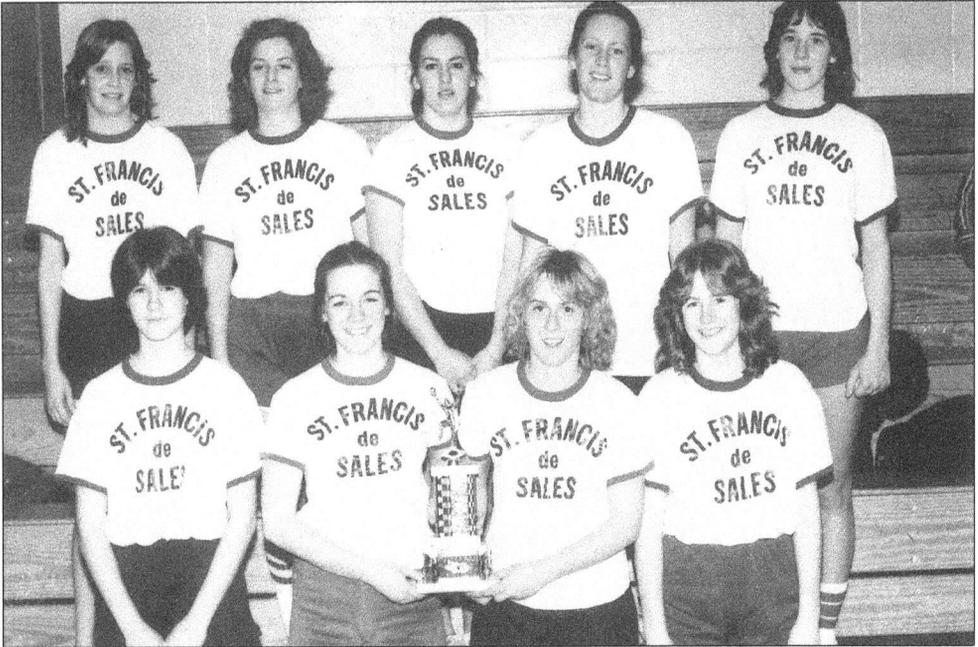

St. Francis de Sales girls basketball team displays the trophy it won in the 1981 Wicomico County Church League playoffs. Team members are, from left to right, (front row) Joan Yascko, Michele Yascko, Valerie Payne, and Margaret Yascko; (back row) Darla Young, Victoria Hochmuth, Terry Colegrave, Terri Rose, and Joan Banks. Linda Brader was not present when the photograph was taken.

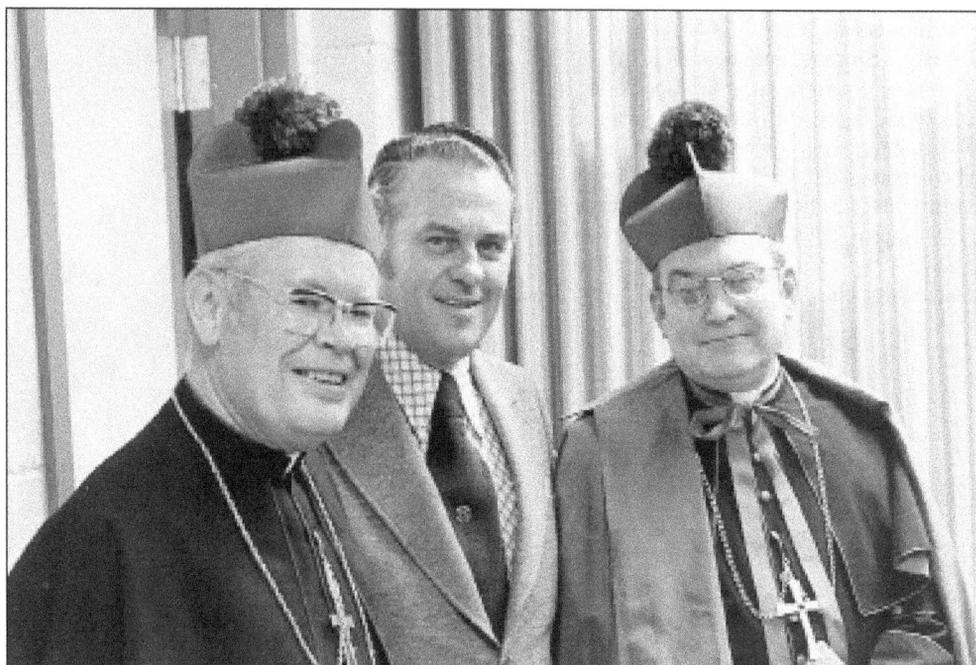

Bishop Mardaga (right), Archbishop William Borders of Baltimore (left), and Delaware Governor Sherman W. Tribbett are seen together on the occasion of St. Mark High School's first graduation ceremony in 1973. (Courtesy of the diocesan archives.)

Father Justin Diny, headmaster of Archmere Academy, converses with U.S. Senator William V. Roth Jr. at a communion breakfast at the school during the 1970s. (Courtesy of the Archmere Academy development office.)

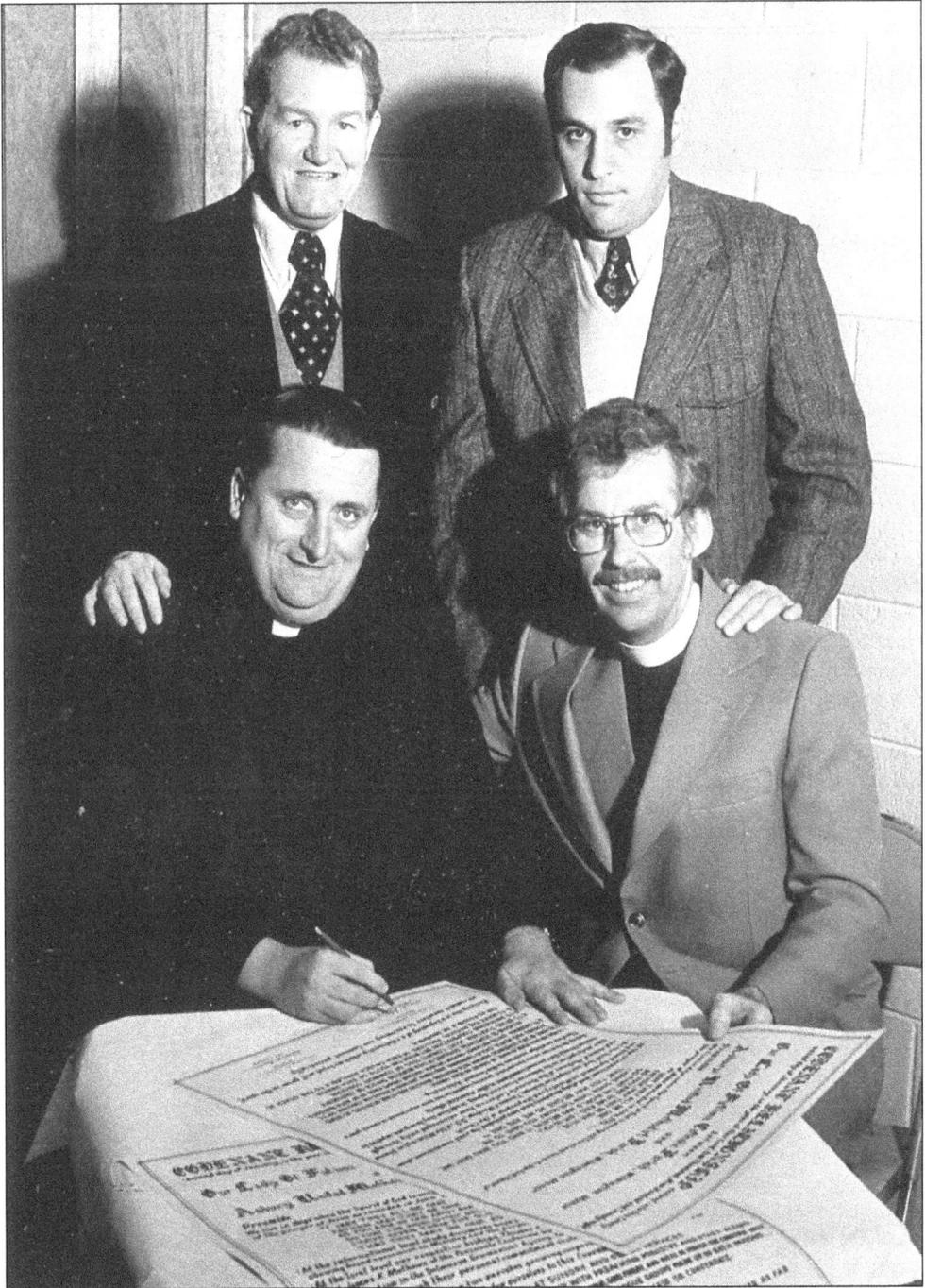

Representatives of Our Lady of Fatima Parish and Asbury United Methodist Church are pictured at the signing in 1978 of a covenant pledging cooperation between the two Wilmington Manor congregations. Participating in the occasion, believed to be a first of its kind in the United States, are Father John F. O'Brien, Fatima pastor (seated, left); Rev. Thomas C. Short of Asbury (seated, right); Mr. Delvin Burns, Asbury lay leader (standing, left); and Mr. Henry Metz, president of Fatima's Parish Council (standing, right). (Photo from *The Dialog*.)

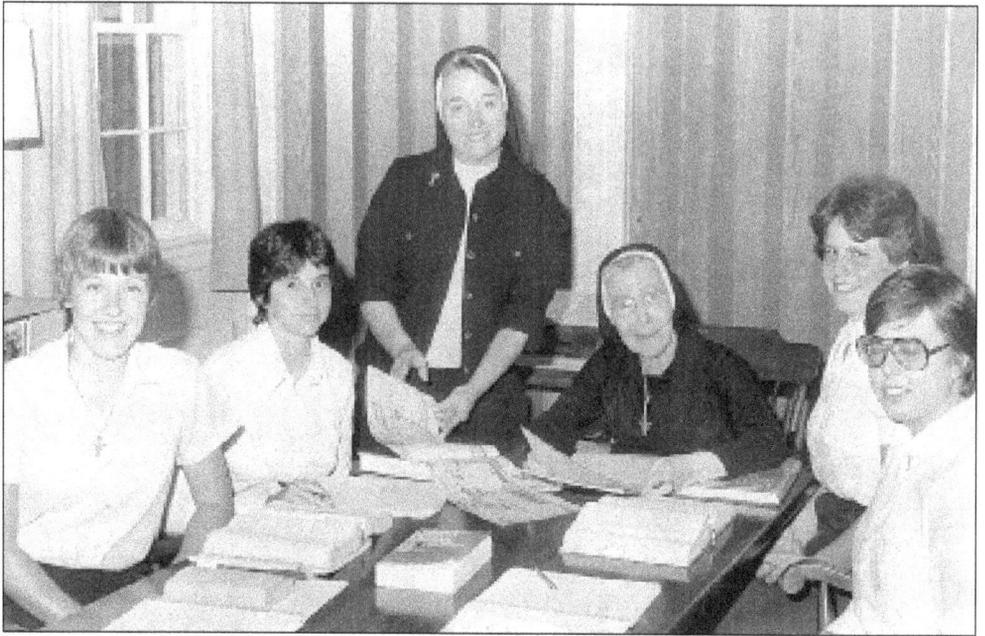

Franciscan novices are in a Scriptures class at St. Catherine of Siena Convent in Christiana Hundred, where the order established a first-year formation house in the 1980s. Sister Angela DeFontes (standing) said moving the training of prospective sisters from the motherhouse in Aston, Pennsylvania, after nearly 100 years, brought "women of the church . . . closer to the local church." Seated, from left to right, are novice Sisters Mary Bernadette O'Connor and Christine Still, Sister Clotilda Schmidt, and novice Sisters Deborah Crist and Donna Marie Bridickas. (Photo from *The Dialog*.)

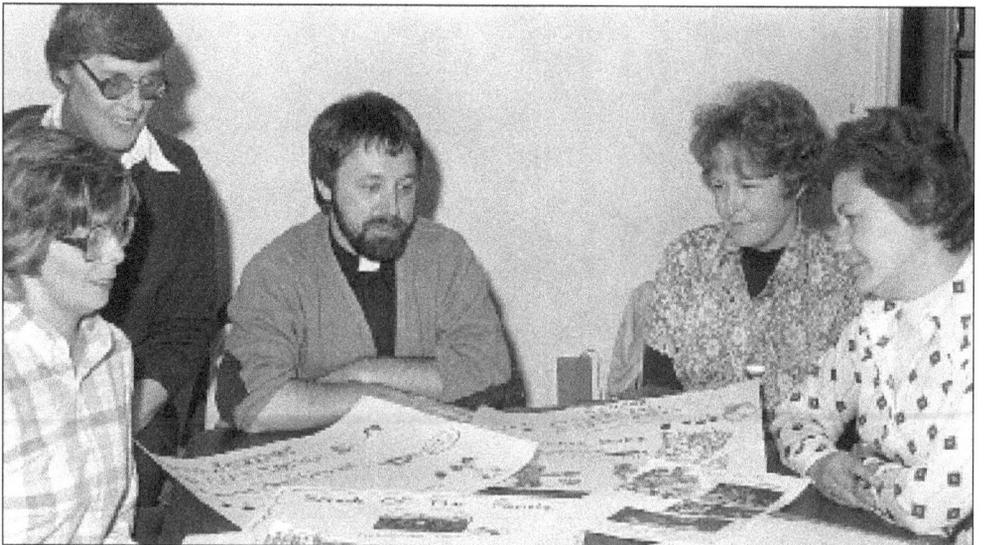

Members of Sacred Heart Parish judge a "Sounds of the Family" poster contest in preparation for a 1981 family life conference sponsored by the Chestertown parish. Sessions were arranged for participants of all ages from six through adult and were followed by dinner. Judges are, from left to right, Ms. Ruth Ann Freeman, Bernadette Stenger, associate pastor Father Raymond Weisman, Jane Spray, and Pat Clarke.

Delaware Governor Pierre S. du Pont IV presents a proclamation declaring April 24, 1983, as St. Vincent de Paul Day, commemorating the 150th anniversary of the founding of the St. Vincent de Paul Society. Mr. Paul Collins, president of the society's Council of Wilmington (left), and Mr. Michael Hofster accept the document. The society, which has been aiding the needy in the diocese since it was established in 1868, presently has 26 active conferences here. (Action photo courtesy of Mr. Collins.)

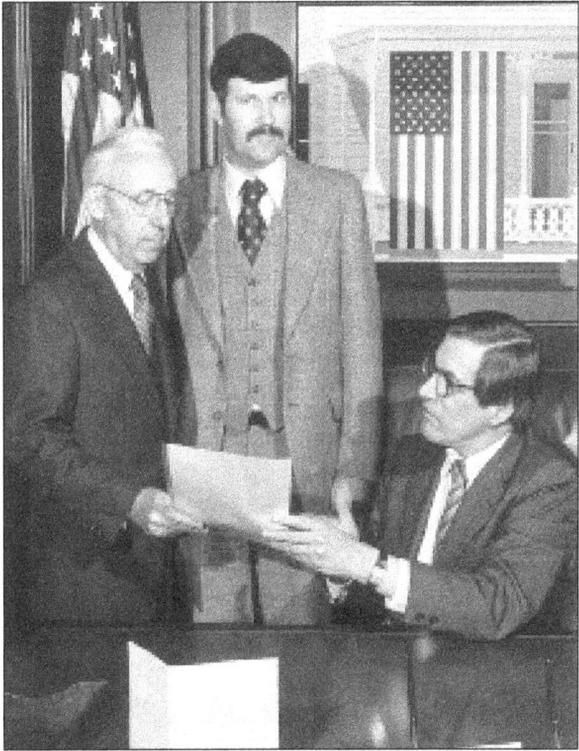

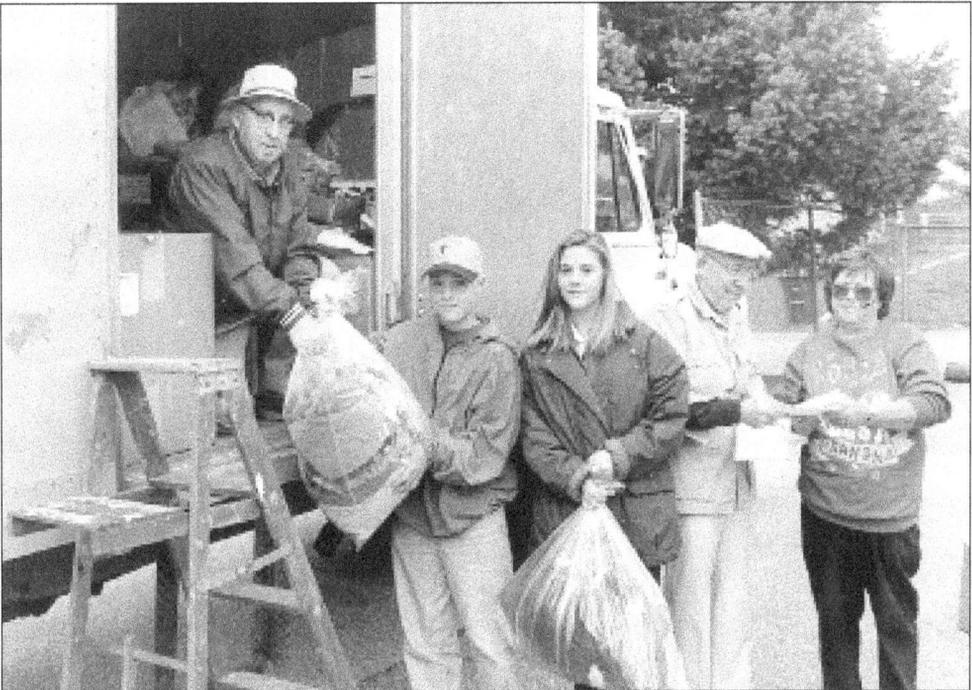

Parishioners load donations for the St. Vincent de Paul Society aboard a truck in the parking lot at Our Lady of Fatima Church, on Du Pont Parkway in Wilmington Manor, during a clothing drive in 1993. (Courtesy of Our Lady of Fatima Parish.)

An angel leads a couple of honorary saints from St. Thomas the Apostle Church in west Wilmington on All Saints Day in 1979. Reversing the practice of applying a secular veneer to the Christian holyday with costume parades on Halloween—All Hallows Eve—several parochial schools took on the practice of providing children the opportunity to impersonate real heroines and heroes on their joint feast day. (Photo from *The Dialog*.)

And not to be left behind, St. John the Beloved Parish turned out more saints for a paraliturgical celebration. Leading the procession are St. Rose of Lima (a.k.a. first-grader Kerry Hutchison) and St. Peter (classmate John Speakman). (Jim Grant photo from *The Dialog*.)

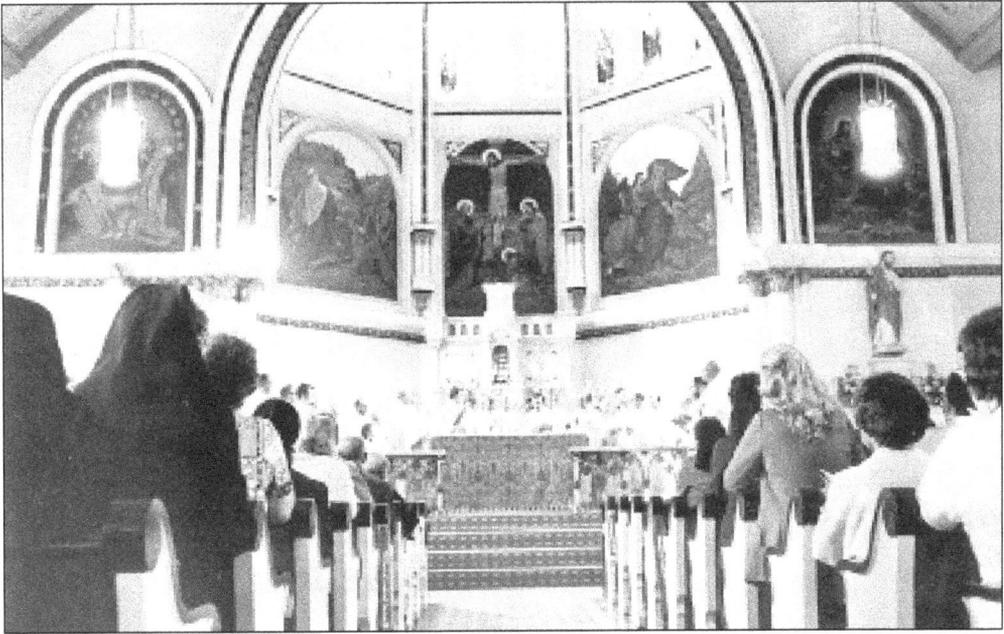

People worship at a concelebrated Mass in Sacred Heart Church at Tenth and Madison Streets in downtown Wilmington. The parish was founded in 1874 to serve primarily the city's German-American population. Throughout its history, it was staffed by Benedictine priests. When the order withdrew in 1996, the parish was officially dissolved. The landmark brick building, however, has been preserved as part of Sacred Heart Village, an inner-city residential community intended to provide affordable housing for the elderly. This photograph was taken in 1977. (Photo from *The Dialog*.)

Statues of St. Joseph and the Blessed Mother were scarred but salvaged after a 1981 fire destroyed St. Agnes Church in Rising Sun. Declared a total loss, the historic building had to be torn down after having served the community for about 90 years. The present church, a brick building erected in 1983, serves as a mission of the Church of the Good Shepherd in Perryville. (James Cheeseman photo from *Cecil Whig*.)

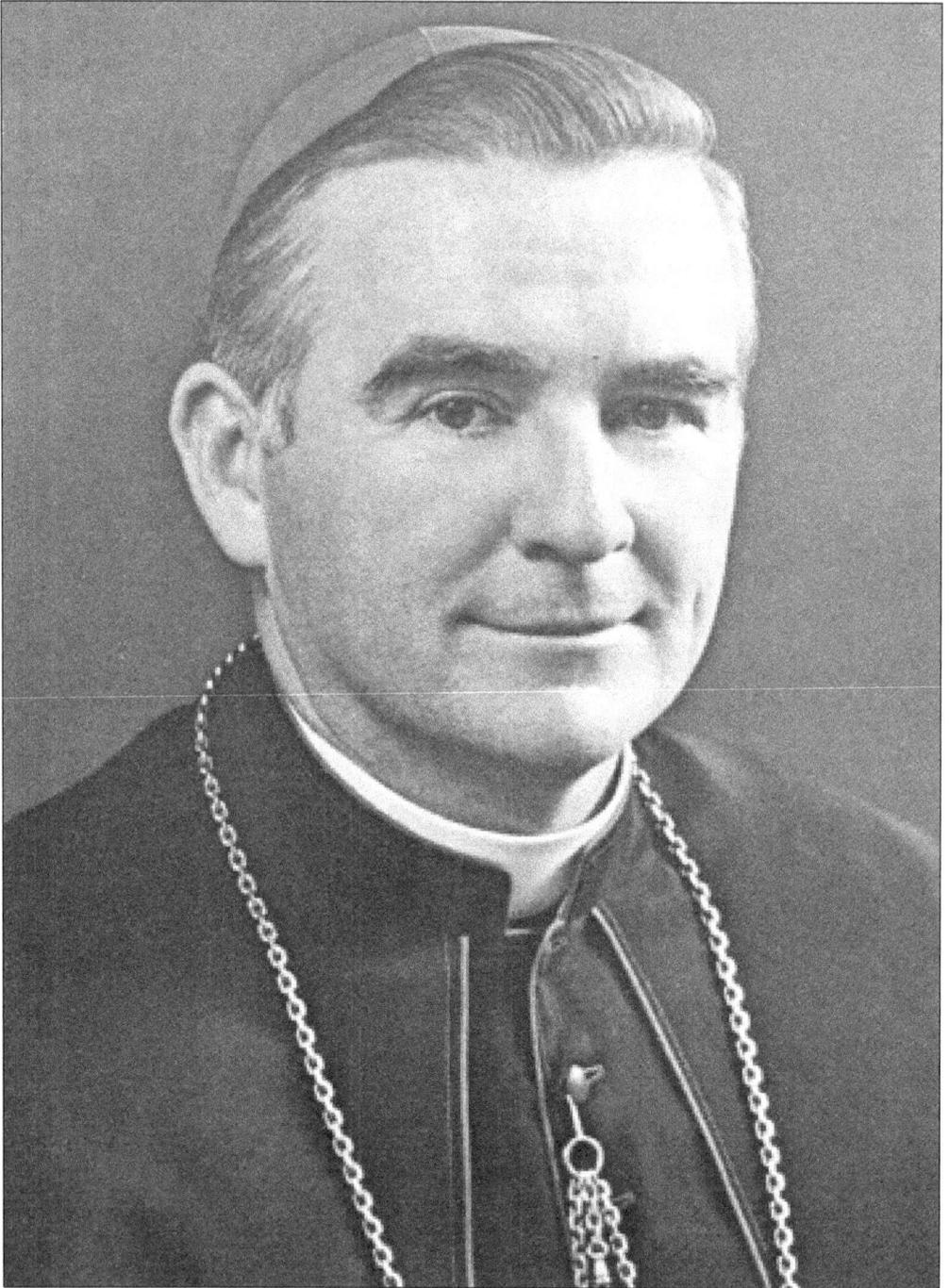

Bishop Robert Edward Mulvee, born in Boston, Massachusetts, on February 15, 1930, was ordained in Louvain, Belgium, on June 30, 1957. He was consecrated as auxiliary bishop of Manchester, New Hampshire, and titular bishop of Summa on April 14, 1977, and installed as seventh bishop of Wilmington on April 11, 1985. On February 7, 1995, he was appointed coadjutor bishop of Providence, Rhode Island, and on June 11, 1997, he was installed as seventh bishop of Providence.

Five

THE PEOPLE OF GOD

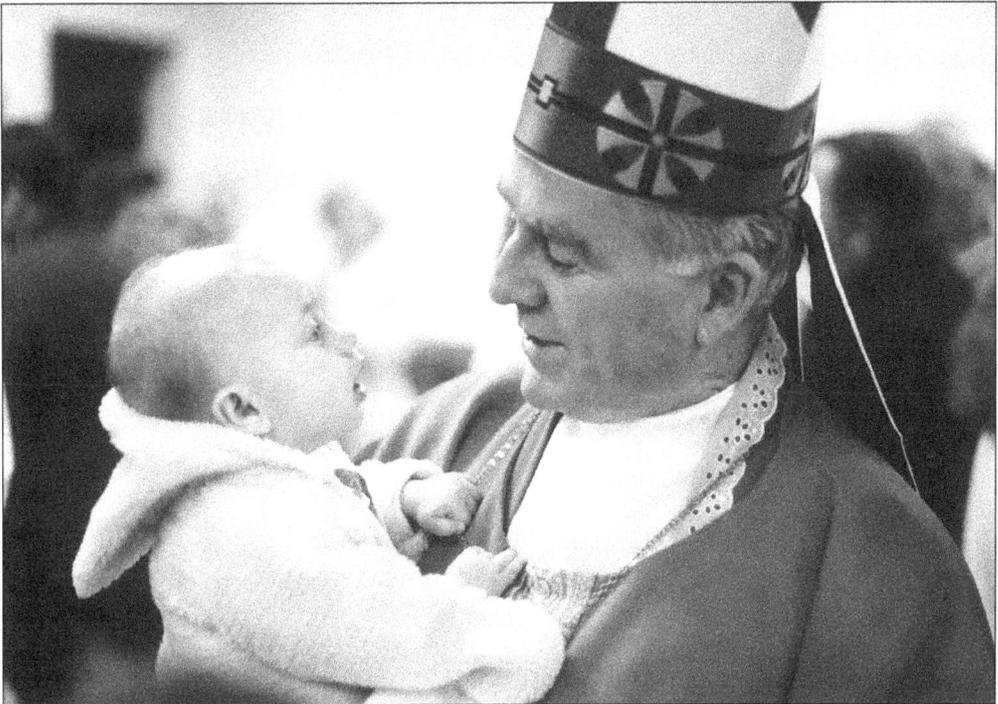

Bishop Mulvee bonds with a young parishioner after conferring the sacrament of Confirmation at Immaculate Conception Parish, Marydel. (Courtesy of Father Douglas Dempster.)

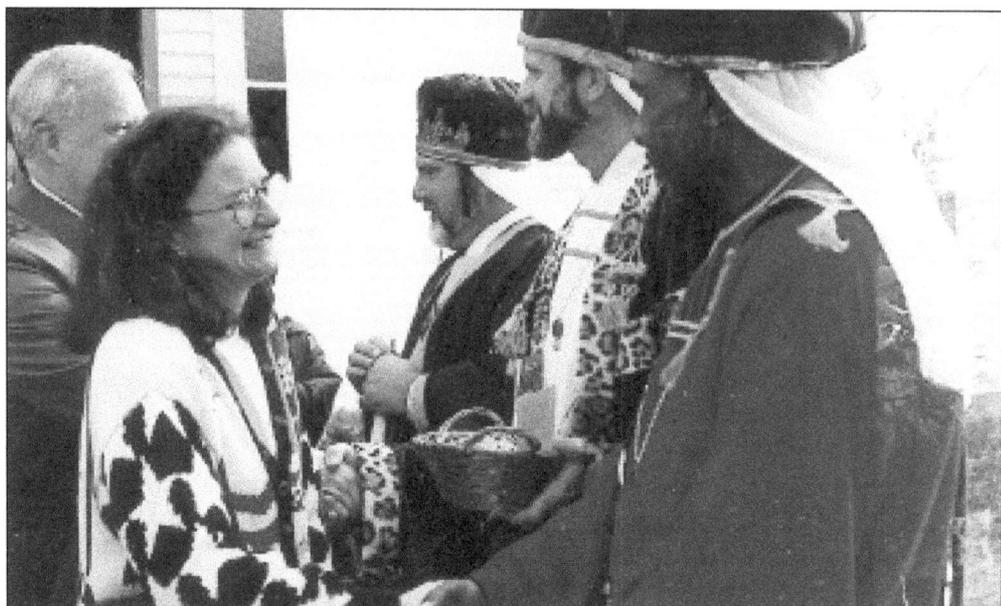

Kings Melchior, Casper, and Balthasar, the Maji, greet worshipers at St. Benedict Church, Ridgely, after Mass on Epiphany Sunday. When not costumed and bearing gifts, they are known as Mr. Eugene Ingram, Mr. Paul Fountain, and Mr. Joseph Dunnington.

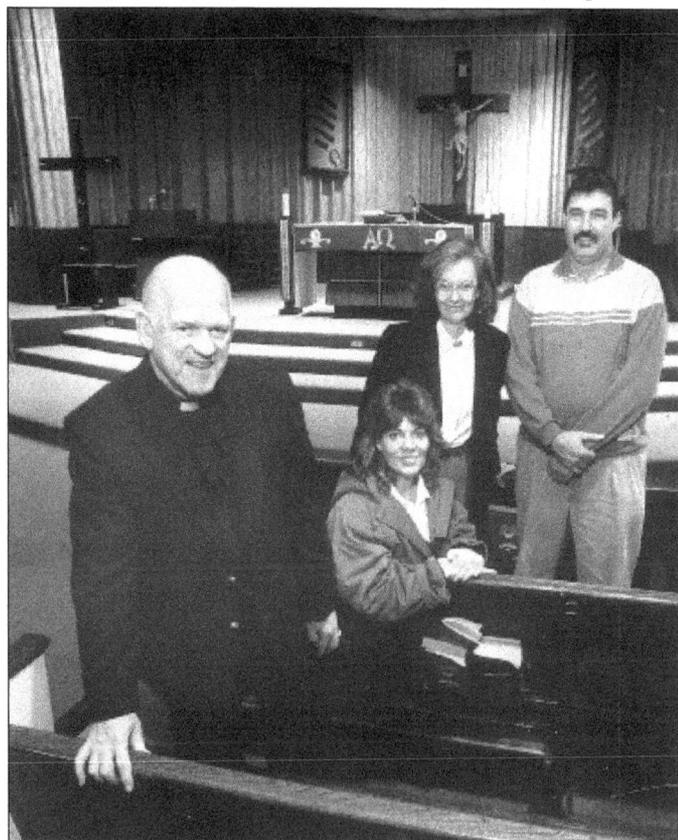

Father John J. Masterson is shown with parishioners of St. Ann Parish in Bethany Beach soon after his appointment as pastor in 1984. The parishioners are, from left to right, Ms. Christine Bauer, Ms. Jeannie Fleming, and Mr. Rob Ward. (Photo by Ralph Freso.)

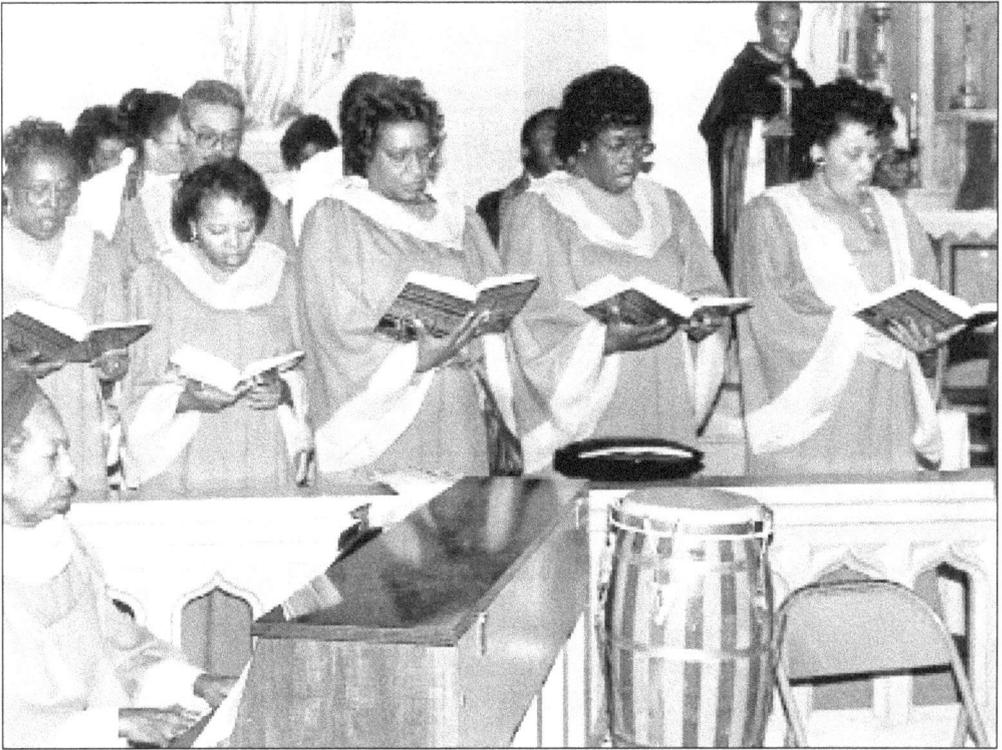

The Diocesan Gospel Choir sings at a liturgy at St. Joseph Church in downtown Wilmington in 1991. (Photo from *The Dialog*.)

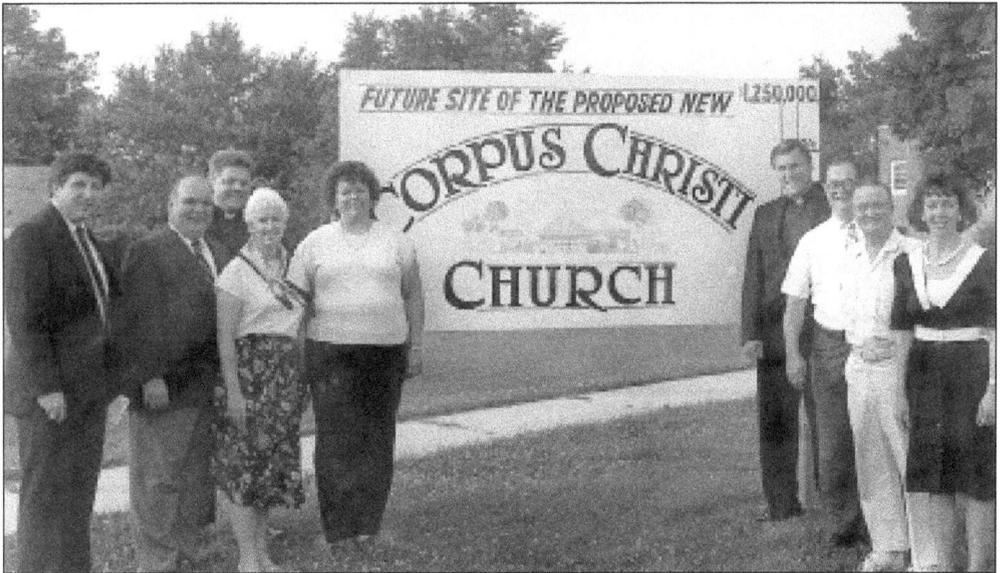

The building committee at Corpus Christi Parish assemble at the site on New Road in Elsmere where the present church is located. Father Thomas F. Gardocki, pastor, is standing at the left of the sign. The parish was founded in 1948 to serve a rapidly growing population at the start of the "Baby Boom." For a time, it conducted a high school as well as a parochial elementary school. (Photo from *The Dialog*.)

Father Charles J. McGinley, shown here with St. Helena parishioner Mr. Starr Cole, was ordained in 1940 and served in several parishes before being appointed pastor of St. Helena's, near Bellefonte, in 1971. He literally died at his desk nine years later from a heart attack at age 66 in the 41st year of his priesthood. (Photo by Action.)

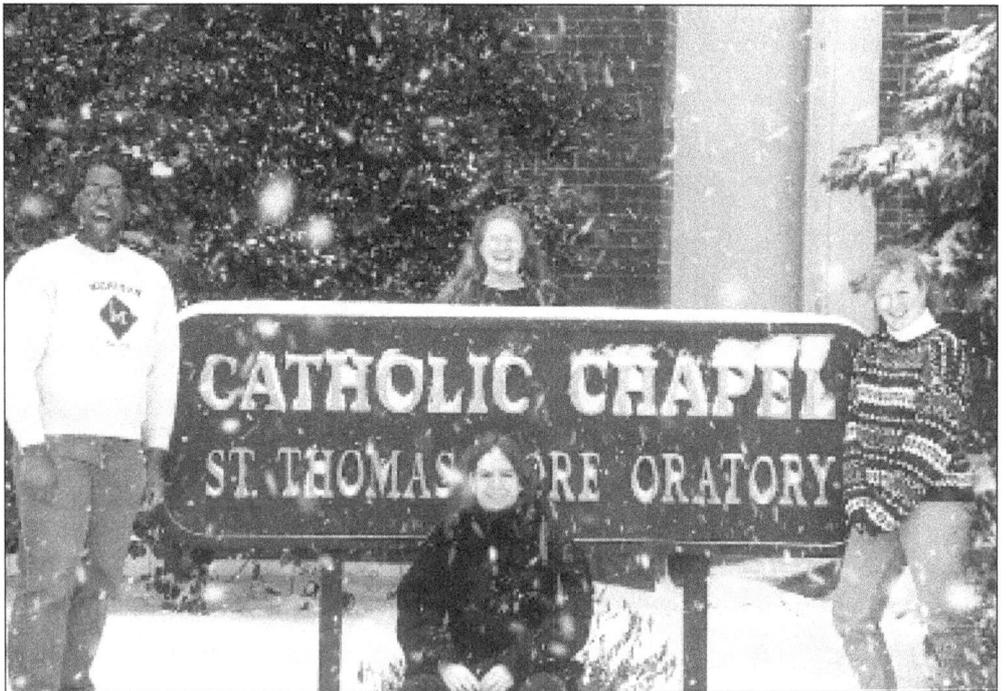

Young parishioners enjoy a snowfall outside St. Thomas More Oratory on Lovett Avenue in Newark. The oratory was founded in 1975 under the leadership of Father Michael Szupper to serve the spiritual needs of Catholics and others in the University of Delaware community.

Bishop James Charles Burke, a native of Philadelphia, was ordained a Dominican priest and served in the order's South America missions. At age 41, he was consecrated as the first bishop of Chimbote, Peru. With a growing trend to replace foreign with native Peruvian clergy, he was relieved 11 years later and invited by Bishop Mardaga to come to Wilmington. He served as pastor of St. Paul Parish in the city and as diocesan director of the Society for the Propagation of the Faith. He died in 1994 in the 38th year of his priesthood and 27th of his episcopate.

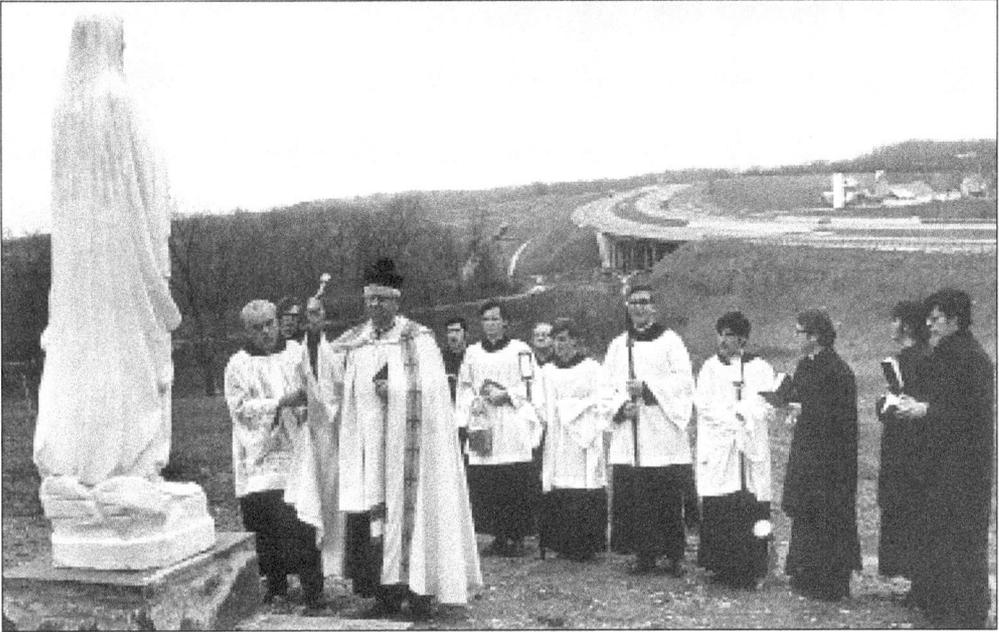

Father John Conmy, provincial of the Oblates of St. Francis de Sales, blesses the shrine of Our Lady of the Highway. At night, the spotlighted statue, on the grounds of the Oblate retreat house and retirement home at Childs, serves as a beacon for drivers northbound on the Maryland Turnpike as they approach Elkton. At all times, it reminds travelers to seek the Blessed Mother's intercession for their safety and other spiritual and material needs. Interstate 95, of which the turnpike is a segment, is one of the most heavily traveled highway routes in the United States. (*Cecil Whig* photo courtesy of the Oblates of St. Francis de Sales.)

Former principals of St. Mark's High School attend an alumni event. Father James T. Delaney (left) was appointed when the diocesan school opened in 1969. He was succeeded in 1972 by Father J. Thomas Cini (right), who served until named the diocese's Episcopal Vicar for Administration. Mr. Ronald Russo, center, then became the third principal. (Photo from *The Dialog*.)

Parishioners engage in an egg toss at St. Christopher Parish's annual picnic in 1992. The parish is located at Chester, on Kent Island, at the eastern end of the Chesapeake Bay Bridges. (Courtesy of St. Christopher Parish.)

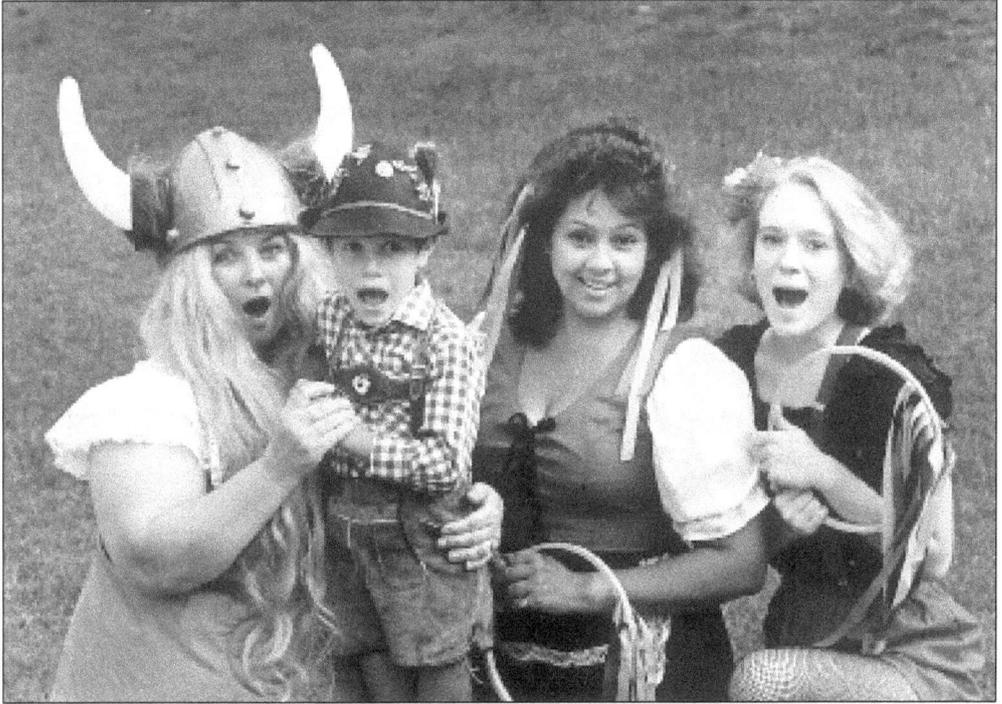

A blonde Valkyrie, goatherders, and a cabaret dancer were among the entertainers at an Oktoberfest variety show at Holy Cross Church in Dover. They are, from left to right, Ms. Carmella Jones, Marc Carson, Ms. Lori Christiansen, and Ms. Danielle Gribbins. (Photo by Fred Kaltreider.)

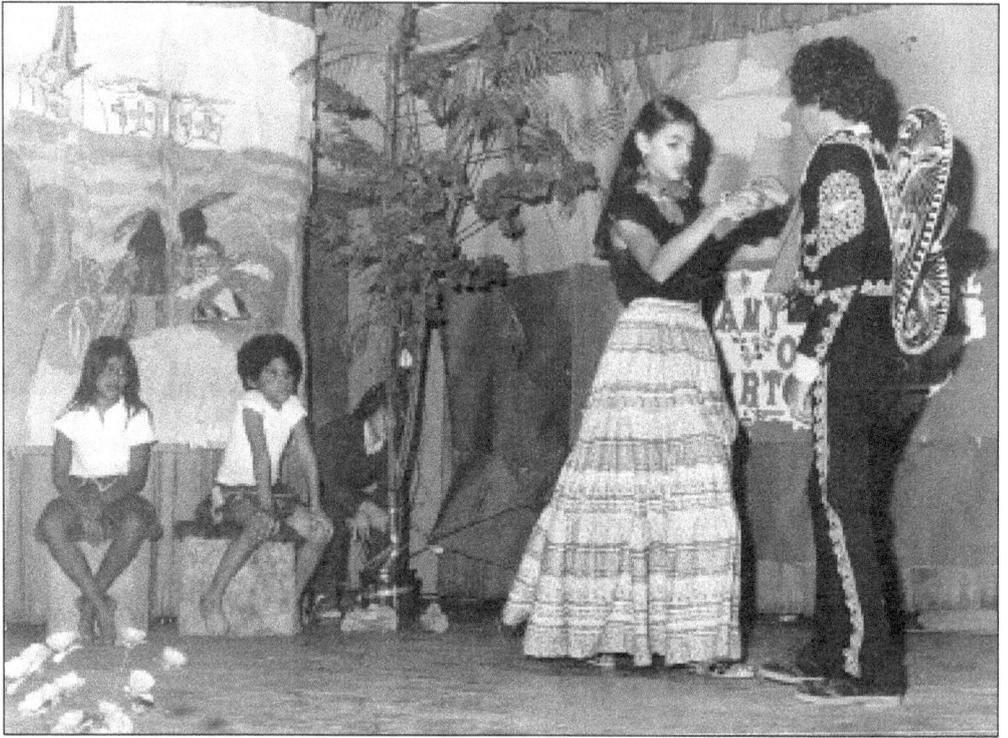

Young parishioners in traditional costume dance at a festival at St. Paul's Church in west Wilmington celebrating their Hispanic heritage. (Photo from *The Dialog*.)

Father Daniel W. Gerres, pastor, takes students from Immaculate Heart of Mary Parochial School on a tour of the new church building at Shipley and Weldin Roads in Brandywine Hundred. (Photo from *The Dialog*.)

They also serve who toil behind the scenes. These ladies of St. Anthony of Padua Parish were responsible for seeing that the youngsters performing in the annual production of *Via Crucis* (Way of the Cross) were properly shod. Pictured are, from left to right, Mrs. Ann Patille, Mrs. Marge Schiavelli, and Mrs. Rose DiFrancesco. The passion play is presented several times each Lent in the church at Ninth and Du Pont Streets in Wilmington. (Photo by Action.)

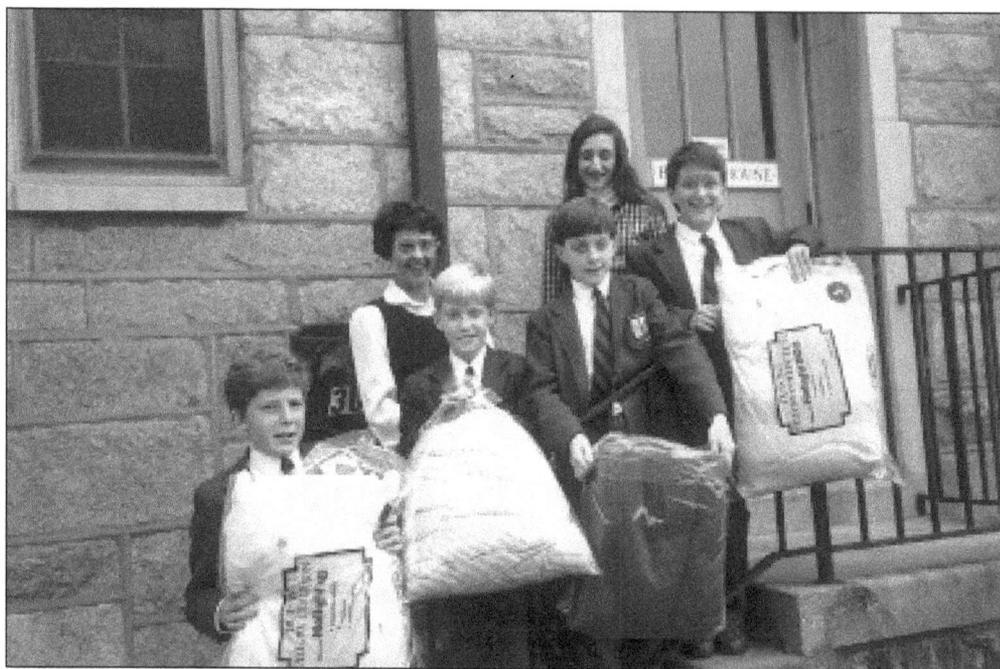

Members of the St. Edmond's Academy Student Council deliver pillows, blankets, towels, and other items to Bayard House, a residence in southwest Wilmington for unwed pregnant women and new mothers. The council was able to buy about $500 worth of items as the result of a 1989 drive. The students here are, from left to right, Fritz Caraher, Sean Mahoney, Chris Hillock, and Dan DiValerio. Accepting the gifts are Sister Eileen Poorten (left), director of Bayard House, and Ms. Debbie Guastella, its social services coordinator.

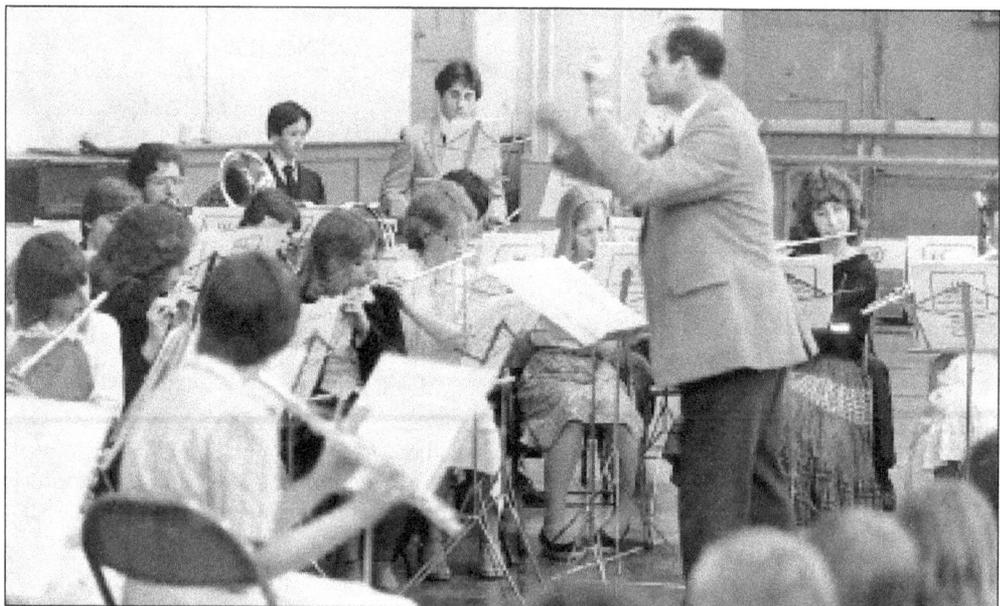

The diocesan student honors band rehearses for a concert in 1987 under the baton of Mr. Joseph Euculano of Instrumental Music Programs Inc. The band was comprised of music students from 12 elementary schools. (Jim Grant photo from *The Dialog*.)

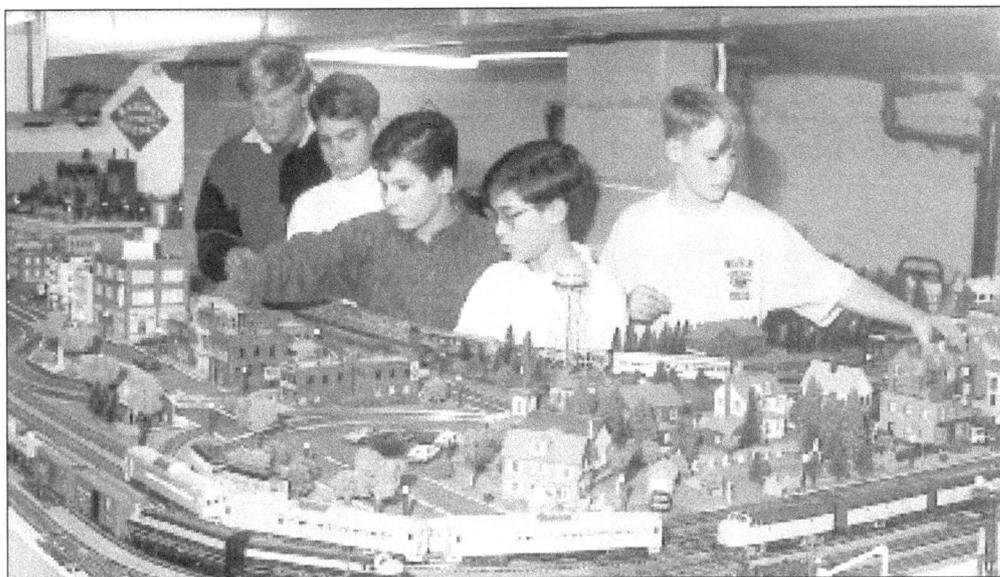

Youngsters in St. Matthew Parochial School check out their own railroad, courtesy of their pastor, Father Michael J. Cook. A model train buff since he found one under the Christmas tree at a young age, Father Cook has taken his fully electrified basic layout through his priestly assignments. At St. Matthew's he turned the hobby into an educational experience offering it as an elective subject for students at the middle school level. (Walt Mateja photo from *The Dialog*.)

Students at Holy Angels School on Possum Park Road north of Newark produced a variety of science projects on display for parents and other visitors at a school fair. (Photo from *The Dialog*.)

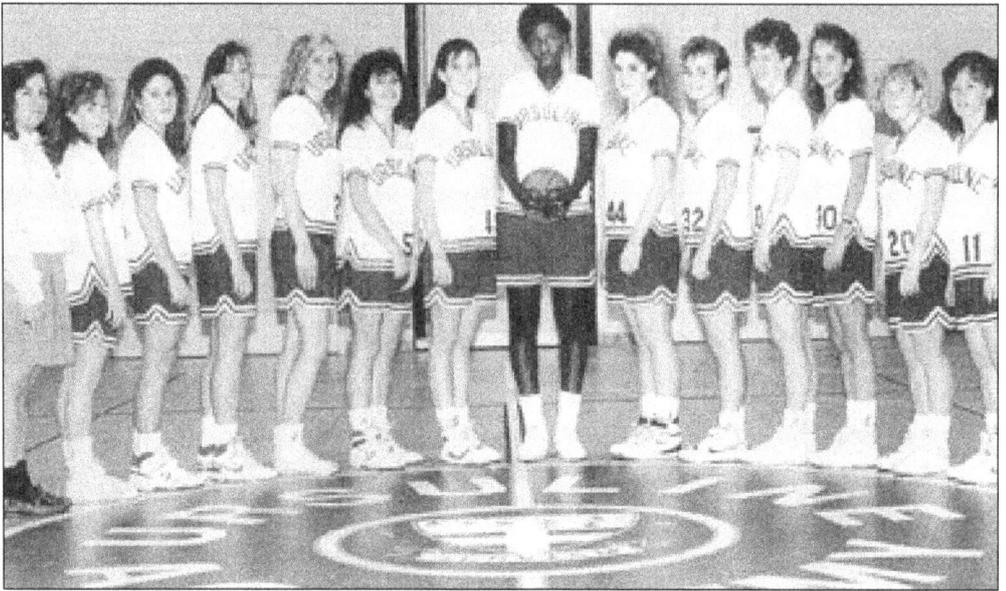

Ursuline Academy was the queen of Delaware basketball when it won the girls state championship six out of eight years between 1985 and 1992 and was runner-up in the other two years. The 1989 team above featured Valeria Whiting, center, who went on to star as a nationally-recognized college and professional player.

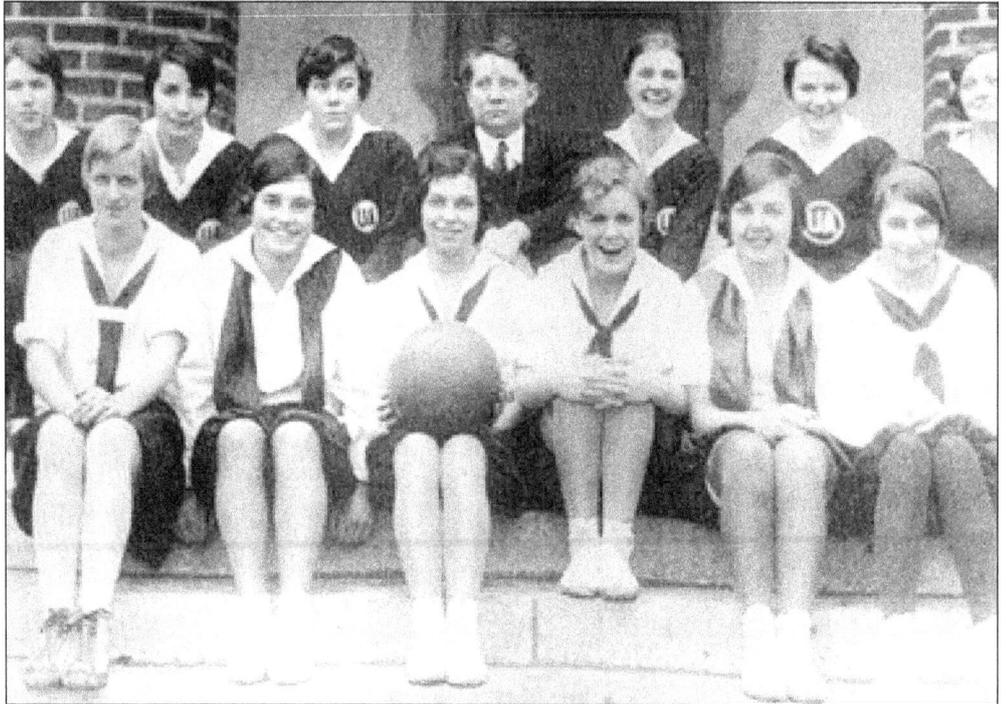

The 1930 varsity basketball team did not receive the same amount of public acclaim as their successors in later years, but the players showed the same kind of enthusiasm. Inclusion of a gymnasium when the school for girls was built in 1926 was something of a novelty at the time. (Both photos from the Ursuline Academy's 1993 centennial booklet.)

Felician Sister Mark Alexander Siegel explains world geography to students at St. Hedwig School. (Courtesy of the Felician Sisters.)

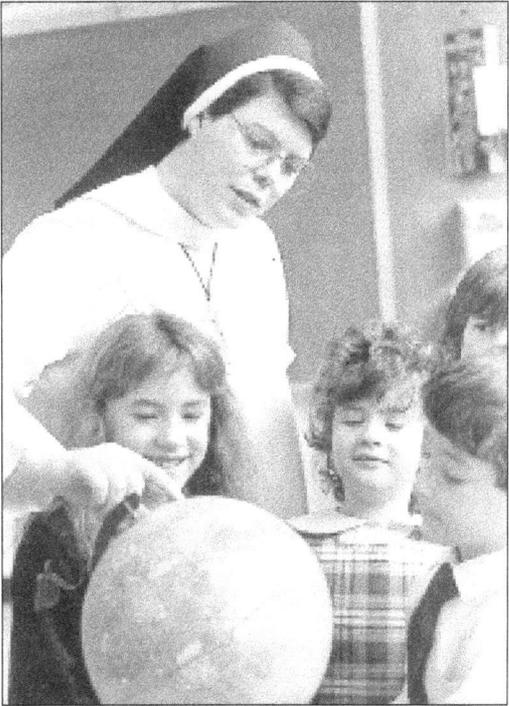

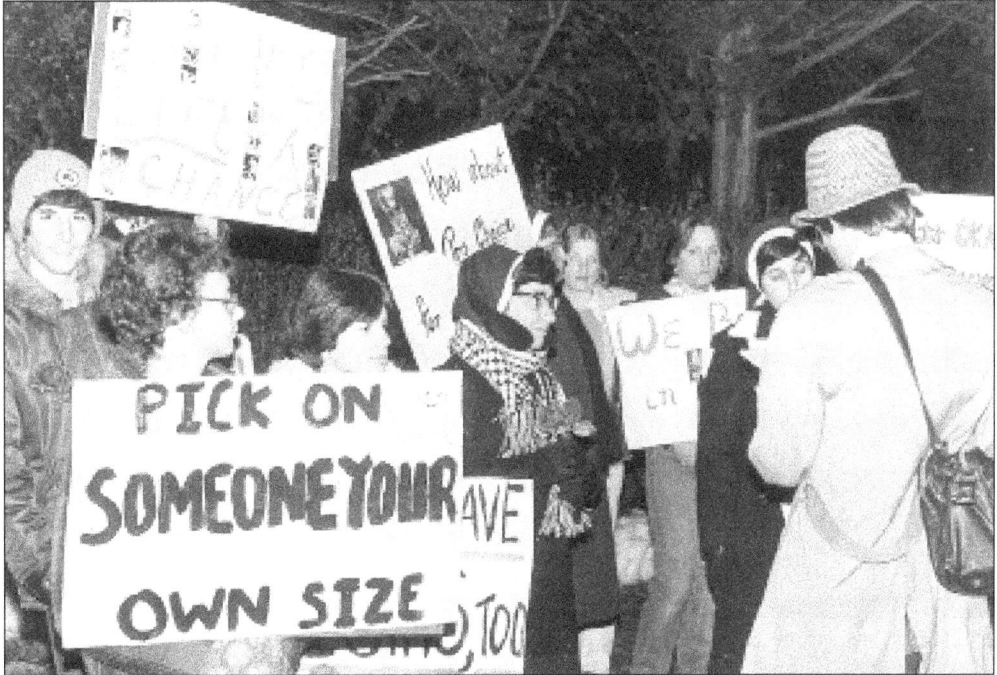

Padua Academy students participate in an anti-abortion demonstration. These young ladies turned out on a cold winter's night to give public testimony to their faith and moral standards. Many members of parishes, schools, and organizations in the diocese have been involved in similar activity since the U.S. Supreme Court declared the taking of unborn life legal. (Photo from *The Dialog*.)

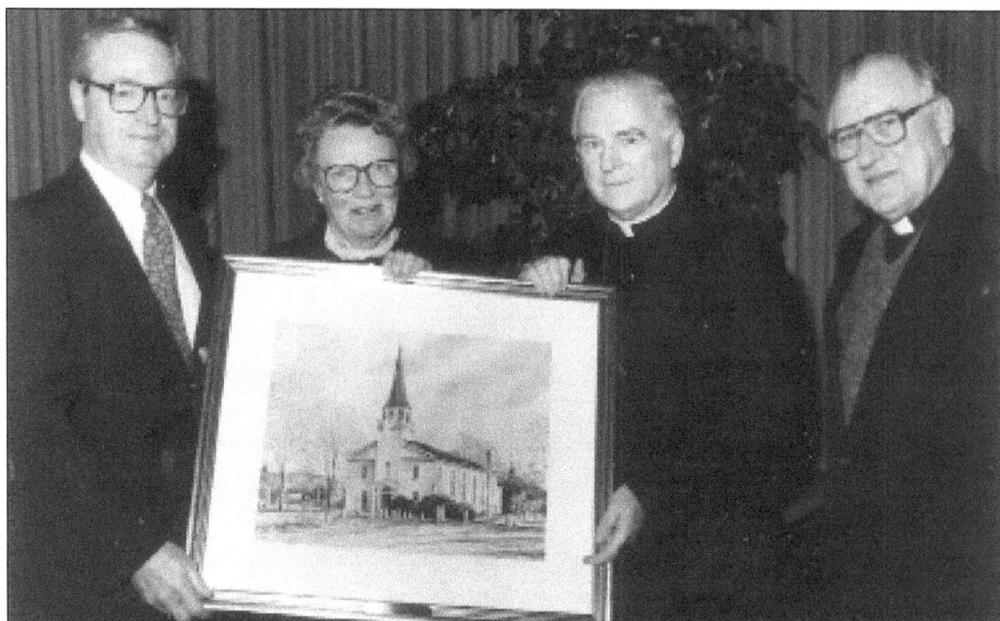

During ceremonies in observance of the Solemnity of St. Joseph in 1991, members of St. Joseph-on-the-Brandywine Parish, Greenville, presented Bishop Mulvee (second from right) with a print of artist W. James McGlynn's painting of the church as it appeared when built in 1841. Sales of numbered prints and the feastday event were part of the parish's 150th anniversary celebration. Participating in the presentation are Judge Joseph Walsh (left) and Mrs. Nancy Corroon, parish trustees, and Monsignor Paul Schierse, pastor (right).

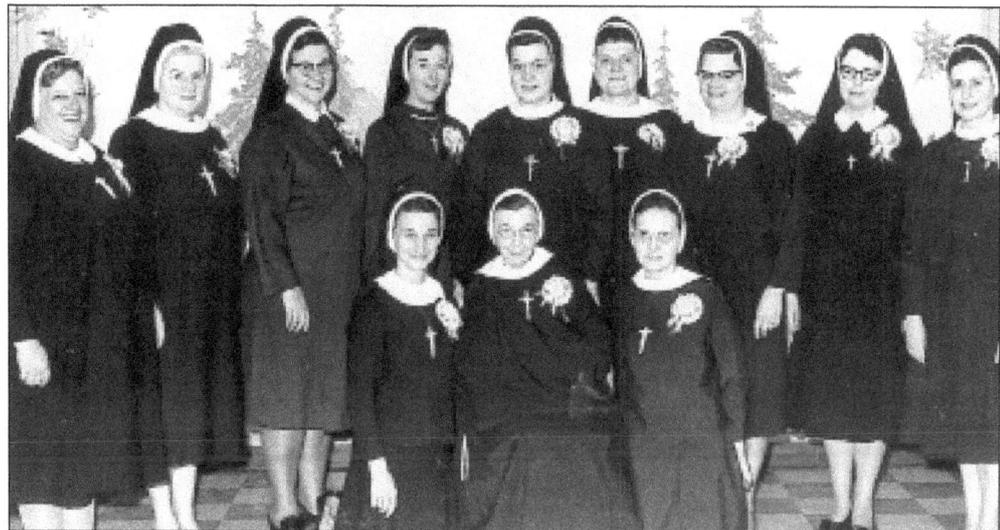

Felician Sisters gather to celebrate the 35th anniversary of their religious profession. The group includes Sisters Jerome, Marcella, Grace, Jolanta, Geraldine, Nora, Vitebia, Archangel, Claver, and Mary. Two of the sisters wearing slightly different garb are members of another province and are not identified. The Lodi, New Jersey, province of the order—officially the Congregation of Sisters of St. Felix of Cantalice—has been closely associated with the diocese since early in the 20th century. Felicians have taught at St. Hedwig, St. Stanislaus Kostka, Holy Spirit, and Holy Cross Parish schools and conducted Our Lady of Grace Orphanage.

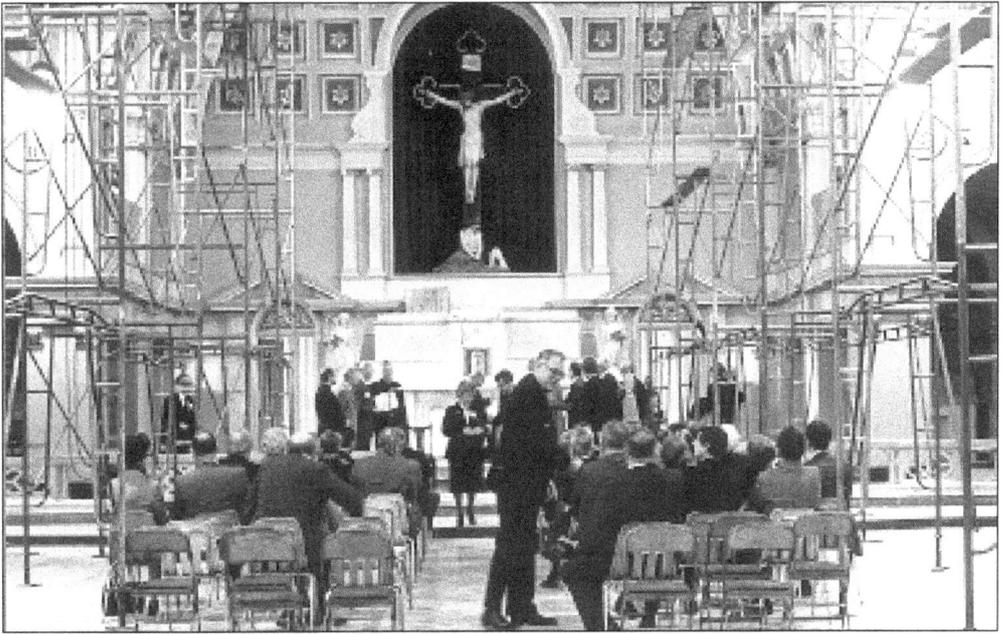

Volunteer workers gather in the cathedral in early 1981 to hear plans to restore and revitalize the historic downtown Wilmington church. It had to be abruptly closed to the public the previous May when a rosette fell from the ceiling. Extensive studies pointed to the need for structural repairs to the diocese's mother church and, at the same time, it was to be updated to meet Vatican II liturgical standards. During the extensive project, parishioners worshipped next door in the school building. (Photo from *The Dialog*.)

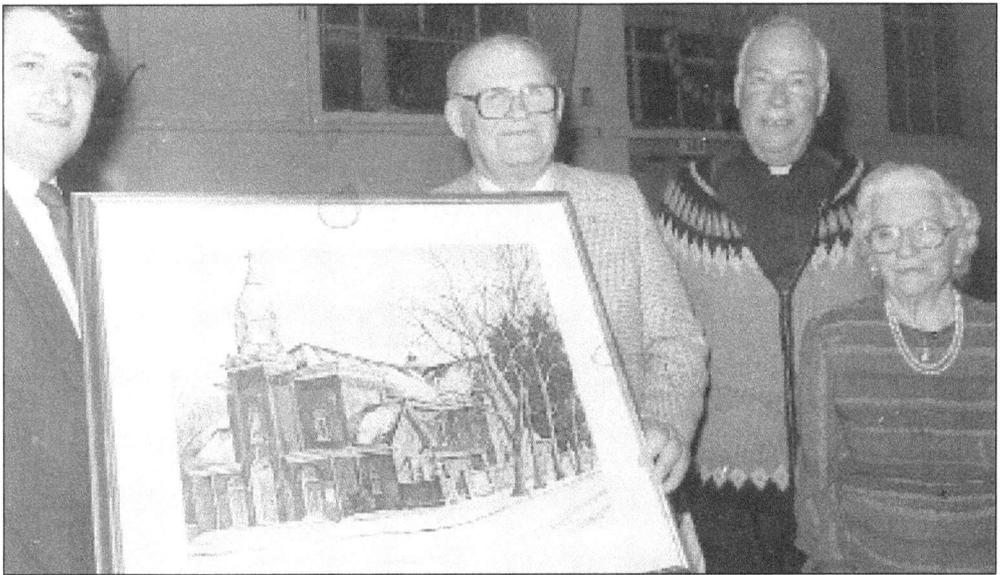

Mr. Ziggy Armstrong (second from the left) receives a framed print of Mr. McGlynn's painting of the Cathedral of St. Peter in recognition of almost 50 years of service to the parish and its school. Making the presentation in 1989 are Mr. Hugh Leahy (left), president of the parish council; Monsignor Paul Taggart, pastor; and Mrs. Theresa Consiglio, a parish trustee. (Kathleen M. Graham photo from *The Dialog*.)

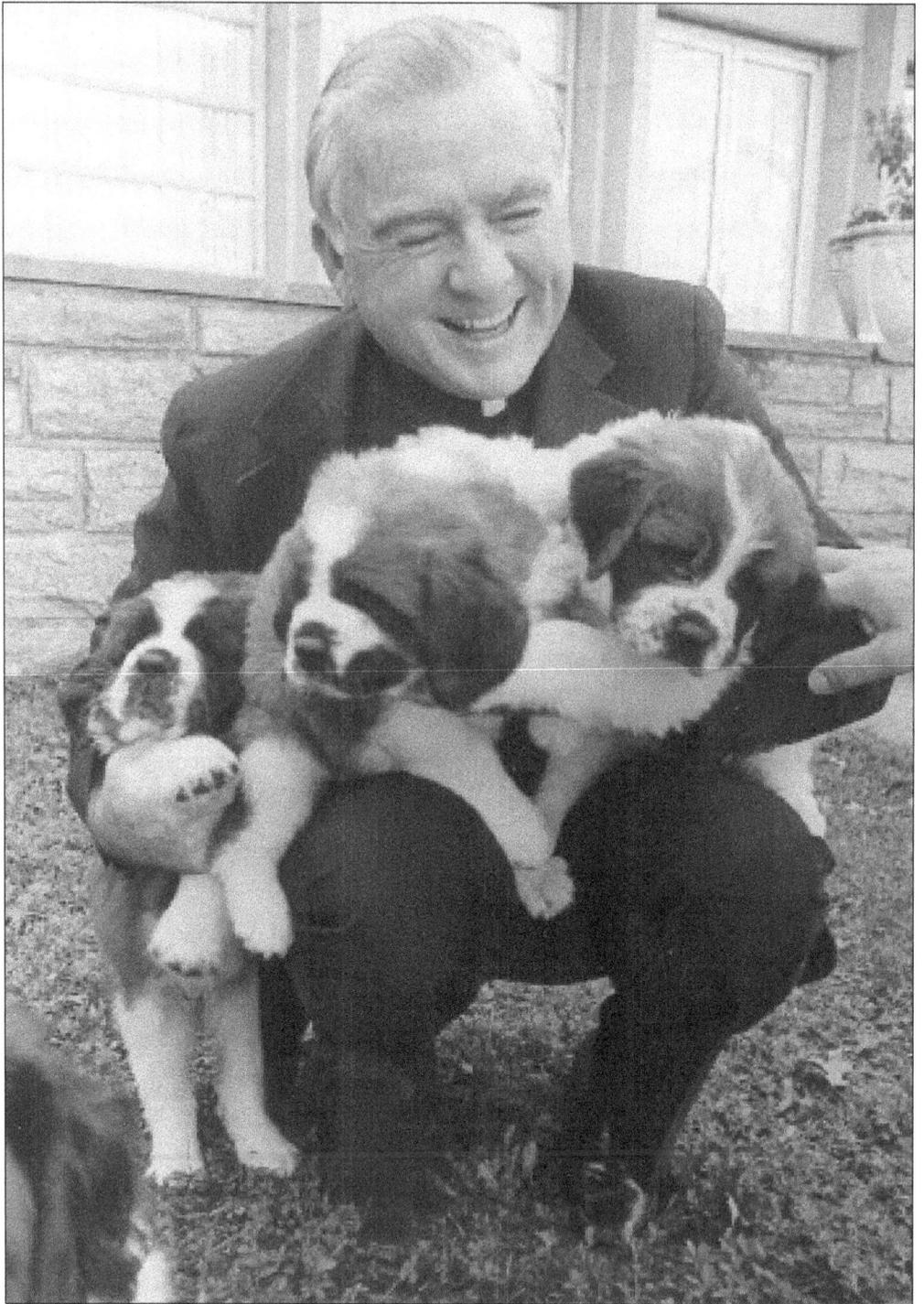

Bishop Mulvee seems to be enjoying himself more than the trio of Saint Bernard puppies he is trying to befriend. The pups were the offspring of Father Roberto Balducelli's canine pet. Father Roberto is pastor emeritus of St. Anthony of Padua Parish, Wilmington, and guiding hand for St. Anthony-in-the-Hills in nearby Kaolin, Pennsylvania. (Courtesy of F. Eugene Donnelly.)

Felician Sister Mary Julutta serves a meal at the Ministry of Caring's Emanuel Dining Room. Engaging in the social apostolate is one of the current activities the order has taken on. The community doing that work lives in what used to be the rectory attached to Sacred Heart Church in downtown Wilmington. (Courtesy of the Felician Sisters.)

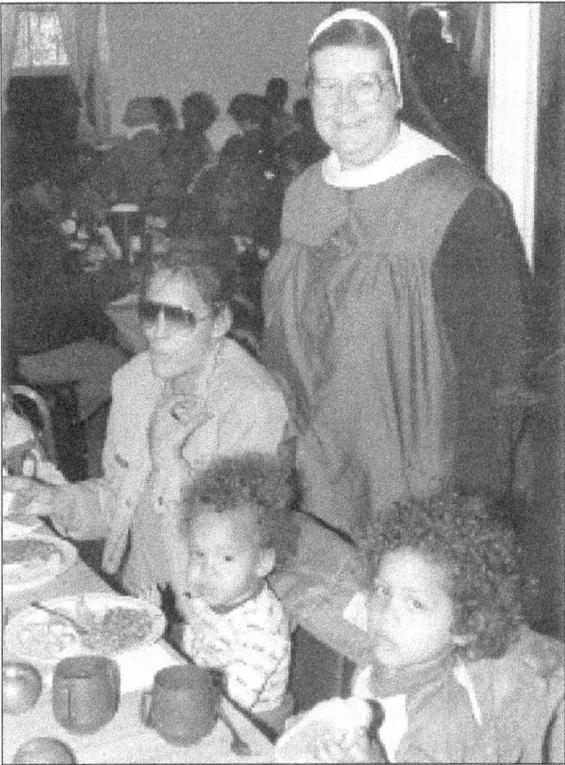

Father John Hynes, pastor, assisted by Deacon John Falkowski and server Hugo Sanchez, baptizes a baby in the running-water pool that is the baptistery at St. Catherine of Siena Church on Centreville Road in Christiana Hundred. (Courtesy of St. Catherine of Siena Parish.)

St. Gertrude Monastery, the motherhouse of the Benedictine Sisters, is located three miles north of Ridgely. This one-story brick building, with its archway and bell tower, replaced the original frame structure in 1971. By 1959, the original academy had evolved into the Benedictine School for Exceptional Children. In 1983 St. Martin's Barn, a food and clothing distribution center, was established, and in 1993, St. Martin's House, a transitional facility for homeless women and their children, was opened. (Courtesy of the Benedictine Sisters.)

Sister Corda Marie Bergbauer, congregational minister for the Franciscan Sisters, breaks grounds for St. Francis Hospital's expansion forward from its original building line to Clayton Street. Built at a cost of $17 million, the five-story section greatly expanded the capacity of the hospital as it entered its second half-century of service. (Lubitsh & Bungarz photo from the commemorative booklet published for St. Francis Hospital's 75th anniversary in 1999.)

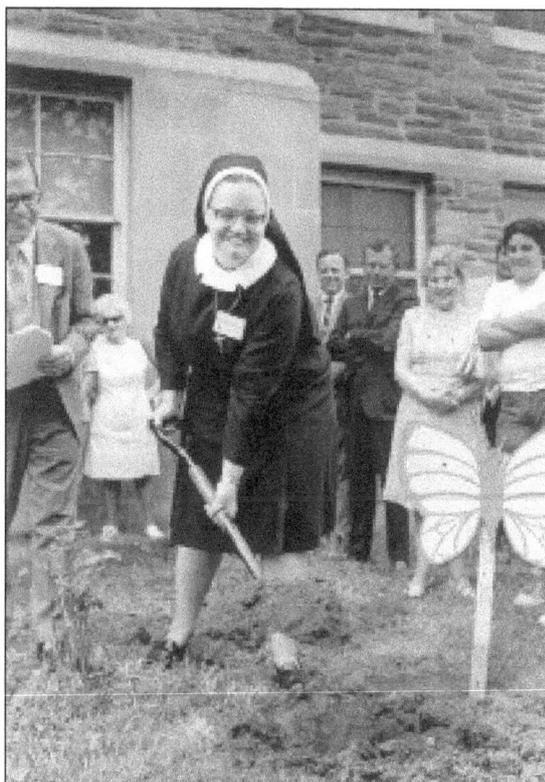

Fathers Richard Reissmann and John Grasing examine smoke and heat damage to the sanctuary of St. John the Baptist Church after a July 1991 fire. Father Reissmann, pastor, credited saving the structure to quick response by and the work of Aetna Hose Hook & Ladder Company volunteers. The fire was discovered at 2:15 a.m. by Mr. Dan McCann, who maintained and lived behind the church. Morning Mass was offered outside as a Mass of Thanksgiving that day. (Jack Louden photo from *The Dialog.*)

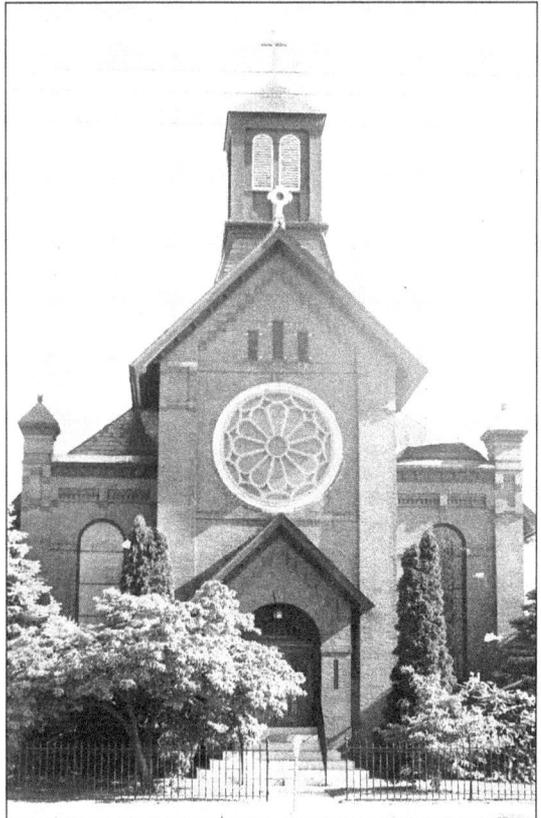

Historic St. John the Baptist Church is located at Main and Chapel Streets in Newark. The parish, which was established in 1891, was the successor to St. Patrick's Mission, which dated to 1868. This photograph was taken in 1969. (Photo from *The Dialog.*)

Father Alex Gorski blesses Easter bread and other foods during a traditional Polish ceremony at St. Stanislaus Kostka Parish. The parish was founded in 1912 to serve the Polish-American community on the east side of Wilmington, many of whose members then worked in the city's thriving Moroccan leather industry. (Courtesy of St. Stanislaus Kostka Parish.)

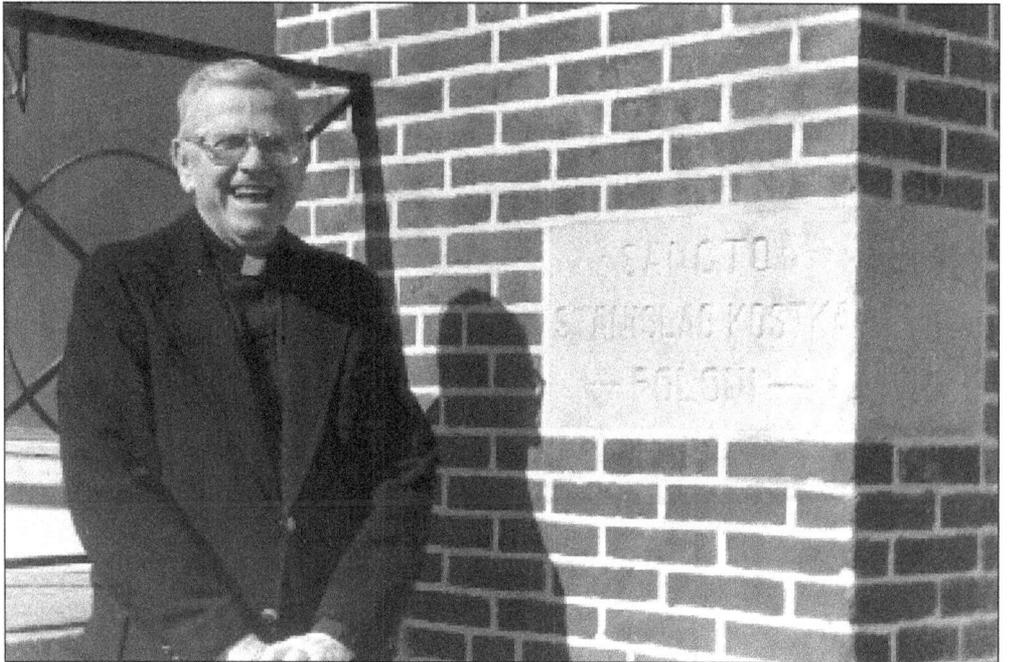

Father Gorski stands outside St. Stanislaus Kostka Church at Seventh and Buttonwood Streets. A native Wilmingtonian, Father Gorski, who was ordained in 1943, was twice pastor of St. Stanislaus and served during his long priesthood as pastor and assistant pastor in several other parishes as well as a chaplain in the U.S. Navy. (Photo from *The Dialog*.)

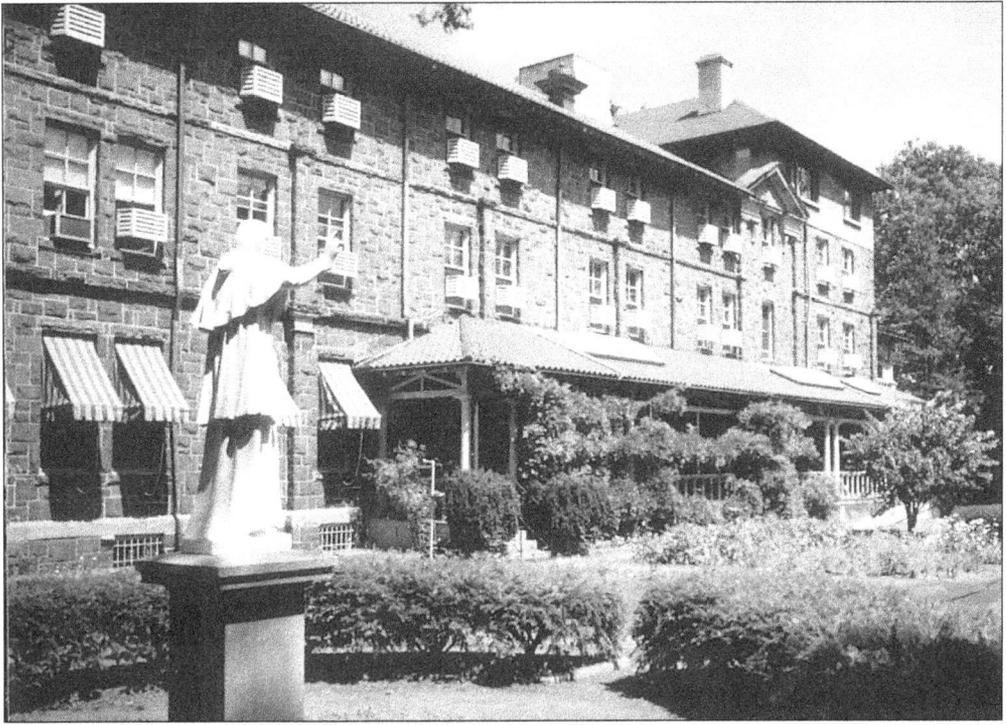

The Visitation Monastery and garden were hidden from view by a large stone wall around the property at Bancroft Parkway and Gilpin Avenue in west Wilmington and therefore seldom seen by outsiders. Bishop Becker invited the Visitandines to Wilmington to establish a school for girls in 1868. Twenty-five years later, they ceded the school to the Ursulines and retired into the cloister.

The Visitation community poses in the monastery garden shortly before leaving in 1993 for their new home in Massachusetts. After their long association with the diocese, the sisters withdrew in favor of a more secluded establishment conducive to contemplative life. (Both photos courtesy of the Visitation archives.)

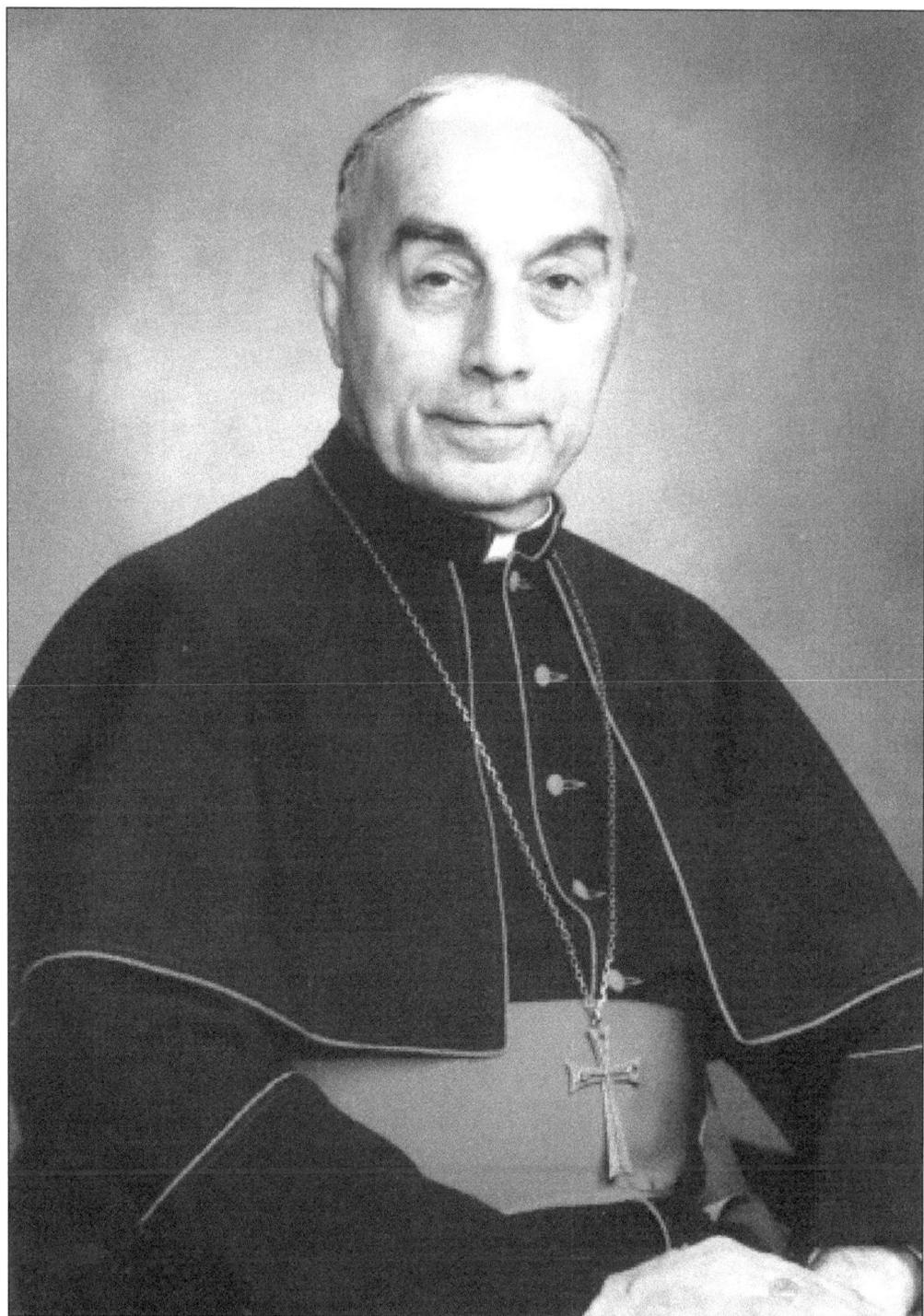

Bishop Michael Angelo Saltarelli was born in Jersey City, New Jersey, on January 17, 1933. He was ordained in Newark, New Jersey, May 28, 1960, and consecrated as auxiliary bishop of Newark and titular bishop of Mesarfelta on July 30, 1990. On January 23, 1996, he was installed as eighth bishop of Wilmington.

Six

INTO THE FUTURE

Bishop Saltarelli visits Our Lady of Grace Home. Hosting him on this occasion, soon after his installation in 1996, is Felician Sister Antonea, administrator of the home. Once known as the "Polish orphanage," Our Lady of Grace, near Ogletown, now cares for abused and neglected children of all heritages. Felicians have conducted and staffed the home since 1931.

Members of the Capuchin Poor Clares came to Wilmington from Mexico in the 1990s to combine a cloistered community with service in the spirit of St. Francis of Assisi. They live at St. Veronica Giuliani Monastery on Jefferson Street and work with the Ministry of Caring. In the photo above, the sisters pose in their garden with Brother Ronald Giannone (a Franciscan priest), who founded the ministry and who invited them to Delaware. All have since become U.S. citizens. (Courtesy of the Poor Clares.)

Parishioners of St. Elizabeth Ann Seton raise a wooden cross as a symbol of both their faith and their determination to raise funds to finance a new church. The idea was to demonstrate that the church would be built around the cross. Founded in 1978 in what then was a sparsely populated rural area, the parish found itself by the time of the ceremony in 1996 situated in the midst of the rapidly developing Bear-Glasgow population center. (Photo by Jennifer Williams.)

Father John F. O'Brien, pastor of St. Mary Magdalen Parish, hits a high note during a celebration marking the retirement of Deacon Richard L. Reece (seated). Deacon Reece was among the first in the diocese ordained to the permanent deaconate. He served St. Mary Magdalen Parish in that capacity for 20 years. Enjoying the celebration are his wife, Flo, and parishioner Mr. Bill Hannigan. (Courtesy of St. Mary Magdalen Parish.)

Shown is the crowning of the Blessed Mother during a May Procession at Ss. Peter and Paul High School in Easton in 1996. Like all Catholic schools, it combines features from a long tradition of religious education with the instruction necessary to prepare young people for meaningful lives in the modern world. (Courtesy of Ss. Peter and Paul High School.)

Smiling for the camera are members of the delegation from the Diocese of Wilmington at World Youth Day in Rome during the summer of 2000. Visiting the ruins of the Coliseum are, from left to right, Allison Muraski, Janet Smith, Bridget Smith, and Jessica Matthews. (Courtesy of the Office of Catholic Youth Ministry.)

St. Thomas More Academy at Magnolia is the newest school in the diocese. The high school was founded to serve students in Kent and Sussex Counties, Delaware, and nearby Maryland. Seniors (above) share a feast on their Senior Day in 2000. The group below are being received into the school's honor society. (Both photos courtesy of St. Thomas More Academy.)

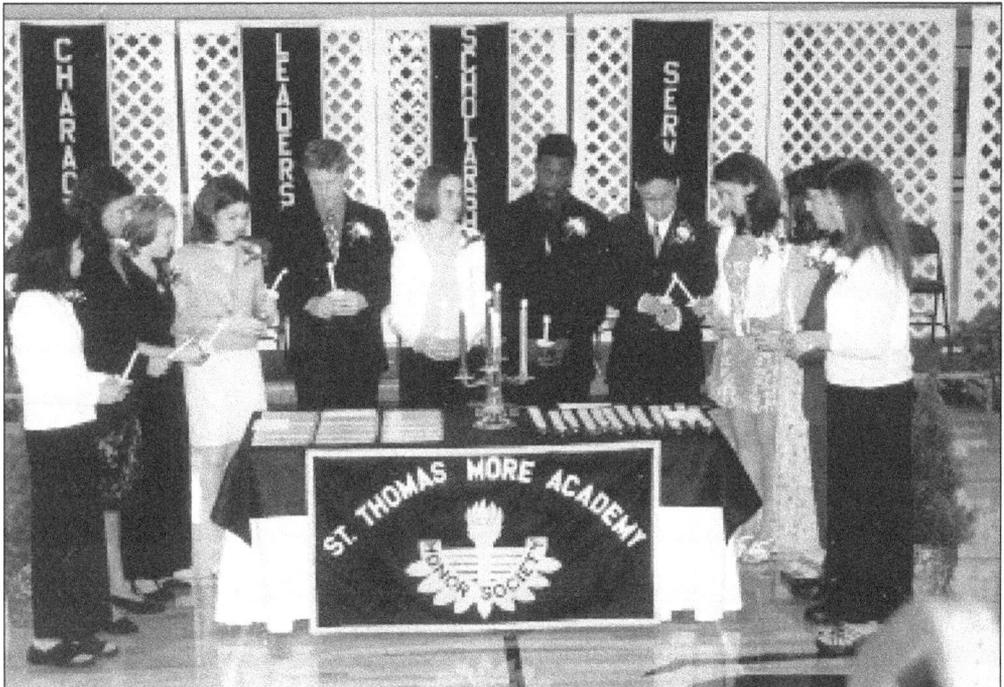

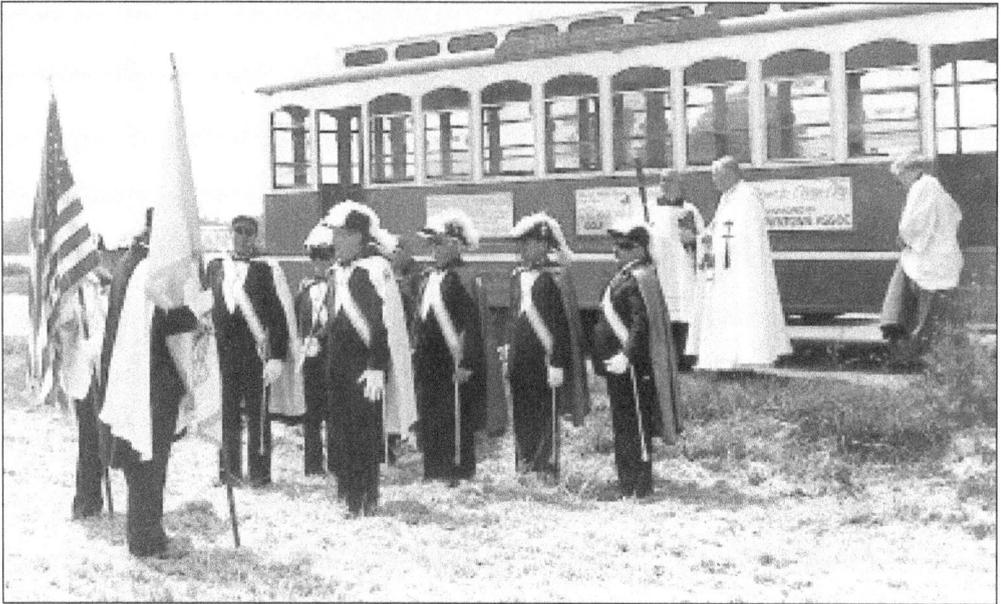

A Knights of Columbus honor guard forms before groundbreaking at St. John Neumann Church in Ocean Pines. Dignitaries were transported to the site in a tourist trolley. The new church is a mission of St. Luke and St. Andrew Parish in Ocean City. Also planned to serve the resort community's growing year-around population is a school. (Marianna McLaughlin photo from *The Dialog.*)

Even though St. Elizabeth Parish and its schools are nearly a century old, they have not stopped growing. The parish and its school community greeted the new millennium by constructing a classroom and gymnasium building for the high school. (Courtesy of St. Elizabeth Parish.)

126

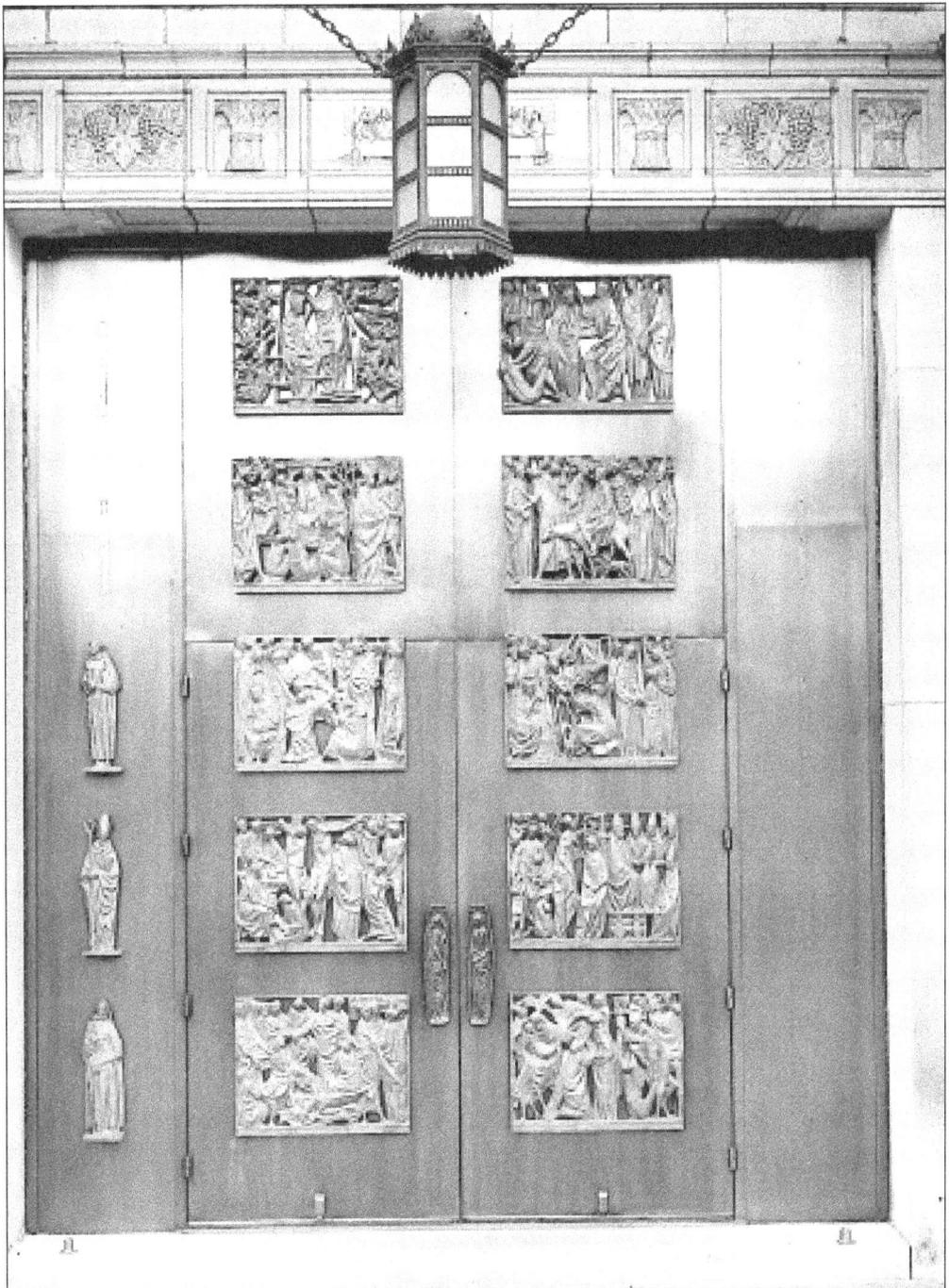

The doors have opened on a new century and millennium. (Photo from *The Dialog*.)

DISCOVER THOUSANDS OF LOCAL HISTORY BOOKS
FEATURING MILLIONS OF VINTAGE IMAGES

Arcadia Publishing, the leading local history publisher in the United States, is committed to making history accessible and meaningful through publishing books that celebrate and preserve the heritage of America's people and places.

Find more books like this at
www.arcadiapublishing.com

Search for your hometown history, your old stomping grounds, and even your favorite sports team.

Consistent with our mission to preserve history on a local level, this book was printed in South Carolina on American-made paper and manufactured entirely in the United States. Products carrying the accredited Forest Stewardship Council (FSC) label are printed on 100 percent FSC-certified paper.

MADE IN THE
USA

www.ingramcontent.com/pod-product-compliance
Lightning Source LLC
Chambersburg PA
CBHW080855100426
42812CB00007B/2032

* 9 7 8 1 5 3 1 6 0 9 3 3 7 *